JAPAN

EARLY
JAPANESE IMAGES

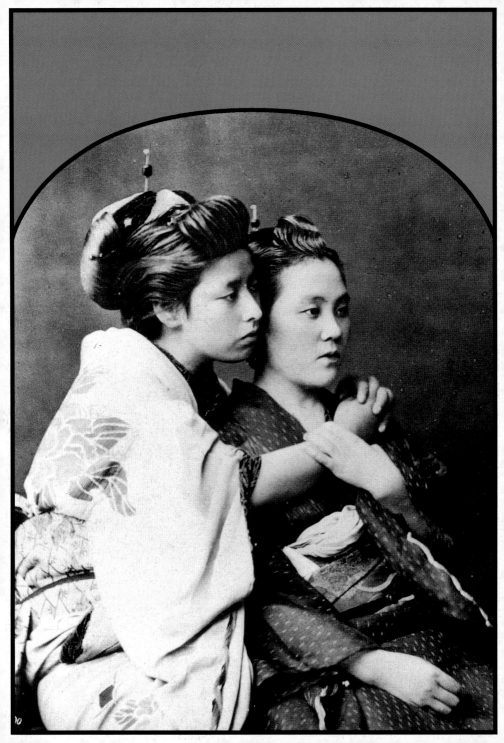

EARLY
JAPANESE IMAGES

Terry Bennett

Charles E. Tuttle Company
Rutland, Vermont & Tokyo, Japan

To Kishiko

Published by the Charles E. Tuttle Company, Inc.
of Rutland, Vermont & Tokyo, Japan
with editorial offices at
2-6 Suido 1-chome, Bunkyo-ku, Tokyo 112

LCC Card No. 95-61322

ISBN 0-8048-2029-5 (hardback)
ISBN 0-8048-2033-3 (softback)

First edition, 1996

Printed in Singapore

Table of Contents

List of Images 7

Acknowledgments 11

Preface 13

Reflections of the Rising Sun *by* Sebastian Dobson 15

Early Japanese Images 29

 The Introduction of Photography to Japan 31

 Early Western Photographers in Japan 33

 Felice Beato *37* Baron Raimund von Stillfried-
 Ratenicz *41* Adolfo Farsari *44*

 Early Japanese Photographers in Japan 46

 Shimooka Renjo *47* Ueno Hikoma *48* Kusakabe
 Kimbei *50* Tamamura Kozaburo *51* Ogawa
 Kazumasa *52* Uchida Kuichi *54* Other Japanese
 Photographers *56*

 Identifying Photographers' Work 59

The Images 63

Notes on Selected Images 137

Appendix 1: Early Japanese Photographs 145

Appendix 2: Photographic Terms 161

Bibliography 163

Notes: Japanese name order, i.e., surname followed by given name, is used within the text, except for the few nineteenth-century photographers who adopted Western name order. Macrons, signifying long vowels in romanized Japanese, are used with italicized words within the text.

The hemp-leaf border motif is from a traditional pattern found on women's wear.

— *List of Images* —

(Unless otherwise indicated, the images in the following list are regular photographs.)

1 *(Frontispiece)*. Two women embracing, Stillfried *page 2*
2. Typical lacquered album *10*
3. Edo Castle, Shimooka *12*
4–6. Members of the first shogunal mission to Europe in London, Caldesi and Company *14*
7. Ikeda Chikugo-no-kami, Gaspard Félix Tournachon (known as Nadar) *14*
8. Shoemaker, Usui *27*
9. Street vendor, Beato *28*
10. Shimooka Renjo in later life, photographer unknown *30*
11. Model wearing dance costume, Ogawa *62*
12. Otometoge, near Mount Fuji, Kusakabe *64*
13. Japanese woman, lithograph, Eliphalet Brown, Jr. *65*
14. Shimazu Nariakira, daguerreotype, Ichiki Shiro *65*
15. Island of Deshima, Beato *66*
16. Dutch officials at Deshima, photographer unknown *66*
17. Two Japanese women, stereograph, photographer unknown *67*
18. Japanese and British legation, stereograph, photographer unknown *67*
19. Japanese cemetery at Edo, stereograph, photographer unknown *67*
20. Port of Kanagawa, stereograph, photographer unknown *68*
21. American legation in Edo, stereograph, photographer unknown *68*
22. Town and bay of Kanagawa, stereograph, photographer unknown *68*
23. Two officials, carte-de-visite photograph, Parker *69*
24. Woman wearing *haori* coat, carte-de-visite photograph, Parker *70*
25. Woman with umbrella, carte-de-visite photograph, Parker *70*
26. Nagasaki, stereograph, Burger *71*
27. *Oiran,* or high-class courtesan, with attendant, stereograph, Burger *71*
28. Japanese warrior, stereograph, Burger *71*
29. Fruit seller, photographer unknown *72*
30. *Kojiki,* or beggars, photographer unknown *72*
31. Itinerant Japanese cobblers, photographer unknown *73*
32. Umbrella maker's house, photographer unknown *73*
33. Namamugi, on the Tokaido, Beato *74*
34. The prince of Satsuma and his principal officers, Beato *74*
35. Warrior in armor, Beato *75*
36. *Bettō,* or groom, tattooed, Beato *76*
37. Group of Japanese, Beato *77*
38. Boats at Nagasaki, Beato *77*

39. Girl playing the samisen, Beato *78*
40. Lord Shimazu's quarters, Edo, Beato *79*
41. Lord Arima's quarters, Edo, Beato *79*
42. Dentist, Beato *80*
43. Japanese high official in court attire, Beato *81*
44. Bridge at Iiyama, Beato *82*
45. Samurai of the Satsuma clan, Beato *82*
46. The Wakamiya shrine, Kamakura, Beato *83*
47. The *daibutsu*, or large Buddha, Kamakura, Beato *83*
48. Firemen, Beato *84*
49. Deshima, Nagasaki, Beato *85*
50. Nagasaki, Beato *85*
51. Teahouse women, Stillfried *86*
52. Reclining nude, Stillfried *86*
53. Woman dressing, Stillfried *87*
54. Two women embracing, Stillfried *88*
55. Girl in heavy storm, Stillfried?/Kusakabe? *89*
56. Tsurugaoka Hachiman Shrine, Farsari *90*
57. Sacred bridge at Nikko, Farsari *90*
58. Transplanting rice, Farsari *91*
59. Enoshima, Farsari *91*
60. Girl with fan, Farsari *92*
61. The Bund, Kobe, Farsari *93*
62. Washerwomen, Farsari *93*
63. Traveling family, Farsari *94*
64. Country scene, Farsari *94*
65. Main gate of the Suwa shrine, Nagasaki, Ueno *95*
66. Nagasaki river scene, Ueno *95*
67. Nagasaki, Ueno *96*
68. Konpira Hill, Nagasaki, Ueno *96*
69. Geisha with koto, carte-de-visite photograph, Shimooka *97*
70. Man in traveling clothes, carte-de-visite photograph, Shimooka *98*
71. Poor traveler and his children, carte-de-visite photograph, Shimooka *98*
72. Samurai, Ueno *99*
73. Bound criminal before official, carte-de-visite photograph, Shimooka *100*
74. Tattooed man and victim, carte-de-visite photograph, Shimooka *100*
75. Two samurai, carte-de-visite photograph, Shimooka *101*
76. Kendo match, carte-de-visite photograph, Shimooka *101*
77. Street peddler, carte-de-visite photograph, Shimooka *102*
78. Group with bonsai tree, carte-de-visite photograph, Shimooka *103*
79. Women with child and drum, carte-de-visite photograph, Shimooka *103*
80. Kawasaki Daishi, Shimooka *104*
81. The Muonji temple, Shimooka *104*
82. Teahouse girls, carte-de-visite photograph, Shimooka *105*
83. Musicians, carte-de-visite photograph, Shimooka *105*
84. Houses by river, carte-de-visite photograph, Shimooka *106*
85. Bathhouse, carte-de-visite photograph of an illustration, Shimooka *106*
86. Group of Ainu women, Uchida *107*
87. Group of Ainu men, Uchida *107*
88. Packing tea for export, Suzuki *108*

89. Eating rice, Suzuki *108*
90. Unidentified Westerner, cabinet card, Suzuki *109*
91. Ueno Park, Usui *110*
92. Pleasure boat on the Sumida River, Tokyo, Usui *110*
93. Tattooed man, Usui *111*
94. Woman and child, Usui *112*
95. Geisha, Usui *113*
96. *Oiran,* or high-class courtesans, and attendants, Usui *113*
97. Japanese beauty with cherry blossoms, Ogawa *114*
98. Japanese flower study, Ogawa *115*
99. Home bathing, Kusakabe *116*
100. Girl reading a novel, Kusakabe *116*
101. Yokohama street, Tamamura *117*
102. Ginza Street in Tokyo, Tamamura *117*
103. Nagoya, Tamamura *118*
104. Hozugawa Rapids, Kyoto, Tamamura *118*
105. Musical instruments, teahouse room, Isawa *119*
106. Deer at Nara Park, photographer of the Shin-E-Do studio *119*
107. "Native town," Yokohama, Beato *120*
108. Yokohama, photographer unknown *120*
109. Hakodate, photographer unknown *121*
110. British fleet off Yokohama, photographer unknown *121*
111. Picnic party on Rat Island, Beato *122*
112. Nagasaki, with Deshima in the background, Beato *122*
113. Body of Charles Richardson, photographer unknown *123*
114. Body of Lieutenant J. J. H. Camus, photographer unknown *123*
115. Capture of the Choshu battery at Shimonoseki, Beato *124*
116. Guns captured by the French at Shimonoseki, Beato *124*
117. Kawazu Izu-no-kami, Gaspard Félix Tournachon (known as Nadar) *125*
118. Ikeda Chikugo-no-kami, Antonio Beato *126*
119. Shogunal mission in Paris, Gaspard Félix Tournachon (known as Nadar) *127*
120. Member of the shogunal mission to the U.S., stereograph, photographer unknown *127*
121. Officer's daughter, photographer unknown *128*
122. Teahouse women, photographer unknown *129*
123. Women of the Yoshiwara, Beato *129*
124. Ainu woman, photographer unknown *130*
125. Ainu man, photographer unknown *130*
126. *Bettō,* or groom, tattooed, photographer unknown *131*
127. Japanese in Western clothes, Stillfried *131*
128. Emperor Meiji, Uchida *132*
129. Empress Meiji, Uchida *133*
130. Kitagatamachi, Gifu Prefecture, photographer unknown *134*
131. Wakanoori village after the Gifu earthquake, photographer unknown *134*
132. Nagoya post office after the Gifu earthquake, photographer unknown *135*
133. Japanese troops landing at Chemulpo, Korea, J. A. Vaughan *135*
134. General Baron Nogi and officers, stereograph, photographer unknown *136*
135. Japanese soldiers cooking rice, stereograph, photographer unknown *136*
136. Portion of loom, Kusakabe *160*
137. Studio artist, Beato *166*
138. Married woman, Beato *167*

Acknowledgments

There are many people I would like to thank for their help and support in writing this book. Clark Worswick first suggested the idea, and it was he who inspired my interest in early Japanese photography when I came across his volume *Japan Photographs: 1854–1905* sixteen years ago.

There are many collectors in the United States, Japan, and Europe who share my interest in nineteenth-century Japanese photography and from whom I have learned much. These include Dietmar Siegert, Fred Sharf, Dr. Henry Rosin, and Professor Himeno Jun'ichi. I am grateful to Shima-zu Kimiyasu for permission to reproduce his ancestor's photograph and to Izakura Naomi for translations from Japanese texts, both Meiji and modern. My secretary, Maureen Playford, is to be thanked for performing the time-consuming task taken by typing the manuscript.

I am indebted to Elena Dal Pra and Fred Sharf for information on Adolfo Farsari. I am also grateful to Hans Schreiber and Dr. Bernhard Stillfried for information on Baron von Stillfried. I offer a special thanks to collector and researcher Torin Boyd, who provided me with ideas and access to his collection of photos from the *bakumatsu*, or last days of the Tokugawa shogunate, and the Meiji era. He has also identified for the first time a number of photographs taken by the elusive Shimooka Renjo.

Sebastian Dobson wrote the introductory essay and a number of the captions. He gave much encouragement and constructive criticism and helped with the translation of some troublesome Japanese names. He also assisted in searching out some obscure Japanese sources that yielded new and surprising information.

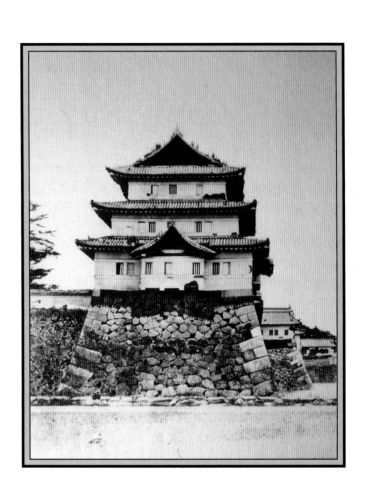

Preface

My subject in this book is the early history of photographic images in Japan and the photographers, both Japanese and Western, who took them. I have been less concerned with photographic processes, types, or equipment.

I have tried to pull together scattered pieces of information about early Japanese photography from both Western and Japanese sources, though the latter have proved especially troublesome. Japanese photographic literature is littered with unattributed statements and opinions. Primary-source material is rare. References are often vague, incomplete, and unreliable. Accordingly, although Japanese sources have been quoted, Western sources have proved to be surprisingly more fruitful.

But in English too the subject of early Japanese photography is not well documented, and nothing comprehensive seems to have appeared since Clark Worswick's 1979 pioneering work, *Japan Photographs: 1854–1905.* For many years I myself have been interested in early Japanese photography, and this volume includes many of my own findings and research that I hope will add to the current store of information on the subject.

In particular, I believe this book should lessen the problem of attribution. Until now, correctly attributing images to photographers has been difficult, and mistakes have been commonplace. For the first time, however, Appendix 1 identifies hundreds of early photographers' works, data that should prove particularly useful to students of early Japanese photography. But more than anything else I hope that the photographs themselves will be of interest to others who, like me, are fascinated by the contradictions of the land and people of Japan.

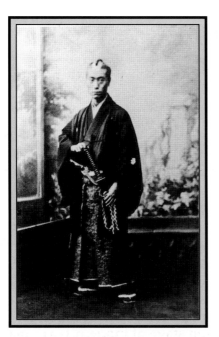
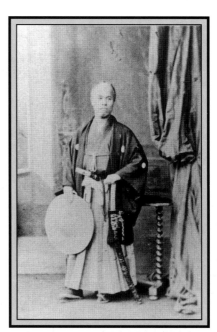
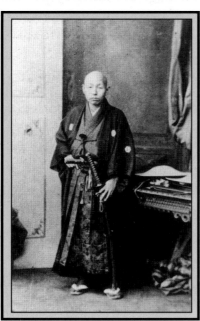
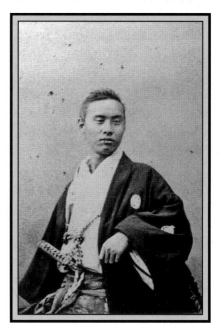

Reflections of the Rising Sun
Japan in the Bakumatsu and Meiji Eras

by Sebastian Dobson

This book offers a unique visual record of possibly the most eventful half century in Japanese history: five decades during which Japan progressed from a backward, feudal society into a modern, industrial nation that, almost a decade before the First World War, defeated a major European power. By the end of this period, the speed of Japan's modernization appeared nothing short of miraculous. In 1905 the Japanologist Basil Hall Chamberlain confessed in *Things Japanese* to feeling "well-nigh four hundred years old" after living in Japan for little over thirty years:

> To have lived through the transition stage of modern Japan makes a man feel preternaturally old; for here he is in modern times, with the air full of talk about bicycles and bacilli and "spheres of influence," and yet he can himself distinctly remember the Middle Ages.

If few contemporaries felt the weight of time as much as Chamberlain, most certainly sympathized. Today, when change is very much taken for granted, it is less easy to accept Chamberlain's complaint. However, we are fortunate that in addition to the vast amount of literature published on Japan at that time (when, as Chamberlain quipped, "*not* to have written a book on Japan is fast becoming a title to distinction"), we also have access to this period through the medium of photography. Many of the photographs contained in this book are historical records in their own right. These include the posthumous portraits of two European victims of samurai (page 123), which bear striking witness to the violence that accompanied the opening of Japan to the West, and the photographic likeness of Emperor Meiji (page 132), which clearly shows the modernizing course Japan took during his reign. Together the photographs offer a

vivid illustration of Japan during the twilight years of the Tokugawa shogunate (1603–1867), known to Japanese historians as the Bakumatsu era, and the subsequent Meiji era (1868–1912). The following introduction is intended to provide a brief historical background to the kaleidoscope of images contained in this book.

By the middle of the nineteenth century, Japan had been ruled by the Tokugawa family for 250 years. The emperor was a shadowy figure at best, who reigned, but did not rule, from the isolation of his court in Kyoto. Since the twelfth century the business of governing the country had been entrusted by the emperor to his shogun, or so-called supreme commander, whose military function provided the martial-sounding appellation *bakufu,* or "tent government," by which the shogun's administration was known for the remainder of its existence. After intermittent civil war, the coveted position of shogun finally passed to Tokugawa Ieyasu and his descendants in 1603. In time, however, the Tokugawa shogunate lost much of its vigor, and the shogun himself became as much a tool of his councilors as the emperor in Kyoto.

The Tokugawa shoguns, ostensibly ruling in the emperor's name from their base in Edo (Tokyo), maintained their power by carefully manipulating both their own vassals and the local feudal lords known as daimyo. The place of the latter in the political geography of Japan depended to a great extent on which side they or their ancestors had fought during the Battle of Sekigahara in 1600. Those who had had the foresight to support the Tokugawas were rewarded with domains close to the center of government and even with the prospect of marrying into the shogun's family; those, on the other hand, who had been damned by their earlier opposition were granted "outer lord" status, which brought with it relegation to domains on the northern and western peripheries of Japan. This group, indirectly benefiting from the distance to Edo, would later form the basis of opposition to the shogunate.

Regardless of their loyalty, however, all lords were required to attend the shogun's court in Edo once a year and, when not resident in the capital, to leave their families behind as security. This "alternate attendance" system proved a useful tool for controlling the daimyo. Not only did it provide the shogunate with virtual hostages during the lords' absence from Edo, but also, since their position demanded that they maintain a suitably impressive estate in Edo and an appropriately large retinue to accompany them on their annual processions to and from the capital, it

diverted a substantial amount of clan funds from more practical uses of which the shogunate might not have approved. Nevertheless, in the first half of the nineteenth century a current of opposition to the *bakufu* began to make itself felt, and more outspoken critics began to question both the legitimacy of the Tokugawa administration and one of its mainstays, the policy of national seclusion.

The early Tokugawas regarded isolation from the outside world as a useful way to stifle opposition inside Japan, since it deprived potentially disruptive elements of the means to ally themselves with predatory foreign nations. Until the arrival in 1853 of Commodore Matthew Perry, Japan's only contact with the outside world was through a small, artificial island at Nagasaki called Deshima, where a few Dutch merchants were allowed to maintain a trading settlement. Through this small, Dutch foothold came a trickle of information about developments in the West, especially in the fields of medicine and military technology. Dutch textbooks and manuals were diligently translated into Japanese, and by this means news of the latest scientific discoveries, including Louis J. M. Daguerre's announcement in 1839 of his successful photographic experiments, reached Japan.

News of more disturbing developments in the outside world also came through Deshima. The first decades of the nineteenth century brought reports of the inroads made by the Western powers in the Far East. Of particular concern was news of the so-called Opium War between Britain and China from 1839 to 1842. The ease with which British warships destroyed the Chinese navy came as a great shock to the Japanese, who had long respected China as a superior civilization. In addition, the concessions extorted from China, including the cession of Hong Kong and the opening of selected ports to foreign trade, provided an object lesson in how Western military strength made a mockery of national isolation. The bogey of seaborne foreign invaders haunted the Japanese imagination over the next two decades, and what many perceived as the inept, not to say spineless, response of the shogunal government to the foreign menace provoked a political crisis that eventually led to the *bakufu*'s demise in 1867.

Although popular opinion in the West favored Russia and Britain as the powers most likely to force Japan to open to trade, it was in fact the United States that took the lead. On July 8, 1853, Commodore Perry, with a squadron of four American warships under his command, landed at Uraga in Tokyo Bay. Bearing a letter and gifts from President Millard

Fillmore, Perry delivered a request for Japan to open diplomatic and commercial relations with the United States, and declared his intention to return with a larger squadron early the following year to receive an answer. Aware of its own weakness and unable to prevaricate, the *bakufu* reluctantly concluded the so-called Treaty of Peace and Amity at Kanagawa in March 1854, by which the ports of Shimoda and Hakodate were grudgingly opened to American ships. Britain, Russia, and Holland swiftly concluded similar agreements.

In July 1858 the door was further opened when the United States consul general, Townsend Harris, secured a commercial treaty with the shogunate. Among its terms, diplomatic representatives were to be exchanged between the two nations; more Japanese cities (including the capital, Edo) were to be opened; Americans were permitted to reside and trade in these areas without hindrance and under the protection of extraterritorial rights; and trade was to be subject to fixed tariffs. This treaty provided a model for similar agreements concluded with Holland, Russia, Britain, and France in the following month. Granting Westerners full exemption from Japanese law while denying Japan the right to fix its own commercial tariffs, these "unequal treaties," as most Japanese subsequently referred to them, set the tone for Japan's foreign relations until the end of the nineteenth century. In the short term, the treaties, and the opposition they generated in Japan, bedeviled the *bakufu* for the remainder of its existence.

With the implementation of the treaties, foreign merchants descended upon the newly opened ports and almost at once proved disruptive to both the economic and social order of the country. Most had come in search of easy profits and, taking advantage of the low exchange rate, sought to export as much gold as possible. The drain of domestic bullion, as well as an unusually heavy demand for commodities like silk and tea, helped dislocate the local economy. The very presence of Westerners was just as disruptive. Most foreign residents tended to be arrogant and overbearing toward the Japanese, and many behaved like the barbarians the Japanese imagined them to be. Not surprisingly, they provided a good target for xenophobic samurai. In 1859, the first year of the foreign settlement in Yokohama, two Russian sailors and a Dutch merchant captain were murdered. The foreign legations established in Edo were also prey to attack. One evening in January 1861 the Dutch interpreter at the American legation in Edo was killed, while six months later a group of *rōnin*, or masterless samurai, staged an unsuccessful night attack on the British legation at the Tozenji temple. Concern about such incidents,

especially at the failure of the Japanese authorities to find or punish any of the perpetrators, led the governments of Britain and France in 1863 to maintain troops in Yokohama for the protection of foreign residents. Ironically the next victims of the *rōnin* were officers of these same garrisons. On October 14, 1863, Lieutenant Henri Camus of the French colonial infantry was dragged from his horse and cut to pieces while riding through Yokohama. His murderers were never found. On November 21 of the following year, two officers of the British 20th Regiment, Major George Baldwin and Lieutenant Robert Bird, were brutally murdered during a visit to Kamakura. Significantly, after five years of such incidents, this was the first attack to be punished, and the summary execution of those involved in the murder discouraged further attacks for a time.

In the years following 1860 the *bakufu* dispatched six major missions to America and Europe, largely in an attempt to settle difficulties created by the treaties of 1858 and occasionally to renegotiate some face-saving amendments. On a diplomatic level these efforts served only to reveal how poorly prepared the shogunate and its representatives were to deal with the realities of international diplomacy. Especially poignant was the mission to France in 1863 of Ikeda Nagaoki, the governor of Chikugo Province (now the southern part of Fukuoka Prefecture). Given the unwanted and unrealistic commission to secure separate French agreement to the closure of Yokohama, Ikeda came round instead to the view that Japan should indeed open to the West. This revelation did not, however, prepare him for the wiles of French diplomacy, and unwittingly, it seems, he concluded a treaty which, far from securing the *bakufu*'s object, committed it to purchasing armaments from French firms and consenting to French intervention against the Choshu clan at Shimonoseki. When Ikeda returned to Edo, he was immediately dismissed and placed under house arrest, and the only pleasant memory he came to retain of his visit to Paris was of having his portrait taken by the celebrated French photographer Gaspard Félix Tournachon (better known by his pseudonym, Nadar). Where the shogunal missions were most successful was in giving their younger members the opportunity to improve upon their knowledge of the West, which so far had been gained only from books. Among those who benefited from this experience and in turn were able to assist in the modernization of Japan was the educator Fukuzawa Yukichi, who served as a member of missions in 1860 and 1863 and in the Meiji era would be the foremost advocate of Western ideas in Japan.

In the meantime the *bakufu* suffered further upsets. Violence against

foreigners by discontented samurai found the *bakufu* powerless to act and yet liable to pay compensation for incidents over which it had no control. Opposition to the opening of the country also swelled the ranks of the shogunate's critics, who now rallied under the slogan *sonnō jōi,* or "Revere the emperor, expel the barbarian." Particularly prominent in the antiforeign agitation were members of the Choshu clan, who for a time influenced the policies of the imperial court at Kyoto. At Choshu prompting, the emperor refused to endorse any of the treaties concluded in Japan's name with the Western powers and in 1862 ordered the shogun to revoke them and to commence expelling the "barbarians" from Japan forthwith. Although painfully aware that such instructions were impossible to implement, the shogunate could hardly refuse. The efforts of its most able councilor, Ii Naosuke, to enforce the treaties had resulted in his assassination in 1860, while the shogun's control over the daimyo had weakened to the extent that the alternate-attendance system was terminated in October 1862. Faced with growing opposition, the shogun reluctantly complied and agreed to a firm date on which expulsion could begin. In the end, only the Choshu domain obeyed the summons, and on the appointed day, June 25, 1863, the Shimonoseki Strait was closed and shore batteries began firing on foreign shipping.

A foretaste of how the foreign powers would respond came a few months later in the form of the British navy. In the previous year a young English merchant, Charles Richardson, had been fatally injured by irate samurai when he and his traveling companions had failed to dismount before the procession of the emperor's envoy to Edo. The culprits had been identified as men of the Satsuma clan, and although the British government had duly demanded compensation from the clan chief, Shimazu Hisamitsu, no satisfactory response had been given. Therefore, in August 1863 the British government dispatched a naval squadron under Vice-Admiral Augustus Kuper to Kagoshima, the capital of the Satsuma domain, to press the matter directly. Attempts at negotiation failed, and Kuper responded by bombarding the city. This episode, the only military action in what was later called the Anglo-Satsuma War, proved surprisingly inconclusive in that both sides were able to claim a victory: despite some losses, Kuper could report that Kagoshima had been devastated, with a fire in the city extending the damage even further; his Satsuma adversaries, on the other hand, could claim that since some of their batteries were still in use and since the British had sailed away after the bombardment without landing, they had successfully defended themselves.

The Choshu clan's stand on the Kammon Strait ended less contentiously. On September 5, 1864, a multinational naval squadron made up of British, French, American, and Dutch warships bombarded the town of Shimonoseki. The Choshu shore batteries, which had terrorized foreign shipping for over a year, were occupied by landing parties of sailors and marines and over the next few days, while the daimyo sued for peace, the artillery was dismantled and destroyed.

The display of Western military might at Kagoshima and Shimonoseki did much to discredit the *jōi* movement, especially at the imperial court, where a coup by more moderate groups had removed Choshu influence and eventually led to the emperor giving his belated approval to the treaties. The Satsuma domain in particular benefited from the lesson in British gunboat diplomacy, and its leaders embarked on a policy remarkably similar to that which the *bakufu* was attempting to pursue (and which the Meiji government would successfully follow): efforts were made to improve relations with the foreign powers, especially Britain; students were sent to Europe; foreign armaments were purchased; and the clan army and navy were built up along European lines. Likewise, the Choshu domain abandoned its anti-Western stance and, on the initiative of some of its younger samurai, began to reconcile its earlier differences with the Satsuma clan concerning the best means of achieving national unification. In 1866, after Choshu had successfully convinced Satsuma of the need to overthrow the shogunate, a secret military pact was concluded between the two clans. This Satsuma-Choshu alliance represented the first appearance of organized opposition to the shogunate, under the weight of which, in 1867, shogun Tokugawa Yoshinobu voluntarily resigned the position his ancestors had held for over 260 years and which he himself had inherited earlier that same year. On January 3, 1868, Satsuma and Choshu loyalists under Saigo Takamori occupied Kyoto and proclaimed the "restoration" of political power to the teenage emperor (to be called Emperor Meiji) and the confiscation of Tokugawa estates.

The new era name of Meiji (meaning enlightened rule) stood not only for the succession of a new emperor but, on a grander scale, for a new era in Japanese history. What had in fact occurred on January 3, 1868, was not so much a "restoration" as a coup d'état, which the Satsuma-Choshu alliance and its supporters carried out in the emperor's name. As coups go, the Meiji Restoration was largely bloodless, especially when compared with the horrors of the recent civil war in the United States. Edo was surrendered to Saigo Takamori with hardly a shot being fired and, after

defeating shogunal loyalists in a couple of skirmishes outside Kyoto, the new "imperial" forces encountered additional pockets of resistance only in the north of the country, the last of which, at Hakodate, held out until June 1869.

Symbolic of the new era was the relocation of the capital to Edo, which was renamed Tokyo, literally eastern capital. The following years saw the abolition of the feudalistic old order and the establishment of a centralized, national government. In 1869 the former class restrictions—under which the population had been organized in the descending hierarchy of samurai, farmer, craftsman, and merchant—were removed. In 1871 the domains and their private armies were abolished and replaced by a prefectural system administered directly from Tokyo. In the same year the new central government formally "permitted" samurai to discard their distinctive swords; five years later, having gained in confidence, the government issued a firm order prohibiting the wearing of swords by all except members of the police and the new armed forces. In 1873 all adult males, regardless of social standing, were declared liable for conscription into the new armed forces. For the samurai, who had long monopolized the profession of arms, these and other measures, such as the reduction and subsequent termination of their hereditary stipends, spelt their extinction as a class. Some accommodated themselves to the new regime and pursued careers in the new armed forces, the bureaucracy, or, unthinkable less than a generation before, commerce. Others could not and, painfully aware that there was no place for them in the new Japan, they formed a discontented and potentially dangerous underclass.

Ironically it was samurai from those domains instrumental in the Restoration who felt most betrayed. Between 1874 and 1876 samurai discontent manifested itself in isolated revolts across the former Choshu and Satsuma domains; in 1877, however, the government was faced with a full-scale rebellion in the former Satsuma domain under the charismatic leadership of Saigo Takamori. The conflict raged for eight months. Despite a spirited resistance by the rebel samurai, they proved no match for the government's conscript army, and after a final, desperate stand at Kagoshima the Satsuma Rebellion ended in defeat and Saigo's suicide on September 24, 1877. Any doubt as to the permanence of the Meiji regime was now removed.

The government could now turn to the task of modernizing the nation. Modernization was not only a matter of national survival in a world dominated by the West but also one of national pride. What the Meiji

government desired above all was the abolition of the "unequal treaties," which, it was naively believed, would occur once Japan had convinced the world that she was now an enlightened and civilized nation. Thus, for the first two decades of the Meiji era, modernization occurred at a frantic pace, marked as much by an indiscriminate adoption of Western institutions, customs, and ideas as by an equally indiscriminate disdain for all things Japanese.

Nothing escaped the attention of the Meiji reformers. After recasting its bureaucracy, armed forces, and other institutions along Western lines, and after encouraging the adoption of outward signs of Western civilization, including Western styles of architecture, dress, and hairstyle, the government also sought to bring Japan more into line with the prudish standards of the Victorian era. Nudity was one particular obsession of the authorities. Whereas the new elite in Japan had learned something of Western notions of shame and decency, the lower classes retained a traditional Japanese indifference to the naked human form, and the government regularly issued ordinances on what could and could not be displayed in public. The centuries-old custom of communal mixed bathing was now prohibited; henceforth, public bathhouses would have to separate the sexes. Grooms, coolies, and rickshaw drivers, who had previously got away with wearing a simple loincloth in the summer heat, now had to cover themselves up. Since tattooing, which had developed into something of an art form, was now frowned upon as a backward custom, and was even banned for a time, the laboring and the other tattooed classes were now doubly obliged to take care of what they exposed in front of foreigners. Such efforts by the functionaries of what some would call "New Japan," both to protect the sensibilities of Western visitors and to prevent the country from being embarrassed by its less "enlightened" citizens, regularly punctuated the national drive toward "civilization" and "enlightenment."

Things almost went too far. One group of patriotic subjects advocated the use of Roman script, another the adoption of English as the official language of the country. One Japanese intellectual even went so far as to suggest that the racial stock of Japan could be improved by encouraging intermarriage between Japanese females and Caucasian males. However, the most conspicuous manifestation and one that came to symbolize the frantic pace of Westernization as a whole was a building called the Rokumeikan.

Constructed at government expense in 1883 on a former Satsuma estate

in what is now Hibiya, this two-story, Italianate-style brick building was intended to provide a cosmopolitan setting where prominent Japanese and foreigners could meet on an equal footing and, at the same time, to serve as a showcase for Japan's claim to be a "civilized" nation. The Rokumeikan boasted billiard tables, card rooms, a ballroom, and other appurtenances of civilization, and a crowded social calendar offered such High Victorian amusements as masquerade balls, charity bazaars, and garden parties. Japanese senior government officials and their wives dutifully learned the intricacies of social dancing from a foreign dancing master specially imported for the purpose and accommodated themselves to wearing Western-style evening dress. Such displays provoked Japanese conservatives to mutter that Japan had surely passed from barbarism to decadence without enjoying an intervening period of civilization. What is more, the approval so desperately sought from the West failed to materialize, and ironically the spectacle of carefully, if unimaginatively, organized costume balls at the Rokumeikan served only to convince most foreigners that, far from being "civilized," the Japanese were merely a race of imitators.

The paradox of the so-called Rokumeikan era was that however much the Japanese government sought to impress them otherwise, Westerners preferred their Japan to be Oriental rather than a copy of the Occident. In a description of a ball at the Rokumeikan that was unsparing in its criticism of his Japanese hosts, the French novelist Pierre Loti reserved his praise for the Chinese guests, who, in his words, had the "good taste" to wear their traditional dress. Loti echoed the sentiments of most foreign visitors to Japan for the rest of the nineteenth century and beyond. In their search for the traditional, the quaint, and the picturesque, most foreigners chose to ignore the conflicting and, as far as they were concerned, unwelcome signs that Japan was soon to join the ranks of the industrialized nations of the world. Catering to this comforting stereotype of a preindustrial Japan were numerous photographers, both Japanese and foreign, whose work, especially in the form of elegantly produced "Kimbei albums" (named after one particularly successful Yokohama photographer, Kusakabe Kimbei), enjoyed enormous popularity among foreign tourists. With such a heavy demand for scenes of popular tourist attractions and studio portraits of "native types" in traditional dress and occupations, it is hardly surprising that photographers had little inclination to record the changes going on around them in Japan.

The ardor of the Rokumeikan era soon cooled. By the end of the 1880s

all that Japan had to show for her efforts to join the international community was membership in such organizations as the Universal Postal Union and the International Red Cross; more importantly, the "unequal treaties" remained in force, and would remain so until Britain took the lead in reversing them in 1894. From the late 1880s a reaction to the excesses of the Rokumeikan era was apparent. The Rokumeikan itself fell into disuse and was quietly sold off to the Peers Club in 1889. The more clear-cut national objective of *fukoku kyōhei,* or "rich country, strong army," came to the fore, owing less to charity bazaars and fancy-dress balls and more to industry and armaments. The foreign instructors who had been employed by the government to advise and assist in the modernization of the country were gradually paid off and replaced by their Japanese former pupils. In particular, Japan's armed forces grew apace, to the extent that by 1897 the Japanese navy already possessed the most powerful battleship in the world.

The historian in search of an architectural symbol for the spirit of the ensuing decades might want to consider the Ryounkaku in Asakusa, which was opened to the public in 1891. Although like the Rokumeikan designed by a British architect, this twelve-story, octagonal brick tower differed radically from the former in its intention. Conspicuous by their absence were the selectivity and self-consciousness that had characterized the Rokumeikan. Entry to the Ryounkaku was open to anyone who could afford the entrance fee of eight *sen* (it cost ten *sen* to send a letter to Europe at that time), and the attractions on offer—including the first automatic elevator in Japan, automatons that could write in Japanese, an exhibition of portraits of local geisha taken by the photographer Ogawa Kazumasa, and shops selling goods from all over the world—enabled ordinary Japanese to experience on their own terms technological advances that the West had to offer. The Ryounkaku had few foreign visitors, a fact that does not seem to have caused the exhibition organizers any concern. The desire for foreign approval that had characterized the Rokumeikan era had given way to a desire to beat the West on its own technological ground, and the construction of such a conspicuously tall building in a land so susceptible to earthquakes as Japan seemed to reflect a newly found confidence in the future.

Japan also came to play a more conspicuous and assertive role in international affairs. Challenging the claim of the Chinese empire over Korea, Japan went to war in 1894 and won a series of brilliant victories over the Chinese army and navy. In 1902, less than forty years after the British fleet

had bombarded Kagoshima, Japan concluded a naval alliance with Britain. Such was the change in Japan's status that some Britons were proud to refer to their partner as the "Britain of the Far East." In 1904 Japan startled the world by responding to Russian intrigues in the Far East with a surprise attack on the Russian Pacific Fleet and a declaration of war on the Russian empire. Western notions of racial superiority received a major blow when Japan, whom many expected to be defeated by the tsar's legions, emerged victorious from a conflict that featured some of the largest battles known in human history at that time. With the addition of Taiwan and the southern half of Sakhalin to her territory, plus the general consent of the great powers to the extension of Japanese influence in Korea (culminating in its annexation in 1910), Japan was now an imperial power.

History is seldom tidy. Although the Meiji era technically ended with the death of the Meiji emperor in 1912, one could argue that, at least in spirit, the era came to an end with Japan's victory over Russia in 1905. Ironically it was not by moral persuasion, as the early Meiji leaders had hoped, but by successfully employing Western weapons and technology against the largest of the great powers that Japan proved her claim to be a "civilized" nation worthy of admittance to the international community. Thereafter, Japan faced the very different problem of coming to terms with her newly acquired status as a world power. Thus, the last seven years of the Meiji era—a confused patchwork featuring such novel developments as dreadnought battleships, Antarctic expeditions, socialist agitation, a nascent mass media, participation in the Olympic games, beauty pageants, and international baseball tournaments—seem to have more in common with the following Taisho era (1912–26), which took Japan through the First World War to the age of democracy and jazz and ultimately to militarism and war. It is therefore appropriate that the last glimpses offered of the Meiji era in this book date from the Russo-Japanese War, a conflict that eloquently expressed the hopes and fears of the time.

This brief essay has attempted to describe in broad terms the historical setting of the images that Terry Bennett has selected for this book. Whether sensational or everyday, intimate or panoramic, the subject matter of these photographs reflects the variety of Japan during the eras of Bakumatsu and Meiji. While some images celebrate the achievements of a country in the course of modernization and Westernization, many also

document a world that was quickly disappearing. It is said that following the Meiji government's prohibitions on wearing swords in the 1870s, the Austrian photographer Baron von Stillfried was suddenly visited at his Yokohama studio by samurai anxious to be photographed wearing their swords and armor for probably the last time. Other photographers, whether inspired by a similar desire to record a fast-disappearing world, or else motivated by an apparently inexhaustible demand from foreign visitors for images of old Japan and its inhabitants, likewise sought out traditional subjects for their cameras to record. The results of their efforts offer us a fascinating view of a country during one of the most momentous periods in its history. Comparing these frozen reflections of Japan taken through the contemporary camera lens, we can begin to appreciate the sense of mock desperation that Basil Hall Chamberlain expressed so pithily on having lived through much of the transition in nineteenth-century Japan that brought her to the threshold of the modern age and beyond.

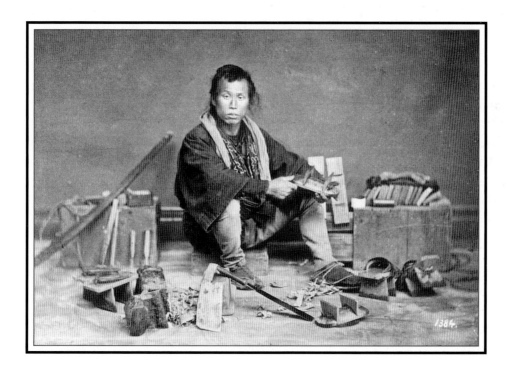

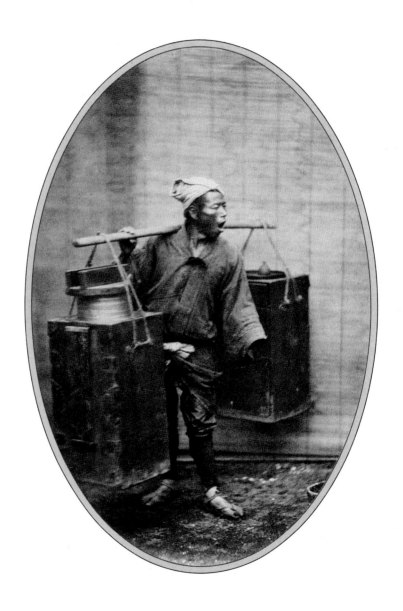

Early Japanese Images

The Introduction of Photography to Japan

When was photography introduced to Japan? Unfortunately this intriguing question may never be answered. To understand the difficulty of solving this puzzle, a bit of background about the Western presence in Japan during the 1840s and 1850s should prove useful.

More than two hundred years earlier, in 1638, Japan had severed almost all connections with the outside world. At the time of the announcement of Louis J. M. Daguerre's famous photographic invention in 1839, Japan's only effective contact with the West was through the tiny trading post of Deshima, an artificially constructed island in Nagasaki Bay. A handful of Dutchmen were permitted to live and trade at Deshima but they were closely observed and guarded. Only officially sanctioned communication between the Dutch and Japanese was permitted. This strict arrangement was not relaxed until August 1855, when the Dutch, at the request of the shogunate, set up a naval academy at Nagasaki and thereafter were given more physical freedom and no longer confined to Deshima. Following the terms of a series of treaties concluded in the previous year, foreigners were allowed, after July 1859, to live and trade freely at the treaty ports of Nagasaki, Yokohama, and Hakodate.

Japanese sources have long held that the first camera was imported in 1841 through Deshima by the Nagasaki merchant Ueno Shunnojo. However, in an article entitled "The History of Early Photography in Japan," photography professor Ozawa Takesi claims that the date was actually 1848.

When was the first photograph taken in Japan? This question too is difficult to answer, as Japanese sources are sketchy.

In 1849 Ueno apparently sold a camera to the powerful Lord Shimazu Nariakira, head of the Satsuma clan. But Ozawa notes that experiments with that camera were not successful, and it is thought that the camera was defective. Photography would have been prohibitively expensive, and not surprisingly it made little or no progress in the feudal Japanese society of that time. It is quite possible, therefore, that no photographs were taken in Japan until the US expedition headed by Commodore Matthew Perry arrived in July 1853.

Perry had been ordered to effect a treaty with the Japanese, using force if necessary. He brought with him a photographer, Eliphalet Brown, Jr., (1816–86), who took numerous daguerreotypes, at least three of which

survive in Japan. The others were destroyed in 1856 in a fire in the United States. But many of Brown's daguerreotypes were illustrated as lithographs in Francis L. Hawks's account of Perry's voyage, *Narrative of the Expedition of an American Squadron to the China Seas and Japan, Performed in the Years 1852, 1853, and 1854,* and one of those appears on page 65. No photographs taken in Japan prior to 1853 have been found.

Apart from Brown's famous images, the oldest surviving photograph in Japan is a daguerreotype taken sometime in 1854 by Lieutenant Aleksandr Fiodorovich Mozhaiskii (1825–90), a member of a rival Russian expedition that arrived in Japan in August 1853, only a month after Perry. This daguerreotype is kept in the Gyokusenji temple in Shimoda.

According to Ozawa, Ichiki Shiro took a daguerreotype portrait of Shimazu Nariakira in 1857. That photograph, which appears on page 65, is kept in the Shimazu family museum in Kagoshima. The only other photo that could be dated before 1860 is a collodian-process image titled "The Three Princesses." In "The History of Early Photography in Japan" Ozawa claimed that the photo was taken by Shimazu Nariakira in 1858. However, in his recent book *Bakumatsu Shashin no Jidai* Ozawa argues that the photographer is unknown and that the image dates from 1863 or later.

Except for the Dutch at Nagasaki, the only other Westerners resident in mainland Japan in the years immediately after Perry's expedition were the American consul, Townsend Harris, and his interpreter and assistant, Henry Heusken, both of whom lived in Shimoda from August 1856. The popular but unfortunate Heusken would have his life cut short by a Japanese assassin in 1861. Neither Harris nor Heusken mentions photography in his journal.

From October 1859 until February 1860 the British journal the *Photographic News* published what was said to be the diary of an anonymous Norwegian who had worked out of the Deshima trading post in 1857. The Norwegian claimed to have masqueraded as a Japanese and traveled in the Nagasaki area with a Japanese merchant, taking a number of photographs. Although the Dutch had more freedom at the port after the establishment of the naval academy in 1855, it would have been extremely dangerous to flout the regulations of the time by making such an illicit journey. Punishment would have been severe had the men been caught.

Japanese scholars, including Professor Himeno Jun'ichi (in the article "The Japanese Modernization and International Informativeness Viewed from Old Photographs—the Nagasaki Photo-history" in the journal *Old*

Photography Study No. 1), doubt the story due to the inaccurate description or two in the account. The Norwegian stated that he had deliberately changed the names of people and places to protect friends, but whether or not the story is true, none of the photographs has come to light.

The British diplomat Lord Elgin took a photographer with him on his mission to China and Japan in 1858. The photographer, the Honorable William Nassau Jocelyn, mentions in his private journal (held by the Yokohama Archives of History) taking numerous collodian-process photographs. Unfortunately none of these has so far been discovered.

For the record it is worth noting that the earliest dated photographs of Japanese taken outside of Japan were those of the 1860 embassy to the United States, one of which is shown on page 127. A number of those photographs have survived.

The few photos described in these paragraphs are all the images that remain from those taken when Japan was more or less closed to foreigners. The following pages will concentrate on Western photography in Japan after the official opening of the country in July 1859.

Early Western Photographers in Japan

No doubt numerous photographs were taken when Westerners began to settle in the treaty ports of Nagasaki, Yokohama, and Hakodate in 1859, but none of those photos has so far been discovered. Indeed, an article entitled "Early Recollections of Yokohama 1859–1864" in the *Japan Weekly Mail* of December 5, 1903, refers to one Orrin E. Freeman, an American, as the first to engage in photography in Yokohama in 1859. Apparently Freeman took only portraits and eventually sold his business to a Japanese, after teaching him photography.

In the journal that he kept during his stay in Kanagawa and Yokohama from 1859 to 1866, the American merchant and correspondent Francis Hall makes a number of interesting references to photography in Yokohama. Hall himself also took numerous photographs in Japan, one of which has been reproduced in his recently published journal, *Japan Through American Eyes*, edited by F. G. Notehelfer.

A number of foreign photographers came to Japan specifically to carry out their trade. The first is thought to have been William Saunders, who arrived in Yokohama in August 1862. Saunders stayed in Japan only three months, then made his name and career in Shanghai, where he lived many years. This fine English photographer was not in Japan long enough to

make a lasting impression, but he did continue to sell his Japanese photographs in Shanghai.

Following Saunders was another English photographer, Charles Parker. The *Hong Kong Directory and Hong List of the Far East* mentions that Parker had a studio in Hong Kong in 1862, then lived in Yokohama from 1863 until about 1868. According to the *Japan Herald* of May 30, 1864, William Parke Andrew, a British artist, formed a partnership with Parker known as Messrs C. Parker and Company. The same newspaper announced on July 22, 1865, that the partnership had been dissolved earlier that month. In November 1865 a firm known as Parker, Crane, and Company was known to be in existence.

A September 1863 issue of the *Japan Herald* carried a curious Parker advertisement referring to views of the Kagoshima Bombardment. A battle between British warships and local Japanese shore batteries did occur at Kagoshima in August 1863, but I have never seen any prints of the incident, though I have seen numerous prints of the Shimonoseki Bombardment in 1864.

There was a great amount of controversy surrounding the former naval action, which proved indecisive, as each side could claim a victory. The British fleet, while bombarding the Japanese land defenses, had to contend with very rough seas and could not land. If Parker was present and took the photos advertised in the *Japan Herald*, how did he take them? Some Japanese emissaries did come aboard the British flagship in a vain attempt to negotiate, and perhaps they were photographed. Charles Wirgman, the *Illustrated London News* artist and correspondent, was present, and a number of his illustrations appear in that magazine. It is possible that Parker's ad in the *Japan Herald* was referring to photographs of those illustrations, a common form of reproduction at the time. (Circumstances during the Shimonoseki Bombardment were different. A landing was made, and the official photographer, Felice Beato, took a number of photographs. Beato also photographed Wirgman's drawings of the same conflict.)

As Yokohama newspapers regularly carried advertisements for his studio, Parker must have produced a significant amount of material. But only a handful of cartes de visite have so far been identified as Parker's, and the fate of most of his work remains a mystery. The only Parker images I have ever seen are in the Worswick collection, which includes probably the best examples of pre-Meiji-era photography anywhere.

The London photography firm of Negretti and Zambra is generally

credited with producing the first commercial views of Japan in 1861. The photographer was thought to have been Abel A. J. Gower, who was on the staff of Sir Rutherford Alcock, the first British minister to Japan. However, I recently discovered a reference in the *Times* of October 3, 1860, that raises interesting questions:

> Photographs From Japan—A case of rare and curious photographs of the scenery of this interesting country, and illustrative of the manners and customs of the Japanese tribes, which have been executed by a special artist sent out for the purpose by the enterprising firm of Negretti and Zambra of London, are expected by the Peninsular and Oriental Company's steamship *Ceylon*, which will probably arrive at Southampton on Wednesday.

This notice makes clear that the Negretti and Zambra photographs were taken in 1860, a year earlier than previously thought. Note also the words "executed by a special artist sent out for the purpose," a passage that undermines the theory that Gower was the photographer. Moreover, Gower's consular duties might have prevented him from undertaking commercial work. In any case, the importance of these photographs should not be underrated, as they represent the first known commercial views taken in Japan. Six were published in T. C. Westfield's *The Japanese: Their Manners and Customs*, and those six stereograph photos appear on pages 67–68.

Negretti and Zambra commissioned a Frenchman known as Rossier to travel to China to cover the Second Opium War of 1856–60. It is known that Rossier was in Nagasaki from 1859 until 1860, as his photographs of Nagasaki were sent to the British Foreign Office at that time, and that he also was in Yokohama. Unfortunately nothing else about Rossier is known, and he remains a very shadowy figure. (See Saitoh's "Shashinshi no Genryu o Tazunete.") Negretti and Zambra also apparently sent the famous English photographer W. B. Woodbury to the Far East. From 1853 to 1863 Woodbury was in Java, China, and Japan. (See Negretti's "Henry Negretti—Gentleman and Photographic Pioneer.")

Much has previously been made of Gower's privileged access to the "interior" of Japan because of his official employment. As Gower was also known to be an amateur photographer, he was thought to have been the photographer of the Negretti and Zambra series, though I am doubtful. Rossier and Woodbury are stronger contenders.

The photographer of the Negretti and Zambra stereo series could have been Rossier, Gower, or Woodbury. Or the series could have been the work of more than one photographer. It is also possible that more than one series was published. Further research into Negretti and Zambra's early commissions (perhaps in the *Times?*) is needed.

Mention should be made of the *Far East*, originally a fortnightly newspaper and later a monthly illustrated with original photographs, which ran from May 1870 until at least December 1878. The editor and publisher was a Yokohama journalist, John Reddie Black. With around 750 photographs, mainly of Japan, the *Far East* provides important visual documentation of the country's modernization. But copies of the *Far East* are almost as rare as Westfield's *The Japanese: Their Manners and Customs*, the first book to contain original photographs of Japan. (See Stephen White's "The Far East.")

Many of the photographs in the *Far East* are of very high quality but attributing the photographers is difficult. That publication mentions an unnamed Japanese photographer, an Austrian who was probably Baron Raimund von Stillfried, and Michael Moser, another Austrian, who came to Japan in 1869 as the assistant to the Austrian photographer Wilhelm Burger (1844–1920).

In his book *Wilhelm Burger* Gert Rosenberg states that Moser, the son of a farm worker, was only fifteen when Burger invited him on the expedition. Moser stayed on in Japan and photographed for the *Japan Gazette*, the *Far East*, and, interestingly, the Japanese government. He appears to have returned to Austria in 1877 and died there in 1912. Rosenberg claims that Moser published *Memoirs of Japan* and wrote a series of articles for the *Steirischenen Alpen Post* in 1887 and 1888. I have not managed to locate these references but they may well contain very interesting information. Certainly the young Moser appears to have accomplished much during his few years in Japan.

The Austrian photographer Wilhelm Burger came from a comfortable middle-class background and was the official photographer with the mission sent by Austria-Hungary to initiate diplomatic and commercial relations with Siam, China, and Japan. The mission left Trieste on October 18, 1868, and arrived in Nagasaki in early September 1869. On the way, three months were spent negotiating treaties with Siam and China, and Burger took advantage of a number of photographic opportunities. At Nagasaki, where the mission stayed two weeks, he took some superb photographs, mainly using Ueno Hikoma's studio, the props suggest. The

expedition moved on and arrived in Yokohama in early October. The props employed in the Yokohama photographs suggest that many were taken at Shimooka Renjo's studio. In early November the expedition left Japan but Burger was asked to stay behind to photograph works of art. In March 1870 he returned to Austria.

Burger was an extremely accomplished photographer who produced some very fine images. His artistic training is very evident in a number of stunning photos. His work is scarce but it is possible to come across some stereographs and carte-de-visite images from his time in Japan.

The Western photographers described in this section played various minor roles in introducing photography to Japan. But it was Felice Beato in the 1860s and Baron von Stillfried in the 1870s and 1880s who were the two early Western photographers to make the most impact on other photographers, both Western and Japanese.

Felice Beato

Felice Beato was probably born in Venice or Constantinople around 1825. He made his name photographing the Crimean War in 1855, the Indian Mutiny in 1858, and the Anglo-French military expedition that occupied Peking in 1860. In China, Beato met the English artist Charles Wirgman, who continued on to Japan and settled in Yokohama in 1861. There is no evidence that Beato accompanied him, but Wirgman no doubt influenced Beato's decision to visit Japan, and by the middle of 1863 Beato was residing in Yokohama. (See the *Illustrated London News* of July 13, 1863.)

Beato traveled extensively in Japan and built up a large portfolio that he sold commercially from his studio. He was the official photographer for the 1864 Shimonoseki Bombardment, and two of those photos appear on page 124. In 1866 a fire destroyed a large part of Yokohama, and Beato lost much of his stock. After a year of frenzied activity he managed to produce replacement material, whose culmination was the volumes *Native Types*, containing approximately one hundred portraits, and *Views of Japan*, containing one hundred landscapes. The images in *Native Types* were elaborately handcolored. The Victoria and Albert Museum in London has both volumes.

After 1868 Beato's photographic activities lessened. In *Japan Photographs: 1854–1905* Worswick claims that the effort to replace the burned material exhausted Beato creatively. More probably Beato began looking

for new areas of business and ceased to be extensively involved in photography. He did maintain his own studio, F. Beato and Company, Photographers, from 1869 until 1877, when he sold his stock and archives to the Austrian photographer Baron von Stillfried. Indeed Beato, in a lecture given in London in February 1886, refers to having retired from photography in 1867, a date that rings true. Although he accompanied the United States Asiatic Fleet as official photographer during an American punitive expedition against Korea in 1871, Beato, perhaps tired of photography, had by this time embarked on a series of other business enterprises. According to the Yokohama Archives of History, Beato owned land and several studios, had a financial interest in Yokohama's Grand Hotel, and was a property consultant and a prosperous dealer in imported carpets and women's bags. In May 1876 the *Japan Punch* published a caricature that aptly depicted Beato as a one-man band playing various musical instruments. Certainly by 1880 Beato was referred to more as a merchant than a photographer.

Beato left Japan in 1884, after which the Yokohama *Mainichi* newspaper of December 5, 1884, carried a piece referring to his having lost his considerable fortune on the American investment markets. On February 18, 1886, he gave a lecture on photographic techniques to the London and Provincial Photographic Society, then appears to have spent considerable time in Burma and India until 1907, after which nothing is known.

Although there are several cartoon caricatures of Beato in the *Japan Punch*, it was not until November 1987 that I found an actual photographic image of him. While viewing some Japanese photographs for a sale at a London auction house, I noticed a carte-de-visite-size image of a European juxtaposed with a similar-size image of the Japanese photographer Ueno Hikoma, an arrangement I found odd. By chance there was a contemporary list of the photographs enclosed, and the number underneath the European image referred simply to Signor Beato. That photograph is reproduced on page 168. Also, Nagasaki University recently uncovered examples of Beato's handwriting on captions of photos taken in the early 1860s. (See Himeno's "The Japanese Modernization and International Informativeness Viewed from Old Photographs—the Nagasaki Photo-history" in the journal *Old Photography Study No. 1.*)

For many years Felice Beato was thought to have been the same person as Antonio Beato, a photographer based in the Middle East. However, in May 1983 Professor Italo Zannier published a paper in Venice proving that Antonio was actually Felice's brother.

Some historians have given Felice the name of Felix but I suspect that this was an anglicized version used by friends and acquaintances. He was known as Felice in 1867 when he was admitted as a Freemason to the Yokohama lodge. (See Pedlar's "Appendix II: Freemasons of Yokohama 1866–1896.") At some point Beato became a naturalized British subject.

By the time Beato came to Japan he was already an experienced, accomplished, and famous photographer. His matter-of-fact journalistic style is evident in much of his early portrait work, portraits in which he seems to avoid trying to interpret his subject. His landscapes show great sensitivity to Japanese scenery, and in them it is possible to detect the influence of the traditional woodblock print known as *ukiyo-e*. His artist friend Wirgman may well have advised him in this respect. Wirgman may also have suggested the handcoloring of photographs. But it is also possible that the photographer Charles Parker and his partner William Parke Andrew, an accomplished artist, were already engaged in this art form.

Recently I found an important reference to Beato in the obscure memoirs of Sir Henry F. Woods, *Spunyarn: Strands from a Sailor's Life*. As a young officer in the Royal Navy, Woods served at Yokohama, and his recollections from that period throw some interesting light on Beato's early life:

> There was at the time, residing in Yokohama, a photographer who had attained a high reputation for the excellence of his work in respect of both portraiture views and landscapes. He was quite a character in a way and a general favourite for his openhandedness and good temper with which he met his reverses.
>
> He had taken up photography in the Crimean War, and going off to India during the Mutiny, worked there for some time, and went on to China. He followed our Army, and was at the sack of the Summer Palace, and made a nice little sum by the purchase and subsequent sale of loot with which he returned to Constantinople. Thinking to make a fortune in a short time he took to the Bourse, and soon lost it all. Off he went to the Far East again, moving on from China to Japan. The gambling fever, however, was ever upon him. He was well paid for his portraits and albums of views, but the work was a "side-line," and whenever he had been able to put by sufficient money, off he went into speculation. Not long before I reached Japan he had made what some would have considered a little fortune, but lost it again in the endeavour to enlarge it. His name was Beat [*sic*]. No one knew his real

origin, and no one troubled themselves about it. He spoke funny English, and it was an amusement to draw him into a long argument. His most unusual expression of welcome was: "I am delight!" He used it on every occasion.

We had become great friends, and when I heard of our approaching trip to Yedo I went to him and told him what I wanted to do, and he willingly fitted me out with a portable dark-room and all the necessary gear and chemicals on condition that I handed over to him the plates of any photos I might be able to take. We left soon enough in the morning for His Excellency to land at Yedo in ample time to settle down before his tiffin, to which he invited the Captain and myself. I spoke to him about my desire to do a bit of photography, and he was kind enough to arrange that I should have a "Yakonin Guard" to meet me when I landed the next day with my outfit, so that I might start work at once. Photography in the open was no easy matter in those days, and my friend Beat's success in that line was due to his wonderful skill in manipulating his plates. There was nothing but the wet process as yet to the fore. It was still in the full vigour of our employment as the dry plate had not passed beyond a very elementary stage of experimental success, and the gelatine film had not even entered the realm of thought.

An important reference to the life of Beato is "A Chronology of Felix (Felice) Beato" in *Japanese-British Exchanges in Art 1850s-1930s* by John Clark, John Fraser, and Colin Osman, a work that summarizes the information on the photographer. Still, there remain a number of unsolved riddles regarding Beato's life, not the least of which is conclusive evidence on when and where he was born and when and where he died.

Beato described himself as a Venetian, and he was often referred to as Signor Beato. Exhaustive searches in Venice, however, have failed to uncover any evidence that he was born there. Woods's recollections, on the other hand, could imply that Beato originated in Constantinople, a line of inquiry that might prove more fruitful for future research.

It is also unclear when Beato first set foot in Japan. The obituary for Charles Wirgman in an 1891 issue of the *Illustrated London News* appears to indicate that Beato arrived in Japan with Wirgman in 1861, directly after their joint coverage of the Second Opium War of 1856–60. But Woods's memoir contradicts this view and states that Beato returned to Constantinople directly from China.

Wirgman first arrived in Japan in April 1861, as is evidenced by his *Illustrated London News* articles. The *Photographic News* in November 1861 recorded Beato's arrival in Britain. In his address to the London and Provincial Photographic Society in February 1886 Beato stated that he took photographs in Japan in 1862. However, the report of his talk states that he took photographs in China in 1870, though the context makes clear that this should be 1860. Obviously some of these dates are unreliable.

We do know that Beato was in Japan and staying with Wirgman in July 1863. He could have traveled with Wirgman, who arrived back in Japan from Shanghai in June 1863. If Beato came to Japan in 1861, the visit would have been short, since he was in Britain in November of that year. It would seem likely that the extract from Woods's memoir is correct and Beato did not go to Japan in that year but traveled to Britain via Constantinople. Thus, he would have first set foot in Japan probably in June or July of 1863.

In his 1886 address Beato claimed to have given up photography altogether in 1867 and subsequently practiced only as an amateur. We do know that he photographed the US expedition against Korea in 1871 and the opening of the first Japanese railway in 1872. Also, his studio in Japan continued until 1877, when he sold his stock to Stillfried. I am inclined to believe that Beato lost interest in photography in 1867, preferring to pursue other ways of making a living and returning to photography only sporadically to supplement his earnings.

By dint of his mere presence in Japan, Beato could not fail to influence photographers, both Western and Japanese. Moreover, as he stayed in Japan for some twenty years, his technical skill, engaging personality, and commercial activities ensured that he would leave a deep and lasting impression on the history of Japanese photography.

Baron Raimund von Stillfried-Ratenicz (1839–1911)

Although Baron Raimund von Stillfried is, after Felice Beato, arguably the most important early Western photographer in Japan, it is regrettable that we know so little of his life in Japan. Japanese sources, apart from the odd newspaper or trade-directory reference, are silent. From the few details Rosenberg includes in his *Wilhelm Burger* and from information provided by the Austrian collector and Stillfried's grandson, Dr. Bernhard Stillfried, I have put together an outline of Stillfried's life.

Ever restless, this Austrian-born nobleman and son of a lieutenant field marshal was always on the move. He chose a military career but abandoned it in 1863. Having demonstrated talent as a painter, he studied under the landscapist Bernhard Fiedler in Trieste. According to Rosenberg, Stillfried traveled as an artist and photographer in the Far East and was in Japan in 1863. The Austrian historian Peter Pantzer in his article "An Austrian Nobleman Rocked the Cradle of the Photographic Great Power Japan" in *Austria Today* states that Stillfried first arrived in Japan in 1867. It is not clear what he did in Japan or how long he stayed but apparently he became reasonably competent in Japanese. According to the diary of Mary Alice Rea, a tourist who bought some Stillfried images, he lost his fortune in Monaco, presumably by gambling.

Resuming his military career, he served as an officer with Emperor Maximilian's forces in Mexico. By 1867 he had returned to Austria and tried to join the 1868–71 Austrian expedition to the Far East and South America. The attempt appears to have failed, but Stillfried decided to make a trip to Japan (his second?), arrived in 1868, and stayed for fifteen years. He must have rendered some service to the expedition because he received an Austrian commendation in 1871. At some stage he worked as an interpreter for the Prussian merchants Textor and Company in Yokohama.

Around this time he must have turned to photography, since an advertisement in the *Yokohama Hong List and Directory* of 1872 mentions the photo studio of Stillfried and Company. Later Stillfried operated studios under the names the Japan Photographic Association (1876), Stillfried and Andersen (1876–79), and the Yokohama Library.

In 1877 Stillfried felt financially secure enough to acquire the stock and studio of Felice Beato. By that time Beato had little interest in photography, though the actual reason for the sale is unknown. With the purchase Stillfried inherited numerous glass negatives of the great artist's portraits and landscapes. Stillfried's subsequent albums contain a mixture of his own and Beato's work. Thus, it is sometimes difficult to differentiate between a Beato and a Stillfried photograph. The Victoria and Albert Museum's copies of Beato's *Native Types* and *Views of Japan,* each with approximately one hundred photographs, are an important starting point for anyone wishing to see the extent to which Stillfried reprinted Beato's work in his own albums after 1877.

Dr. Henry Rosin, an American collector, has compared Beato and Stillfried photographs to differentiate the two and to identify Stillfried's

Beato reprints. His conclusions were contained in an interesting article that appeared in 1987 in the magazine *Bulletin de l'Association franco-japonaise.*

Rosin accepts that Beato's *Views of Japan* and *Native Types* contained original Beato images. However, he states that Stillfried and H. Andersen's most important publication, *Views and Costumes of Japan* (circa 1877), contained photos taken by both Beato and Stillfried, as well as reprints of Beato images. Nevertheless, Rosin argues that certain facts and clues aid differentiation.

According to Rosin, Beato's landscapes, unlike Stillfried's, are distinctive and "take the viewer into the unknown and strange . . . views of cemeteries, obscure towns . . . are typical." As for the portraits, Rosin notes that Beato's pictures were taken in "feudal" times, whereas Japan was rapidly modernizing by the time that Stillfried was producing his own "native types." Rosin continues, "Beato's vignettes of the Japanese evoked a relatively primitive society while von Stillfried's works used actors with great frequency, merely illustrating what he could no longer photograph. Though Beato also sometimes used actors in studio portraiture his work is less stiff and mannered than that of von Stillfried."

Rosin further notes that "the early efforts of Beato were albumen prints, landscapes and portraits with an old yellow-gray appearance. In many cases Beato wrote the title of the subject on the reverse of the print . . . the title is in English and shows through on the 'albumen' side as reverse writing most commonly near the upper or lower margins. The writing can be read with the page held almost perpendicularly before a mirror." Beato originals are also evidenced by the existence of "an oblong scrolled paper, glued to the page, containing the title and brief description of the photograph appearing on the next page." Rosin notes that the text wording differs in later reprints. He also observes that Beato's landscapes were rarely colored, and when they were, the color was delicate. His portraits, however, were usually colored strongly and showed sharp and excellent brushwork. They were usually "vignetted" in oval cameos, with a background of "a shade made of thin, transverse bamboo reeds, connected by a specific type of zigzag cord binding used by no one but Beato."

Rosin provides quite convincing pictorial evidence to show that Stillfried "doctored" some of Beato's negatives by adding painted material or cropping photographs. Such alteration may have been necessary with ten- or fifteen-year-old negatives that had by then become damaged.

Of interest to collectors today was Stillfried's practice of numbering his

photos. Rosin writes that "the Austrian developed a system of scratching or thinly painting in tiny numbers to identify his photographs. The presence of the classical Stillfried numbers is of great help in identifying his work. Beato originals have no numbers of this type, so it is obvious that the numbered images of classical Beato works are von Stillfried reprints." One should also remember that "Beato's work was exceptional, and never smudged. What appear to be smudges in the negative or emulsion may mean that something has been 'painted out.'" Rosin is saying, therefore, that any evidence of smudging implies that Stillfried altered the original Beato negative before reprinting.

According to Rosenberg, Stillfried left Japan for good in 1883 and returned to Austria. The Stillfried expert Hans Schreiber says that he left behind two daughters and a Japanese wife. Letters from the woman are held today by the Stillfried family. Back in Austria, Stillfried became a father again at the age of sixty. His studio in Japan continued until 1885, when his stock was sold to Farsari and Company. At this time Kusakabe Kimbei also managed to obtain some of Stillfried's original negatives and included those images in some of his albums in the late 1880s and 1890s. Since not so many Stillfried images appear in Farsari albums some photohistorians have wrongly concluded that Stillfried sold the bulk of his stock to Kusakabe and only some to Farsari. However, it must be remembered that when Farsari started his business in 1885, it was billed A. Farsari and Co—Late of Stillfried and Andersen. Also, a fire in 1886 destroyed all of Farsari's stock, which would account for the absence of Stillfried prints in later Farsari albums. It is my belief that in 1885 Kusakabe came to an arrangement with Stillfried or Farsari or both to acquire some negatives, possibly those he had personally taken when he was employed as an assistant to either Beato or Stillfried.

This brief account can serve as a mere introduction to the life and work of Baron von Stillfried, a great photographer though one destined to be overshadowed by the even greater Felice Beato. Obviously more research is needed on this Austrian photographer who played an important role in the early days of Japanese photography.

Adolfo Farsari (1841–98)

Born in Vincenza, Italy, on February 11, 1841, Farsari emigrated to the United States in 1863, exchanging an Italian military career begun four years earlier for a short spell with the Union Army during the remainder

of the American Civil War. He married an American woman but the marriage was unsuccessful. In 1873, when he was thirty-two, Farsari left his wife and two children for Japan, where he stayed for seventeen years. For the first ten years he was engaged in business enterprises involving everything from cigarettes to stationery to imported books. These undertakings seem to have been successful since, in a complete change of direction, Farsari taught himself photography in 1883, and in 1885 had enough capital to acquire the stock of the Japan Photographic Association, Stillfried's studio, which had some fifteen Japanese employees.

The large number of Farsari photo albums sold to Western visitors suggests that his studio was very successful. When Farsari finally left Japan in 1890 to return to Italy with his daughter, he must have been a wealthy man. The girl's Japanese mother, whom Farsari had not married, did not accompany them. His studio continued until at least 1917 and possibly until 1923, when an earthquake destroyed most of Yokohama.

While Farsari's work was popular, it appears to me inconsistent and lacking the quality found in the photography of Beato, Stillfried, or Kusakabe. However, Farsari employed excellent artists, used the best paper, and produced some stunningly colored photographs. Some Farsari albums contain photos that look as though they were taken yesterday.

The fourth edition of *Keeling's Guide to Japan* advertises Farsari as a photographer, painter, and surveyor. An inserted advertisement for January 1, 1887, includes the following:

> As soon as the fire of February 1886 had destroyed all our negatives, our Mr. Farsari started on a professional tour, which lasted over five months. During that time he secured Photographs of views along and near the following roads: Nakasendo . . . Kiokaido . . . etc.
>
> We are the only photographic artists in Japan who have been accorded permission to take views of the Imperial Gardens (Fukiage) in Tokio.
>
> Our pictures may be more expensive than others, but as we use the best materials and our painting is so far superior that it cannot even be compared . . . we are the only ones who paint them as they really are.

It is interesting to note that albums Farsari produced after the 1886 fire would not, then, contain Beato and Stillfried reprints, whereas the albums of Kusakabe, whose stock of negatives was not destroyed, could have included such reprints.

As mentioned previously, attributing photos to the photographer who actually took them can be difficult, and mistakes are common. Some of Farsari's exclusive photographs of the imperial gardens appear regularly in albums of other artists, notably those of Kusakabe and Tamamura. We must assume that these photographers acquired stock or the actual negatives of the images from Farsari. By this time there were also talented amateur freelance artists who sold their work to more than one studio. Further study in the attribution area is definitely needed.

Farsari's studios in Yokohama were located at 32 Water Street, 17 The Bund, 16 The Bund, and 184 The Bluff. In 1904 the firm moved to Motomachi 1-1; from 1907 its final address was Yamashita-cho, number 30.

Farsari and Company was the last Western studio of any note to operate in Japan. In 1886 Farsari was already the only Western photographer in Japan, according to the contemporary *Keeling's Guide to Japan*. The Japanese were taking over photography for themselves.

Early Japanese Photographers in Japan

The first professional Japanese photographers, who operated from around 1862, served the foreign community almost exclusively. Japanese nationals, with very few exceptions, could not afford to pay for a studio sitting. Also, at that time in Japan there was a general superstition that being photographed would bring ill health or even death to the sitter.

The two pioneers of Japanese professional photography, Shimooka Renjo and Ueno Hikoma, courted a foreign clientele until around 1867. During those uncertain days of the Meiji Restoration many young Japanese soldiers thought their death in battle quite likely and overcame their qualms sufficiently to want to leave behind some photographic likeness. From that time the number of Japanese patrons at photography studios increased dramatically.

Many talented photographers must have emerged but it seems that, with a few exceptions, only those who took advantage of the foreign-tourist boom, which lasted until around 1910, had their work preserved. Another factor limiting our understanding of those early days of photography is the fact that preservation of documents and photographs in Japan has always been difficult because of the high humidity and recurrent natural disasters. Thus, it is not possible to make a comprehensive list of

early professional Japanese photographers but the following pages describe those with enduring reputations.

Shimooka Renjo (1823–1914)

It is not certain that Shimooka Renjo was actually the first professional Japanese photographer, but in Japan he seems to be the most venerated and is generally thought of as the father of Japanese photography. Shimooka's studio in Yokohama opened in 1862, the same year that Ueno Hikoma's studio opened in Nagasaki. No earlier Japanese photography studio has yet been discovered.

Despite Shimooka's high reputation only a few of his images have so far been discovered and identified. However, research by me and especially by Torin Boyd has identified more Shimooka images than were previously known. Still, at present fewer than thirty images worldwide, mainly carte-de-visite format, can be credited to Shimooka.

One important factor in the scarcity of Shimooka images is timing. Probably ninety-five percent of the tourist photo albums that come up for for sale at auctions and in antiquarian bookshops date from the 1880s and 1890s, but Shimooka retired from photography in 1877. Thus, it seems reasonable that fewer Shimooka albums should turn up, but what is very mysterious is that up to now not one Shimooka album has been identified. This lack of material makes a meaningful assessment of Shimooka's talent difficult.

Shimooka Renjo was born Sakurada Hisanosuke in Shimoda in 1823, the third son of an official shipping agent to the customhouse of the Tokugawa shogunate. At the age of thirteen he went to Tokyo to become an artist but was unable to find a teacher. After trying various jobs, he secured an apprenticeship, at the age of twenty, to the artist Kano Tosen. In 1844 Shimooka saw a daguerreotype that so impressed him that he decided to learn more about photography.

During the following years Shimooka was employed as a coast guard and draftsman. The latter employment gave him the opportunity to board foreign vessels to sketch. Doing such work he should have had the occasional opportunity to inquire about photography but apparently he did not learn anything useful.

Townsend Harris, the American consul, and Henry Heusken, his interpreter, lived in Shimoda from 1856. At some point Shimooka was also there, and Heusken taught him the basics of photography. When Yokoha-

ma was opened to foreigners in July 1859, Shimooka went there and stayed at the house of Raphael Schoyer, an American merchant.

Schoyer had commissioned Shimooka to do eighty-six oil paintings of Japan, a job that took him a year to complete. During this time an American photographer or missionary was also staying with Schoyer. The American's name, translated back to English from Japanese, is unclear. The *Practical Photographer* of September 1896 renders it Wanshim, *History of Photography* of October 1981 writes it Winshin, and Ogawa Doso-kai's *Sogyo Kinen Sanju Nenshi* lists Unshin. The American gave Shimooka his first formal training in photography and sold him his equipment when he left Japan. Recently researchers at the Yokohama Archives of History have identified the mysterious American as a Captain John Wilson.

In 1862 Shimooka, who at the time was using the name Koin Renjo and would not adopt the family name Shimooka until around 1865, opened his first studio and after some early financial difficulties prospered. Indeed, he was so successful that later he was able to diversify into a number of other businesses. During his career he took various photographic apprentices, some of whom—Yokoyama Matsusaburo, Usui Shusaburo, Esaki Reiji, and Suzuki Shin'ichi—would later become famous.

Shimooka was baptized a Christian by an American missionary in Yokohama in 1872, an action that would have been looked upon with disapproval by most other Japanese at the time. This decision and his probably reasonable command of English may well have enhanced his reputation among foreigners and thereby assisted his business.

W. K. Burton, a British engineering professor resident in Japan at that time and an expert photographer himself, notes that Shimooka can claim a number of other accomplishments outside photography. According to Burton, Shimooka was the first Japanese oil painter and lithographer, the operator of the first omnibus in Japan (between Yokohama and Tokyo), and the man who introduced the rickshaw to Japan.

The grand old man of Japanese photography died at the age of ninety-one. It is said that his various enterprises did not leave him wealthy but he was no doubt able to view his life as eventful, colorful, and satisfying. During his later years he returned to his first love, painting.

Ueno Hikoma (1838–1904)

Probably because Ueno Hikoma's studio operated in Nagasaki from 1862 through the turn of the century, quite a number of his albums and

images have survived. Still, they seem to be rarer than those of photographers based in Yokohama. One reason may be that there were more tourists in eastern Japan than in the western part of the country. Another reason may have been Ueno's seeming preference for uncolored photographs. Late nineteenth-century visitors to Japan were fascinated by colored images and may have patronized those studios that employed colorists.

Ueno, born in Nagasaki, was the son of the talented Ueno Shunnojo, the merchant who imported the first camera into Japan. After finishing his studies of Chinese classics, Ueno attended the naval college headed by the Belgian-born Dutch physician Johannes L. C. Pompe van Meerdervoort. Pompe van Meerdervoort also instructed Ueno in photography, though Ueno made real progress only after taking lessons from Rossier, the visiting French professional photographer.

After studying under Rossier, Ueno was determined to pursue a career in photography but the cost of the needed equipment was prohibitive. Fortunately Horie Kuwajiro (1831–66), Ueno's friend and fellow student, bought a wet-plate camera with funds supplied by his clan chief, Todo Takayuki (1813–95), lord of the Tsu domain (present-day Mie Prefecture). Horie was ordered to take the camera to the Todo residence in Edo and photograph clan officials, friends, and retainers of the shogun.

In 1862 Horie and Ueno coauthored a textbook on Western science and the Dutch language called *Seimikyoku Hikkei* (A handbook to science), which includes an explanation of how to take collodian-process photographs. Ozawa Takesi has carried out successful experiments with those instructions.

Later in 1862 Ueno returned to Nagasaki and opened a photo studio in the garden of his home. The first years were unsuccessful and the family suffered financial hardship. But gradually business grew and Ueno's studio became well established. The studio was popular with foreigners and was mentioned in guidebooks and in Pierre Loti's well-known novel *Madame Chrysanthemum*. Ueno Ichiro's biography of his famous ancestor, *Shashin no Kaiso: Ueno Hikoma*, contains several hundred photos, images that have lessened the problem of identification, although some of them have been wrongly attributed.

Ueno was a major figure in nineteenth-century Japanese photography and a consummate artist. Perhaps he has been overshadowed by the more colorful Shimooka, who endeared himself to his countrymen by overcoming many early obstacles. Nevertheless, there is little Shimooka material to judge, whereas there are many examples of Ueno's quite exceptional

landscape and portrait work. His beautifully sensitive photographs of Nagasaki scenery remain unsurpassed in artistic excellence, and he has left behind a catalog of portraits of important personages, both Japanese and foreign.

Kusakabe Kimbei (1841–1934)

Kusakabe Kimbei is one of my favorite Japanese photographers. He worked with and understood Western photographers and their techniques but developed his own very Japanese style of photography. In particular, his landscapes capture the beauty of nineteenth-century Japan. The models in his posed shots seem more at ease than those in his contemporaries' photos. His portraits are not at all wooden, and Kusakabe was often able to conjure up an atmosphere of quite disturbing intensity, somewhat reminiscent of Stillfried's best studio photos. Kusakabe's work is, I believe, underrated.

Kusakabe was very popular with foreigners. Only Tamamura and Farsari seem to have been able to match him in output, and Kusakabe's work is not difficult to find. His various studios in Yokohama operated from 1881 until at least 1913. Advertisements for Kusakabe often appeared in guidebooks, and obviously he was successful. Since he lived until he was ninety-three, it is frustrating that so little is known about his life.

Japanese sources appear to agree only on Kusakabe's being born in 1841 in Kofu, Yamanashi Prefecture, into a family of textile merchants. (See *Saishoku Arubamu. Meiji no Nihon—Yokohama Shashin no Sekai,* edited by Yokohama Kaiko Shiryokan, i.e., the Yokohama Archives of History.) Thereafter, everything is vague, though he seems to have been an apprentice to either Beato or Stillfried, working initially as a photo colorist and then as an assistant. He could have been an assistant to both men, since Stillfried took over Beato's studio in 1877.

What is known for certain is that Kusakabe operated his own studio in 1881 on Bentendori, 2-chome, numbers 27 and 36. From 1885 he managed to acquire a number of Beato and Stillfried negatives, which were reprinted with some regularity in his albums. Also, he must have purchased some of Ueno Hikoma's negatives of Nagasaki, since these images appear in some of his albums. In 1889 his studio found a permanent home at Honmachi 1-chome, number 7.

Collectors today are often confused when they see Kimbei, instead of Kusakabe, in late nineteenth-century advertisements. However, as West-

erners made up most of his clientele, the photographer's choice of Kimbei, easier to pronounce than Kusakabe, makes sense.

Kusakabe died in 1934 in Hyogo Prefecture and has yet to receive the full recognition that his talent deserves.

Tamamura Kozaburo (1856–19??)

Born in 1856 in Edo, Tamamura Kozaburo was the eldest child born in a family of hereditary retainers to the Hoshinno of Rinnoji, a branch of the imperial family whose head had served as chief priest of the main temple in Nikko since 1654. In 1867, the last year of the Tokugawa shogunate, Tamamura began an apprenticeship to the photographer Kanemaru Genzo in the Asakusa section of Edo, where he worked for seven years. After this training, Tamamura opened his first studio, an outdoor *shajō*, in the Okuyama area of Asakusa in 1874. The vicinity included numerous studios operated by Esaki Reiji, Uchida Kuichi, and others. (See *Sogyo Kinen Sanju Nenshi*, edited by Ogawa Dokosai.)

Two years later Tamamura relocated to Yokohama, and by 1881 that studio was a thriving business selling prints of Japanese scenes, glass slides, and paintings, mostly to a foreign clientele. Tamamura continued to expand his business and gained a reputation as a skilled professional. Large orders for glass slides were placed from such prestigious schools as the universities of Cambridge and Chicago.

In 1882 Tamamura was commissioned by a Japanese tea company to photograph the tea industry. Using new design techniques, he produced photos that were said to have boosted overseas tea sales. Afterwards, many other companies commissioned him to document their various activities.

Tamamura continued to enlarge his business and experimented with new ideas, especially expanding his business with foreigners and overseas clients. He sometimes traveled abroad himself on photo assignments. His photographs won awards in Japan and abroad, and Tamamura became internationally known. His renown brought even more foreigners and celebrities to his Yokohama studio. In 1906 the American Friendship Association hired Tamamura to document the making of a stone memorial dedicated to Commodore Matthew Perry in Kurihama. Some of these photos were presented to Emperor Meiji.

Tamamura was a photographer and entrepreneur, with many notable accomplishments. An article in the *Mainichi Shimbun* of July 19, 1896,

noted that he had just exported 40,000 photographs of various sizes to a dealer in Boston by the name of Silhouette. This shipment was the first installment of an enormous order for one million photographs for which Tamamura employed 105 assistants for printing and handcoloring. The second installment, scheduled to go out the following month, included 180,000 photographs. This order undoubtedly provided the photographs used in Captain Francis Brinkley's book *Japan: Described and Illustrated by the Japanese,* which featured tipped-in albumen photographs. In 1898 Tamamura changed his studio name to Tamamura and Company.

The *Yokohama Boeki Shimpo* of March 11, 1908, included a Tamamura advertisement offering a fifty-percent discount to celebrate his twenty-fifth anniversary. Another article in the same newspaper called Tamamura the best photographer in Yokohama and noted that many foreigners agreed with that appraisal. In the following year the editors of the business publication *Yokohama Seiko Meiyokan* wrote that Tamamura and Company was the largest tax-paying photographic business in Japan.

Tamamura held several addresses during his long career in Yokohama. Although by 1890 he was known to be at his most famous address, Benten-dori, 1-chome, number 2, he also had a studio called Gyokushin-do at Sumiyoshi-cho, 4-chome on Bashamichi-dori. Perhaps the latter was an early address, since it shows up on cartes de visite that appear to have been made in the early 1880s. An advertisement in the 1903 *Japan Advertiser Directory* mentions that Tamamura also had a branch at an address designated "No. 2 Kobe." His final address, at Ogami-cho, 5-chome, was his most prestigious, a spacious two-story building that he occupied from 1916 to 1923. Unfortunately this location was destroyed by the Great Kanto Earthquake of September 1, 1923, which put an end to Tamamura's business. The date of his death is unknown.

Ogawa Kazumasa (1860–1929)

Ogawa Kazumasa's father was a samurai and retainer of the Matsudaira family, lords of Musashi (present-day Tokyo and parts of Saitama and Kanagawa prefectures). Born in 1860, Ogawa himself had a faint recollection of the civil war of 1868–69 that accompanied the Meiji Restoration. He recalled being on the battlefield with his father and being wounded in the foot by a spent bullet, and remembered his sister carrying a *naginata*, the spear with which women of that time were taught to fence.

It appears that Ogawa became interested in learning English at an early

age and in photography at the age of fifteen. Obtaining knowledge of photography was extremely difficult but eventually a Japanese photographer gave Ogawa some limited advice and assistance and also sold him a camera. Ogawa later gained employment with a professional photographer by the name of Yoshiwara. After about six months he was still dissatisfied with his level of knowledge and resolved to study English in Tokyo and then travel abroad.

Through the influence of friends, Ogawa was hired as a sailor on the American frigate *Swatara* and set sail for the United States in July 1882. He was discharged six months later and eventually studied portraiture, carbon printing, and collotype in Boston. He moved to Philadelphia, then returned to Japan, where in 1884 and after an absence of around eighteen months, he quickly established a large studio in Tokyo, using funds from a Japanese benefactor he had met in the US, Viscount Okabe Nagamoto (1855–1925), later vice-president of the Photographic Society of Japan. In 1889 Ogawa reestablished *Shashin Shimpo,* Japan's first photographic periodical, which had run for a short time between 1881 and 1882, and set up a photomechanical printing factory in Tokyo.

W. K. Burton, who in addition to being a founding member of the Photographic Society of Japan, was a personal friend of Ogawa and described him as follows in 1894:

> I think it safe to give Mr. Ogawa the title of the leading professional photographer in Japan. Did the title depend merely on common studio work there are many others who would hold the same rank as Ogawa, as, for example, Suzuki, Esaki and Maruki; but Ogawa's present reputation is based on many other kinds of work than mere studio portraiture . . . I consider Mr. Ogawa to be most happy in landscape work, and in what is commonly called genre subjects.

Ogawa gained more popular recognition in 1891, when, to mark the opening of the Ryounkaku in Asakusa, its proprietors commissioned him to photograph one hundred local geisha. Affectionately known as the "Asakusa twelve stories," this octagonal brick tower enjoyed fame both as the tallest building in Tokyo before the 1923 earthquake and as the earliest modern amusement center in Japan.

Ogawa again went to the US in 1893, when the world's fair was held in Chicago. He also received several official commissions in Japan and China. The Japanese government requested him to photograph treasures in

old Kyoto shrines. In 1900 Ogawa photographed the aftermath of the Boxer Rebellion in China. He also produced numerous collotype books that are listed in standard bibliographies like Friedrich von Wenckstern's two-volume work, *A Bibliography of the Japanese Empire.*

Ogawa had tremendous success with his collotype photography and clearly did not need to produce the more conventional tourist album filled with original handcolored, albumen photographs. Nevertheless, I have been able to attribute to Ogawa a small number of albumen images. But increasingly I am left with the impression that he gave albumen photography very little attention and may not have produced even a single album of albumen photos.

Two excellent biographical articles on Ogawa written by W. K. Burton are in the March 11, 1890, issue of *Anthony's Photographic Bulletin* and the June 1, 1894, issue of the *Practical Photographer*. Note that Ogawa is sometimes referred to by two alternative readings of his given name, that is, Ogawa Isshin or Ogawa Kazuma.

Uchida Kuichi (1844–75)

Japanese sources agree that Uchida Kuichi was an important and influential photographer. He was so famous and respected that in 1872 and again in 1873 he was permitted to take the first photographs of Emperor and Empress Meiji.

Uchida was born in Nagasaki in 1844. When he was thirteen, his father died of cholera and he was adopted by Matsumoto Ryojun, at that time a student of photography with the Dutch physician Pompe van Meerdervoort, quite likely the photographic inspiration in Uchida's life. When he was sixteen, Uchida purchased photographic equipment from the Dutch at Deshima and opened his first studio in Osaka in 1865. A year later he moved his studio to Tokyo, and in 1868 opened a second in Yokohama. In 1875 Uchida died young of unknown causes. (See Kanagawa Shinbunsha's *Meiji no Yokohama Tokyo Nokosareteita Garasu Kanban Kara* and Worswick's "The Disappearance of Uchida Kyuichi [*sic*] and the Discovery of Nineteenth Century Asian Photography.")

I know of only two Western references to an Uchida and both strike me as curious. The first is from the 1881 and 1884 editions of *A Handbook for Travellers in Central and Northern Japan* by Satow and Hawes, which lists four Tokyo-based photographers, including a certain Uchida Kiichiro at Kaya-cho, Asakusa, though this could be a different Uchida. The

second reference is from W. K. Burton, writing in 1890 about Ogawa Kazumasa in "A Japanese Photographer" and explaining how he came into contact with an Uchida:

> The art had been, until a very little before the time that I write of, practically a monopoly in the hands of one Uchida, the oldest photographer in the country, who had learned it in the very old times from a Dutchman. Uchida must have made considerable hay whilst the sun of those days shone. He charged the modest sum of $75 for a carte-size glass positive. It is true he got very few sitters, for there was a superstition among the Japanese of the time that the taking of their photograph meant the loss of some of their vital energy. He used, however, to get very high prices from foreigners for photographs of Japanese, and made much money by selling such, although he had to pay models to so far overcome their scruples as to sit for him. He afterwards, when prices came down from $75 to $5, took to instructing in the art for a high fee, and under a bond of secrecy. At the time that Ogawa turned his attention to photography, Uchida was still the only purveyor of photographic goods in the country, and must have made a pretty good thing of it—or someone must—to judge by the prices he charged. Here are a few of them. Nitrate of silver, $7.50 an ounce; collodion, $1 an ounce; sulphate of iron, $2 per pound; albumenised paper, $1 per sheet! Not a likely time for a boy who had never even seen a camera, and who was pretty nearly penniless to turn his attention to the practice of photography!
>
> However, at last Ogawa did manage to get sight, at least, of a camera, and that the camera of no less a man that Uchida himself . . . Eventually the opportunity presented itself to Ogawa of employment with an actual professional photographer, one H. Yoshiwara. With him he remained about six months . . . At this time Uchida's stock of collodion ran short.

As Ogawa first became interested in photography when he was fifteen, in 1875, the year Uchida died, some of these dates are very tight and appear suspect.

Professor Burton, usually so accurate, is also surely talking about Shimooka Renjo. The meeting with Ogawa referred to in the text would have taken place around 1875. Uchida would have been thirty-one, hardly the "oldest photographer in the country." It looks, therefore, that Burton was

wrong, yet I feel somehow uneasy about the whole Uchida story, as the known information about him does not quite ring true.

No real evalutation can be made of Uchida's photographic ability, since only a few images have so far been attributed to him. More research on Uchida is certainly needed. One encouraging factor is that there are a number of carte-de-visite photographs with his studio stamp on the reverse.

Other Japanese Photographers

In the early days of Japanese photography Nagasaki was the training ground for any aspiring photographer due to the presence there of Johannes L. C. Pompe van Meerdervoort. This influential Dutchman arrived in Japan in 1857 at the age of twenty-eight and stayed for five years. A naval medical officer, he taught medicine, physics, chemistry, and photography at the naval college and later at Japan's first Western-style medical school, whose founding he had recommended and which today forms part of Nagasaki University.

Among those who studied collodion-process photography under Pompe van Meerdervoort were the future director of Japan's military hospitals, MATSUMOTO RYOJUN (or Jun as he was later known, 1832–1907) from Edo, and MAEDA GENZO (1831–1906) from northern Kyushu. In his autobiography Matsumoto recalled that his former teacher was not entirely successful in his photographic endeavors and did not, in fact, have much previous experience. Maeda later met the Frenchman known as Rossier, who was apparently more successful. Ueno Hikoma, in his 1862 book *Seimikyoku Hikkei* (A handbook to science), also mentioned studying under Rossier. Certainly some of Ueno's early photographs show a distinctly European influence.

In Hakodate, KIZU KOKICHI (1830–93) was taught photography in 1858 by the first Russian consul to be stationed there, Iosif Antonovich Goshkevich. In 1864 Kizu opened a studio in Hakodate and is today remembered as Hokkaido's first professional photographer.

YOKOYAMA MATSUSABURO (1838–84) set up a studio in Yokohama in 1865. In 1876 he was appointed lecturer in photography at the Japanese Military Academy. Yokoyama took a series of photographs of the old Tokyo castle just prior to its reconstruction.

ESAKI REIJI (1845–1909), born the son of a farmer in Mino, moved to Tokyo at an early age. For a few months in 1872 he served as an apprentice

to Shimooka Renjo in Yokohama before setting up his own studio in Tokyo. At first he was very successful, but his business subsequently failed and he opened a second shop in Asakusa, where he was much more successful. Esaki is credited with being the first user of dry plates in Japan in 1881. He succeeded in photographing torpedo explosions on the Sumida River in the presence of Emperor Meiji. In 1884 the government requested him to photograph the eclipse of the sun but the attempt was unsuccessful due to rain. He did, however, photograph a lunar eclipse in 1884, the first time an eclipse was photographed in Japan.

SUZUKI SHIN'ICHI (1855–?) was born in Izu Kamagun but moved to Yokohama in 1869 to study painting under Charles Wirgman. There he saw a photograph of a wrestler and became intrigued with photography. Wirgman taught him the basic principles of photography, and Suzuki decided to forsake painting. In 1870 he apprenticed himself to Shimooka and stayed with him seven years before starting his own studio in Nagoya in 1876. He became dissatisfied with the level of his knowledge and traveled to San Francisco, where he stayed for one year as an apprentice to an I. W. Taber. He returned to Japan in 1881 and built a studio in Tokyo. He was commissioned to photograph international exhibitions in France and Spain, as well as a national exhibition in Japan. In 1888 he photographed Emperor and Empress Meiji. He also photographed many famous international statesmen. In the mid 1870s Suzuki took the previously unattributed *shajō* photographs, many of which appear in *Japan: Caught in Time*. Note that Suzuki's birth and death dates are disputed.

KASHIMA SEIBEI (1866–1924) was a very talented amateur photographer active in the 1890s. A wealthy merchant, he helped finance Ogawa's collotype business, and Ogawa used some of Kashima's pictures in his collotype albums. Kashima gave up his business after an accident with magnesium flash-powder. A number of his photographs are illustrated in Augus's *Japan: The Eastern Wonderland* and in volume 7 of the *Practical Photographer*. Kashima is often erroneously referred to as Kajima.

IZAWA SHUJI was another talented amateur active in Tokyo during the 1890s. He was also editor of the photography periodical *Shashin Sowa*.

NAKAJIMA MATSUCHI worked in Tokyo as an artist and later became a photographer, opening his first studio in 1875. He produced many glass lantern slides.

Mention should also be made of the owner of RYO-UN-DO in Kobe. This very successful studio was located close to the famous Nunobiki Waterfall and thus was well situated for the tourist trade. Ryo-Un-Do was active in

the 1890s and produced tourist albums of handcolored photographs. Apart from seeing the studio advertised in Murray's guidebooks of the time, I have managed to obtain little information on Ryo-Un-Do. The identity of its owner remains a mystery.

SHIN-E-DO was, like Ryo-Un-Do, a Kobe-based studio active in the 1890s that produced the familiar tourist albums. Again, the only references I have found to Shin-E-Do have been in Murray's guidebooks.

USUI SHUSABURO was originally an apprentice to Shimooka but apparently left that studio around 1877. Little is known of his life other than that he was a native of Shimoda. Advertisements of the time suggest that he was very keen to undercut his competitors, and his Yokohama-based studio must have been successful, at least for a time. His albums seem to date from the late 1870s and 1880s, and much of his work is of high quality. Usui's photos are often mistaken for Stillfried's because Usui used similar numbers on his negatives. Sometime around 1894 Usui seems to have disappeared. He was a fine artist and, like Suzuki, is underappreciated.

According to *Saishoku Arubamu. Meiji no Nihon—Yokohama Shashin no Sekai,* from the end of the nineteenth century OGAWA SASHICHI (not to be confused with Ogawa Kazumasa) operated a studio in Yokohama that catered to foreigners who passed through the city. Sashichi is said to have married Kusakabe's daughter and, if so, no doubt learned much from his father-in-law. In 1896 he had a business at Sakai-cho, 1-chome, number 24. In the November 21, 1908, issue of the *Illustrated London News* his studio sign apppears in an illustration of a Yokohama street. On his albums Sashichi sometimes used a small, oval-shaped name stamp, which has so far proved to be the only means of identifying his work.

OKAMOTO R. operated a lavish studio in Tokyo known as the Genroku-kan. For a time he was the sole agent for Kashima Seibei's photographs. A collage of thirteen of his photos appears in the October 24, 1903, issue of the *Illustrated London News.*

This listing of early Japanese photographers is, of course, incomplete. There were no doubt other Japanese pioneers of photography but their work, in the main, has not survived. The Japanese climate is not kind to photographs, and preservation anywhere but in the best-equipped museum is extremely difficult. Wars and natural disasters have also taken a toll on nineteenth-century images.

It follows, then, that with a few exceptions, only those photographers who were successful in selling their work to late nineteenth-century visitors to Japan have been remembered. This is because these photo-

graphs were thereby exported to countries where they have survived in reasonable numbers. One factor to mention here is the nationality of those visitors. By far, most were from England, followed by those from the United States and then those from France. These are the countries where most early Japanese photographic material can be found today.

Identifying Photographers' Work

The Western traveler in Japan, particularly from the 1860s onward, could easily acquire souvenir albums of original albumen photographs of scenes and portraits, most of them handcolored. The albums were often bound in ornate lacquer covers and encased in felt-lined cardboard boxes to protect them on the long sea journey home. Even today many of these albums and their photographs are remarkably well preserved. In mid to late nineteenth-century Japan there were more British tourists, consular officials, and expatriate workers than there were other foreigners, and many nineteenth-century albums and individual photographs ended up in British bookshops, auction houses, and attics.

A tourist purchasing a souvenir album would naturally want pictures that illustrated his or her tour. The tourist would select favorite images and a lacquer album to hold them, and the next day the album with mounted photos would be delivered to the purchaser's hotel. However, the tourist could also visit different studios and buy separate images. He might then have taken those back home and had them mounted in a Western-style album. Attribution is complicated with such albums, often identified by their Western binding. Attribution is easier with an album of photos purchased at one studio, though there are troublesome images in this type of album too.

In the late nineteenth century most visitors to Japan would start their tours in Yokohama or Nagasaki, then usually visit Matsuyama, Kobe, Osaka, Nara, Kyoto, Mount Fuji, Kamakura, and Tokyo. More adventurous spirits (or those with more time on their hands) might visit Hokkaido, via the port of Hakodate, to see the Ainu. Almost everyone would have wanted to visit the imperial gardens in Tokyo. Mention of photographs of the imperial gardens leads directly to the problem of attribution.

In the 1890s the Yokohama firm of Adolfo Farsari had sole rights to photograph inside the imperial gardens. But it is certain that Farsari sold some of those images to other photographers, since they appear in albums attributed to Kusakabe, Tamamura, and others.

Another troublesome image is a portrait of a woman who was thought at the time to epitomize Japanese feminine beauty. This print, shown on page 128, was in demand and appears in a number of different photographers' albums. The original photographer is unknown, though Stillfried seems likely, if only because it seems the print first appeared in his albums.

Images of Nagasaki in albums by Kusakabe, who was based in Yokohama, also pose a problem, as most were probably photographed by Ueno Hikoma, who was based in Nagasaki. Since Nagasaki and Yokohama are about six hundred miles apart, it is not surprising that the photographers exchanged local views. Many albums also include occasional prints by talented amateurs like Izawa Shuji and Kashima Seibei.

It is very likely that successful photographers like Tamamura, Kusakabe, and Farsari had agents in Kobe and Nagasaki. Photo dealers like Nagasaki-based Tamemasa T. seem to have compiled and sold albums of one or more of these photographers. (Contemporary advertisements in travel guides seem to have been consistent in distinguishing between a photographer and a photographic dealer, a useful distinction.) Moreover, rival photographers probably operated some sort of exchange system. Ueno Hikoma's images of Nagasaki could have appeared in Kusakabe's albums as a result of such an exchange. Or perhaps photographers simply used each other's work with impunity, since copyright laws were relatively lax, though there may have been some sort of unofficial understanding among photographers to prevent widespread plagiarism.

From the middle of the 1870s all images had to be registered with the authorities. According to Nihon Shashinka Kyokai's *Nihon Shashin Shi 1840–1945*, photography regulations were promulgated in 1876. One regulation stipulated that anyone who filed three copies of a photograph, along with a sum equivalent to the cost of twelve copies of the photo, was given the "copyright to photography" and permission to sell the photograph exclusively for five years.

In 1887 these regulations were changed. Revisions decreed that the right to a commissioned photograph belonged to the person who had commissioned it, and that anyone who wished protection, for a period of ten years, had to submit to the Ministry of Home Affairs two copies of the photograph, along with a sum equivalent to the cost of six copies of the photo.

As has been stated previously, attributing an image to a photographer can be a difficult task, though the problem has lessened somewhat in recent years. Most photographs have numbers and/or titles inscribed on

their negatives. In the early 1980s I began trying to link the numbers on the images to individual photographers. Fortunately a few albums had the trade name of the photographer stamped on the front inside cover. Occasionally a full frontispiece advertisement also appeared, particularly in the albums of Kusakabe, Farsari, Stillfried, and Tamamura.

As a typical album consists of fifty photographs, most with reference numbers and captions, it was possible to make a start at attributing images by grouping together these numbers under the name of the photographer whose trade stamp appears in the album. Kusakabe, Farsari, and Tamamura albums are relatively common, and it did not take long to build up a comprehensive cross-referencing list, which eased the task of attributing these artists' photos, even those in unstamped and anonymous albums.

Different numbering systems on some of Kusakabe's images also proved an important clue for identification purposes. Kusakabe's Nagasaki images (the ones probably taken by Ueno Hikoma) generally display a different form of numbering, as Kusakabe must have wanted to differentiate these images from his own.

I confirmed my initial attributions when I was able to check stamped albums by these artists. In 1988 I visited the American collector Henry Rosin, who showed me a small Kusakabe catalog that lists the photographer's actual reference numbers for more than two thousand images. I was pleased to see that the numbers in this primary-source document matched my own attributions.

I have seen literally hundreds of albums, the majority dating between 1880 and 1900, and would say that around ninety percent of them can be attributed to Beato, Stillfried, Kusakabe, Tamamura, Ueno, Farsari, or Usui. These photographers clearly dominated the field and were all extremely successful.

Until now research on nineteenth-century photography has been limited. In general, Japanese sources do not help much with identification, though I can mention two books that have proved helpful to me. In 1990 the Yokohama Archives of History published *Saishoku Arubamu. Meiji no Nihon—Yokohama Shashin no Sekai,* which includes a provisional list of photographic numbers and attributions for some of the Yokohama artists. A Japanese book on the work of Ueno Hikoma, *Shashin no Kaiso: Ueno Hikoma,* is also very useful for identification purposes. Among the compilers of this study are Professor Ozawa Takesi, an expert on nineteenth-century Japanese photography, and Ueno Ichiro, a descendant of Ueno Hikoma.

Finally, it should be said that when attributing work to a photographer, we should perhaps rather attribute it to the studio, as rarely can we be absolutely sure of the actual photographer of most nineteenth-century Japanese images. There were no doubt numerous instances of a photographer's assisant or other member of the staff taking the photograph, with or without the presence of the "master."

Appendix 1 is a first attempt at classification that I admit is far from complete. Space alone dictated a certain selectivity. Also, Beato's work is not listed here since he did not include numbers on his images. Still, I hope that the list will provide stimulus to future researchers. While it is my belief that the lists are generally accurate, I acknowledge that any mistakes in classification are mine and welcome any comments or criticisms.

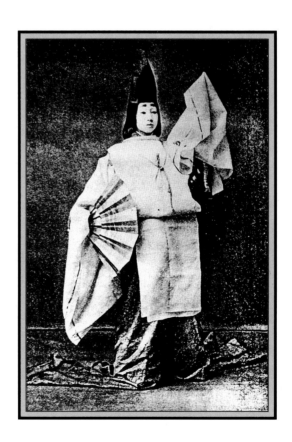

The Images

Note: An asterisk after a caption indicates that additional information on that image can be found in the Notes section, beginning on page 137.

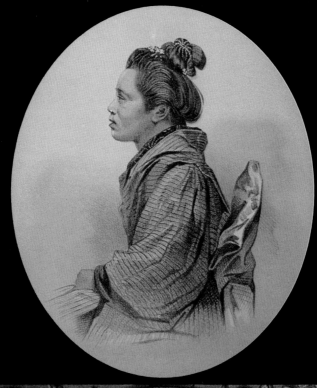

13. *(Above)* ELIPHALET BROWN, JR. Japanese woman, lithograph, 1856.*
14. *(Below)* ICHIKI SHIRO. Shimazu Nariakira, daguerreotype, 1857.*

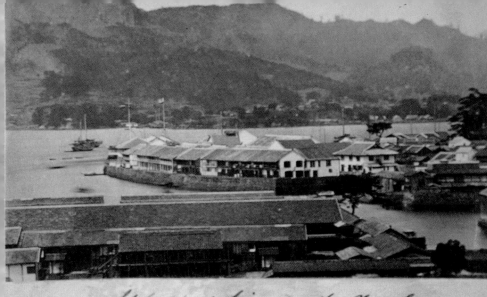

Island of Decima. the Dutch Settlement at Nagasaki. & Russian settl'ts the opposite side of the bay. *June. 65.*

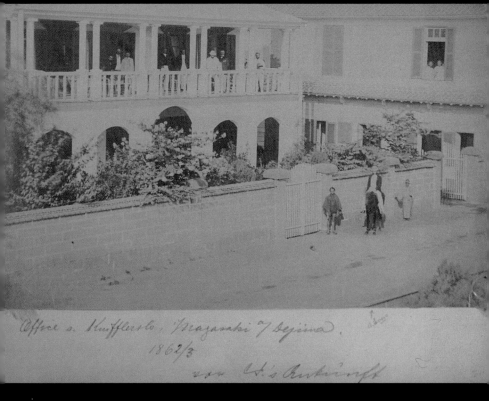

Office o. Kniffler+Co, Nagasaki o7 Dejima.
1862/3
U.'s Ankunft

5. *(Above)* BEATO. Island of Deshima, 1865.*
6. *(Below)* Unknown photographer. Dutch officials at Deshima, c.1862–63.*

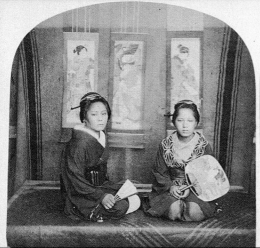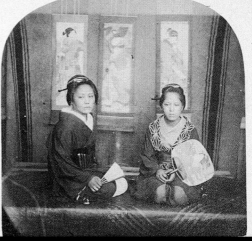

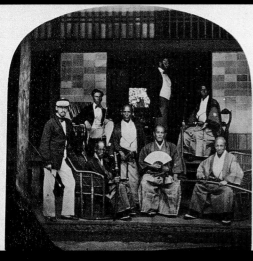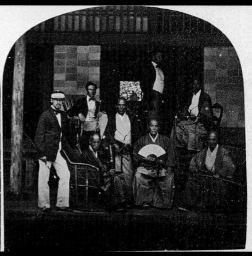

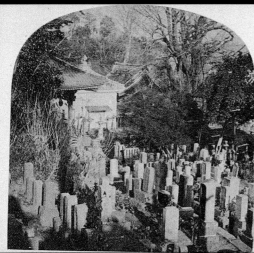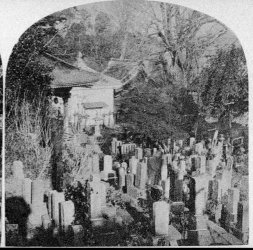

17. *(Above)* Unknown photographer. Two Japanese women, stereograph, 1860–61.*
18. *(Center)* Unknown photographer. Japanese and British legation, stereograph, 1860–61.*
19. *(Below)* Unknown photographer. Japanese cemetery at Edo, stereograph, 1860–61.*

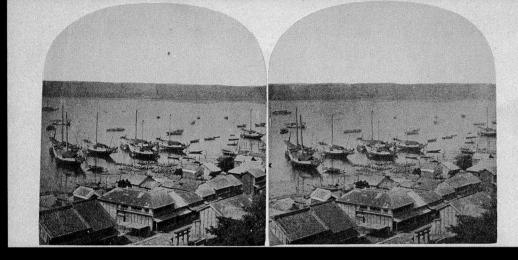

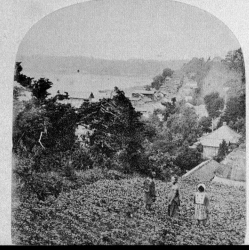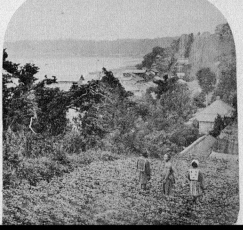

20. *(Above)* Unknown photographer. Port of Kanagawa, stereograph, 1860–61.*
21. *(Center)* Unknown photographer. American legation in Edo, stereograph, 1860–61.*
22. *(Below)* Unknown photographer. Town and bay of Kanagawa, stereograph, 1860–61.*

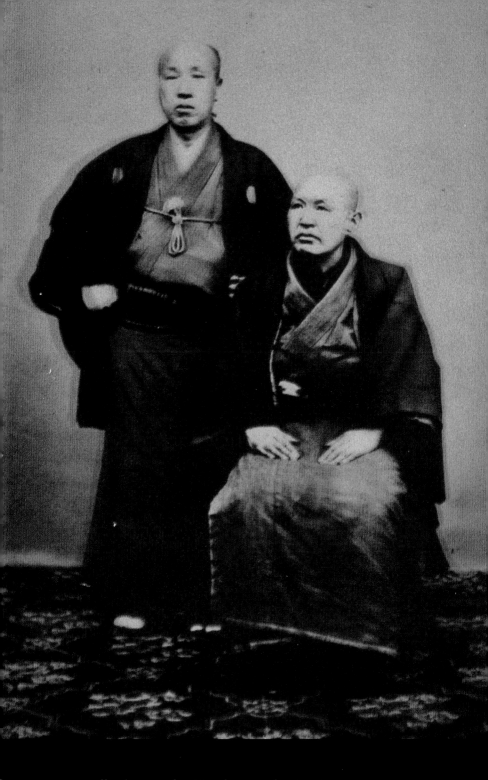

3. PARKER. Two officials, carte-de-visite photograph, 1863–68.*

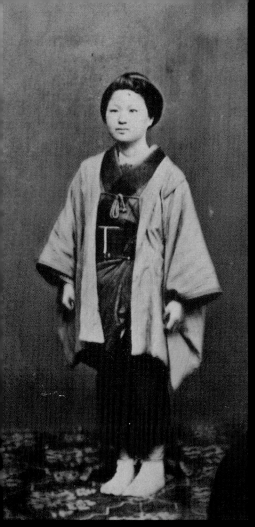

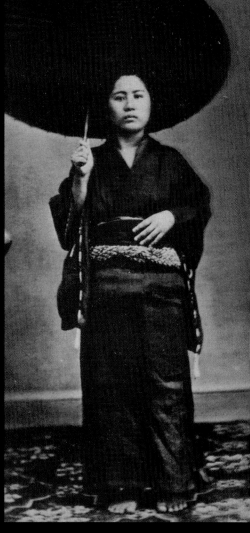

24. *(Left)* PARKER. Woman wearing *haori* coat, carte-de-visite photograph, 1863–68.*
25. *(Right)* PARKER. Woman with umbrella, carte-de-visite photograph, 1863–68.*

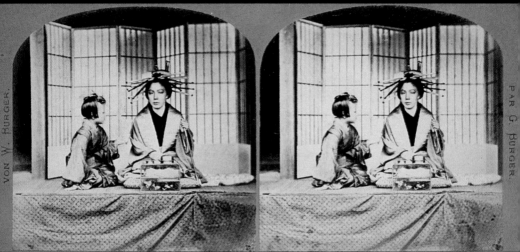

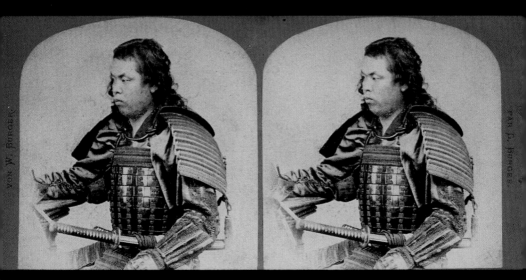

26. *(Above)* BURGER. Nagasaki, stereograph, c.1869.*

27. *(Center)* BURGER. *Oiran*, or high-class courtesan, with attendant, stereograph, c.1869.*

28. *(Below)* BURGER. Japanese warrior, stereograph, c.1869.*

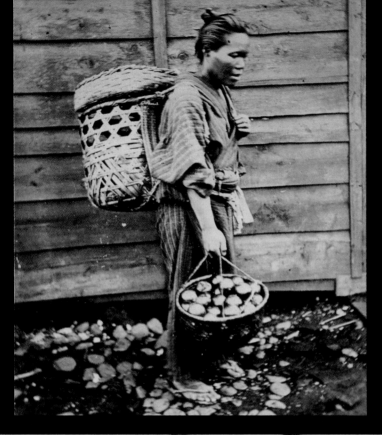
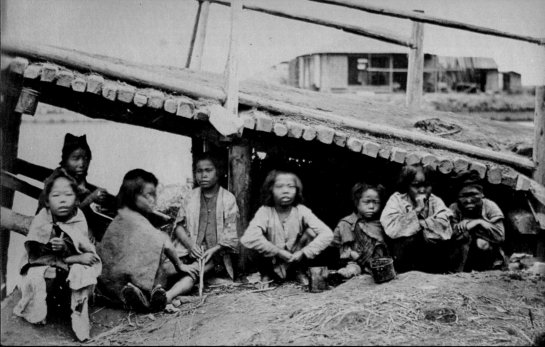

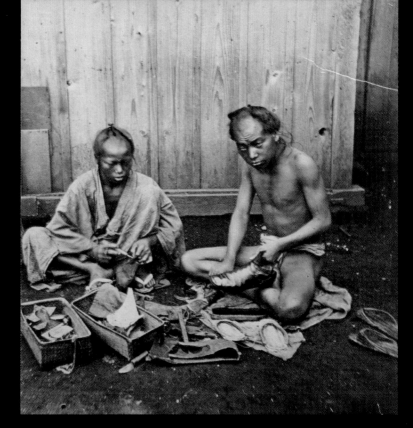

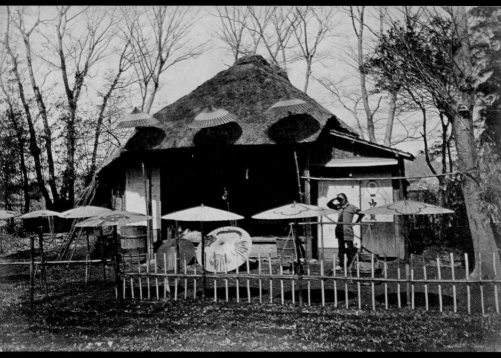

31. *(Above)* Unknown photographer. Itinerant Japanese cobblers, 1870s.*
32. *(Below)* Unknown photographer. Umbrella maker's house, 1870s.*

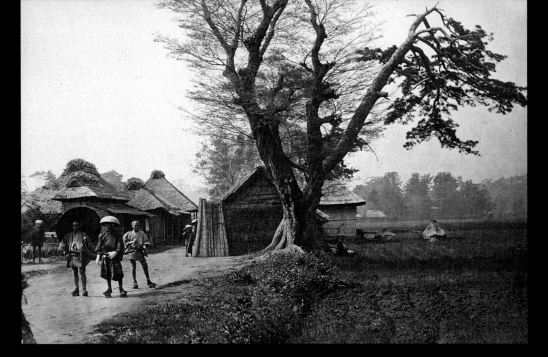

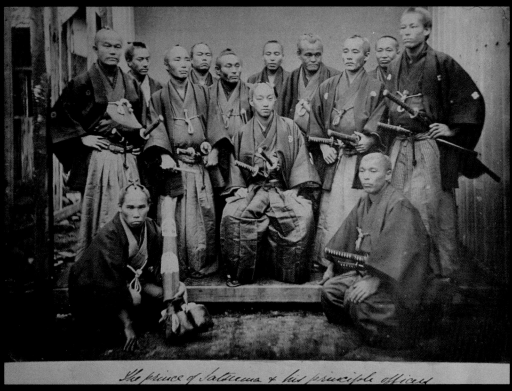

The prince of Satsuma & his principle officers

33. *(Above)* BEATO. Namamugi, on the Tokaido, 1860s.*
34. *(Below)* BEATO. The prince of Satsuma and his principal officers, c.1866.*

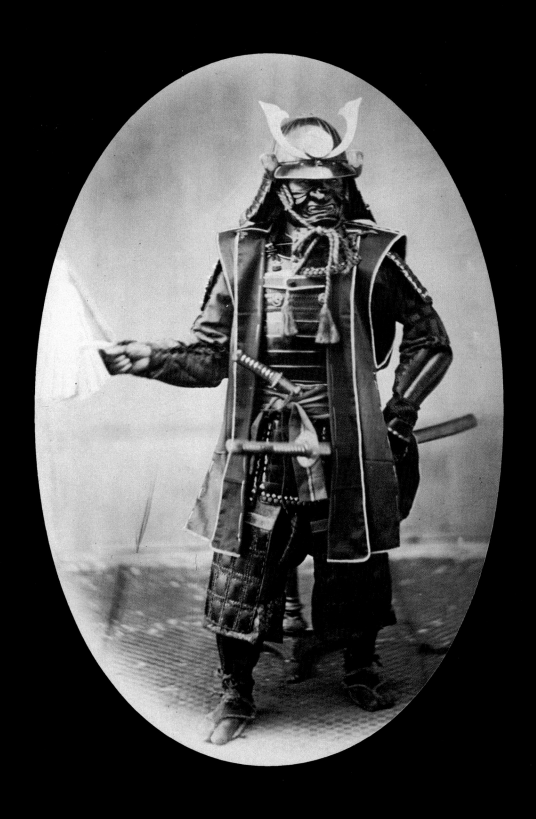

35. BEATO. Warrior in armor, 1860s.*

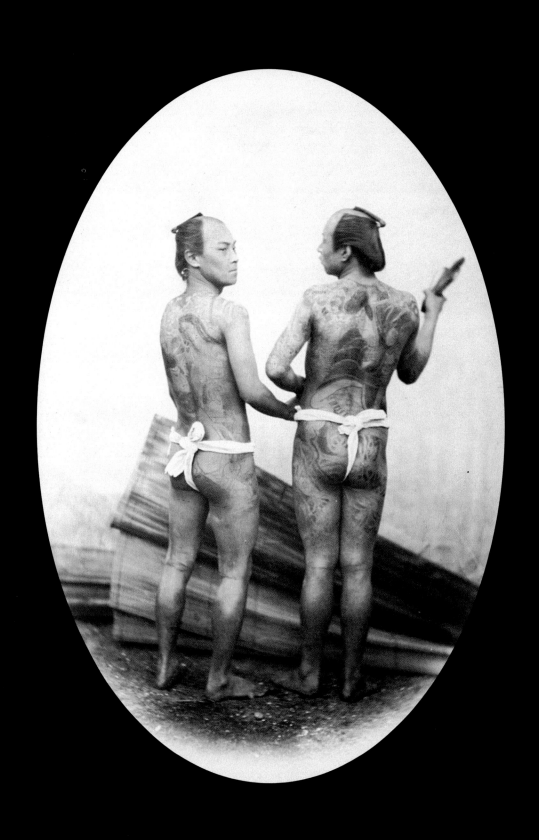

36. BEATO. *Bettō*, or groom, tattooed, 1860s.*

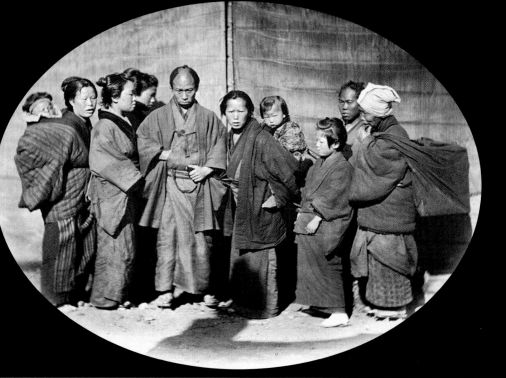

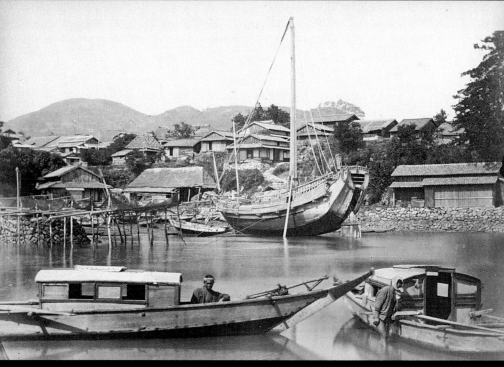

37. *(Above)* BEATO. Group of Japanese, 1860s.
38. *(Below)* BEATO. Boats at Nagasaki, 1860s.

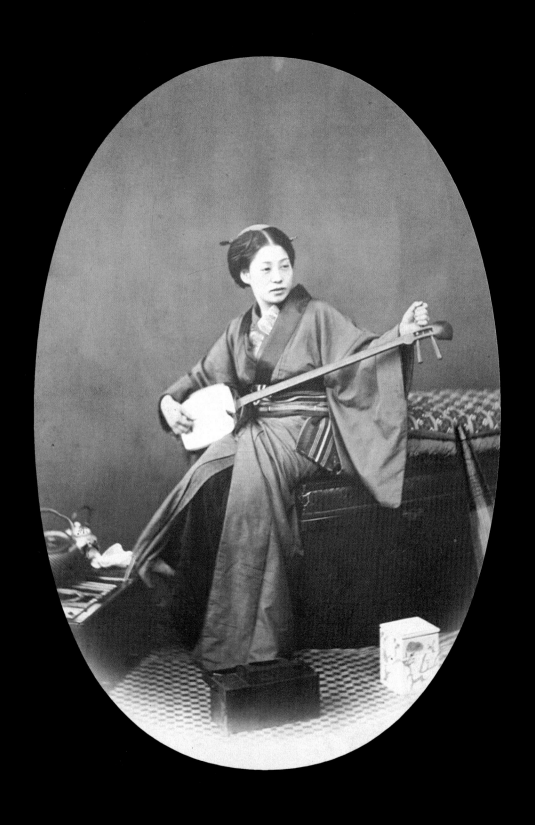

39. BEATO. Girl playing the samisen, 1860s.*

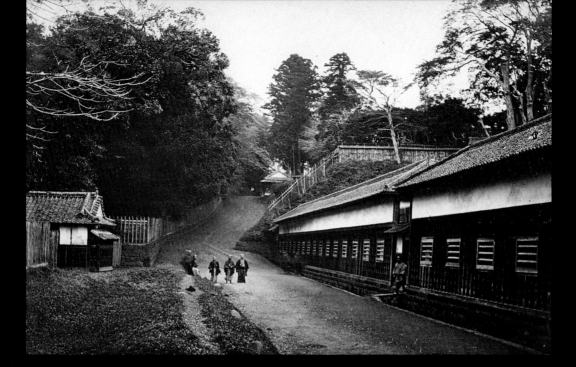

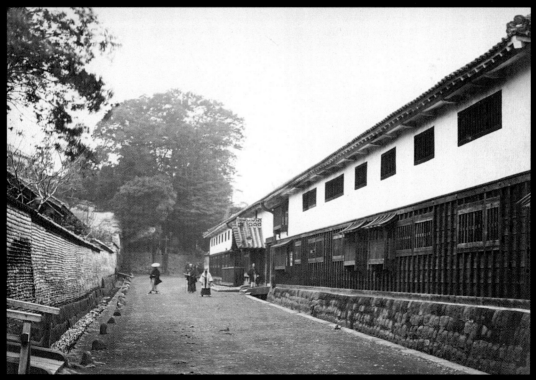

40. *(Above)* BEATO. Lord Shimazu's quarters, Edo, 1860s.*
41. *(Below)* BEATO. Lord Arima's quarters, Edo, 1860s.*

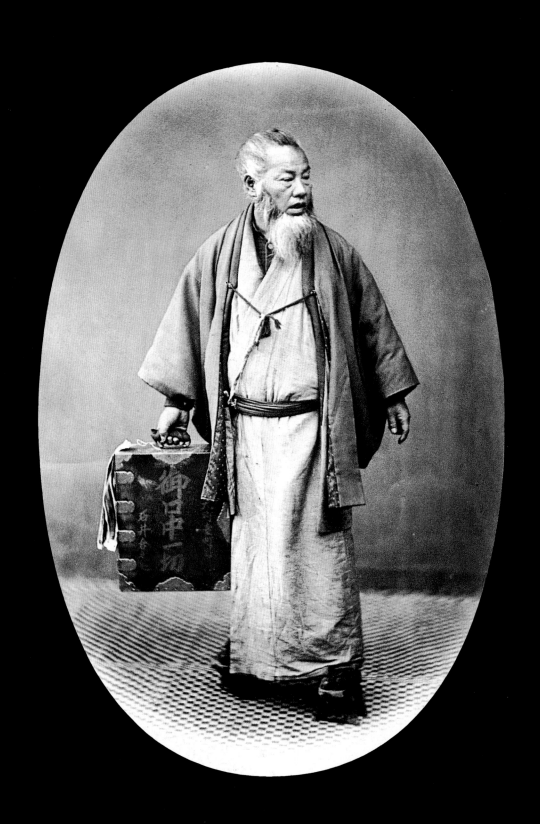

42. BEATO. Dentist, 1860s.

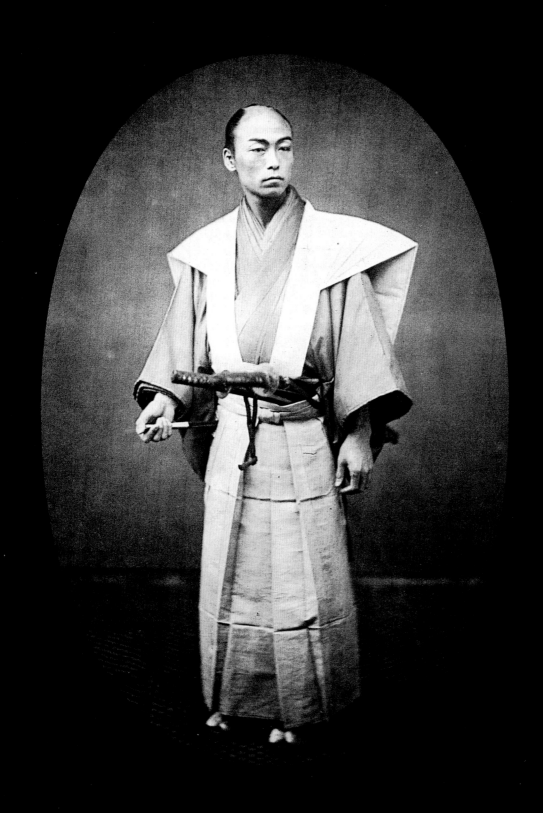

43. BEATO. Japanese high official in court attire, 1860s.

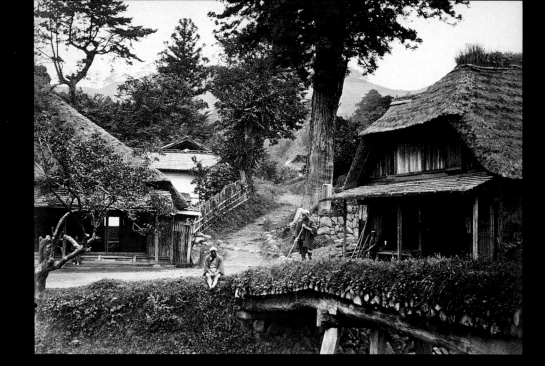

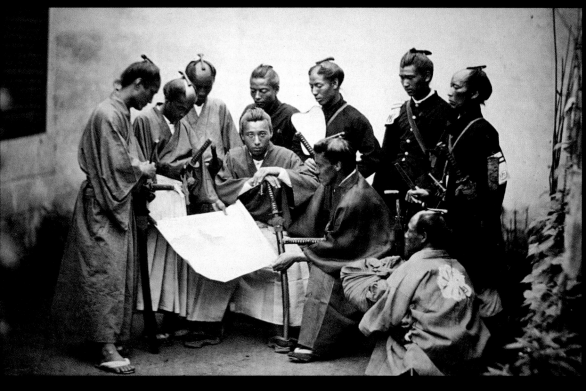

44. *(Above)* BEATO. Bridge at Iiyama, 1860s.*
45. *(Below)* BEATO. Samurai of the Satsuma clan, 1860s.*

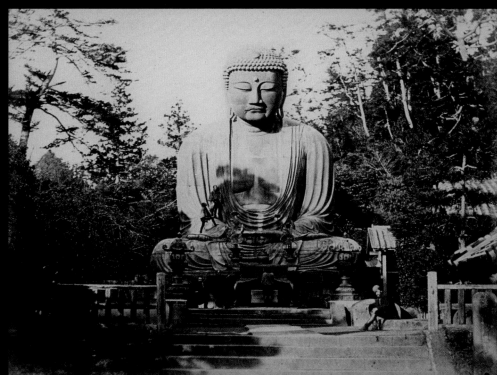

46. *(Above)* BEATO. The Wakamiya shrine, Kamakura, 1860s.*
47. *(Below)* BEATO. The *daibutsu*, or large Buddha, Kamakura, 1860s.*

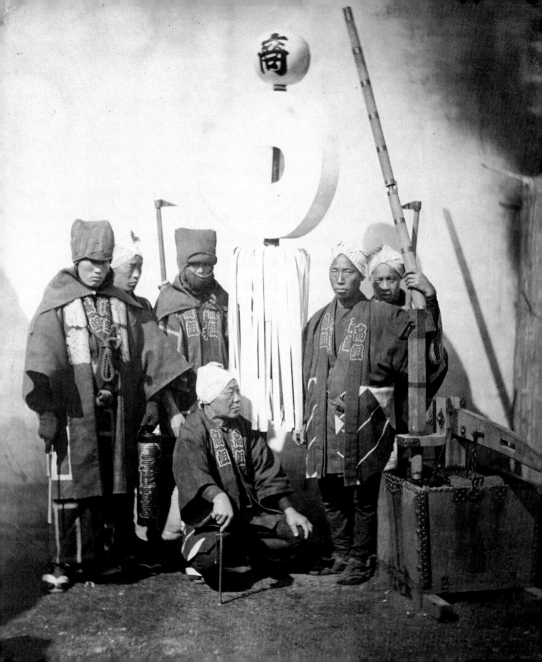

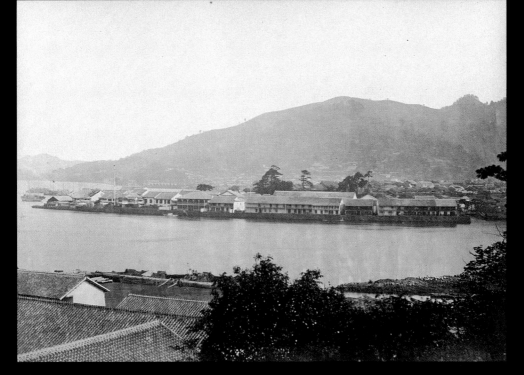

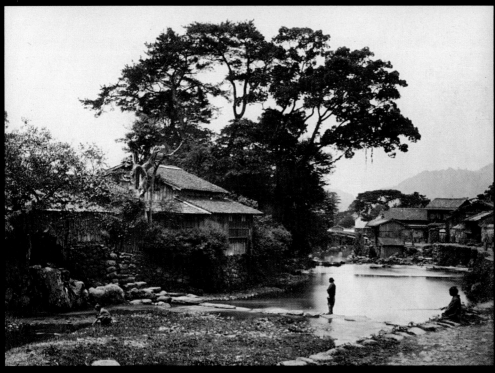

49. *(Above)* BEATO. **Deshima, Nagasaki, 1860s.**
50. *(Below)* BEATO. **Nagasaki, c.1867–68.***

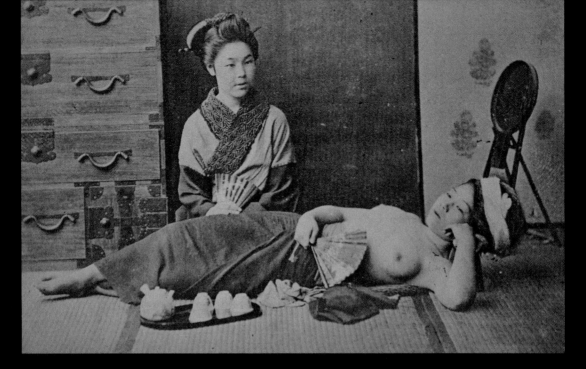

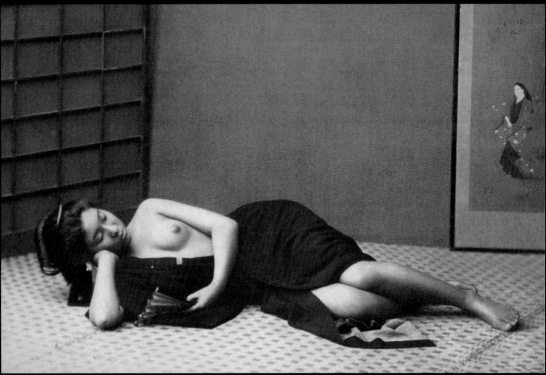

51. *(Above)* STILLFRIED. Teahouse women, c.1880.
52. *(Below)* STILLFRIED. Reclining nude, 1870s.*

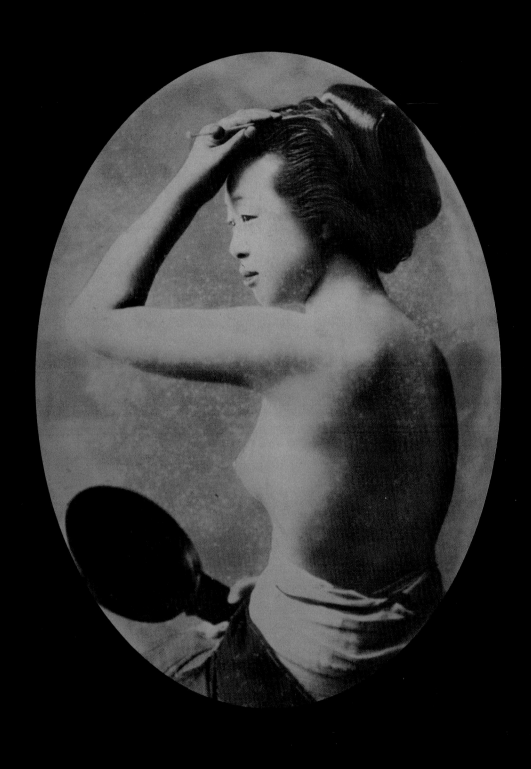

53. STILLFRIED. **Woman dressing, 1870s.**[*]

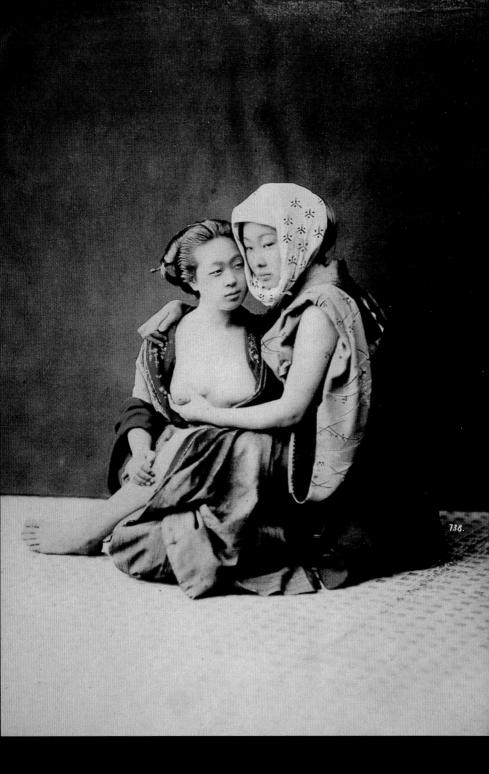

54. STILLFRIED. Two women embracing, c.1880.*

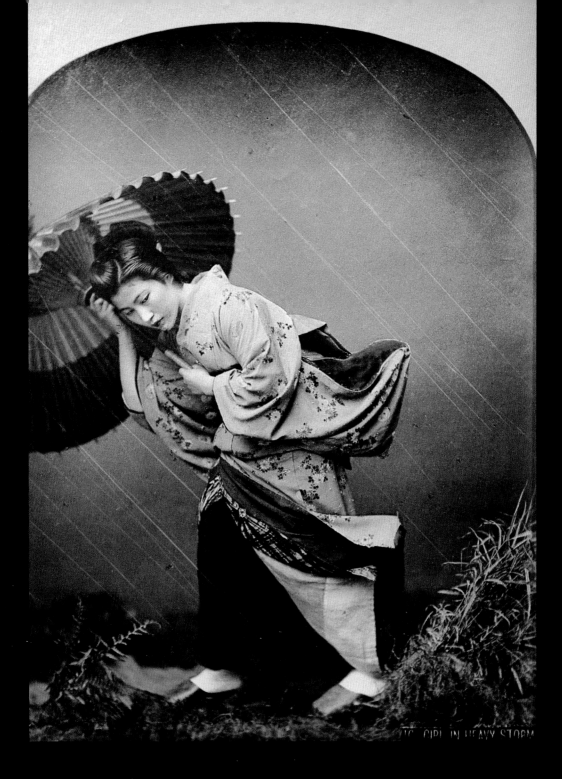

55. STILLFRIED?/KUSAKABE? Girl in heavy storm, c.1880.*

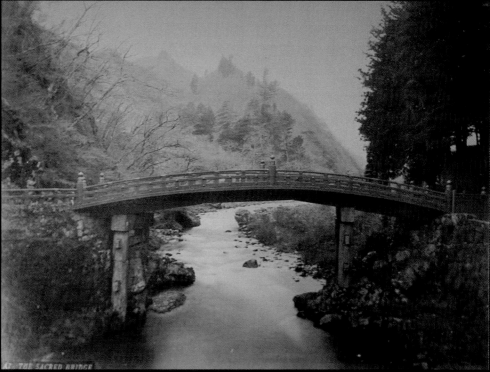

56. (*Above*) FARSARI. Tsurugaoka Hachiman Shrine, c.1890.*
57. (*Below*) FARSARI. Sacred bridge at Nikko, c.1890.*

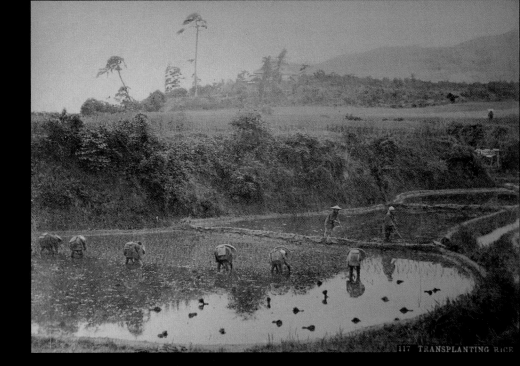

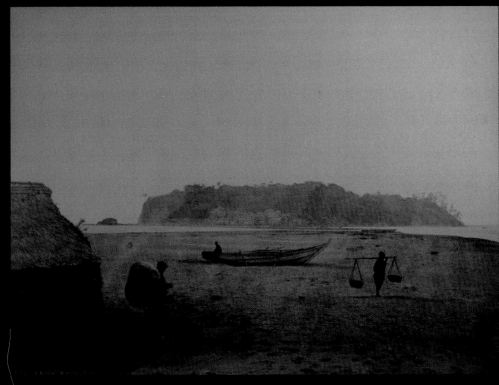

58. *(Above)* FARSARI. Transplanting rice, c.1890.
59. *(Below)* FARSARI. Enoshima, c.1890.*

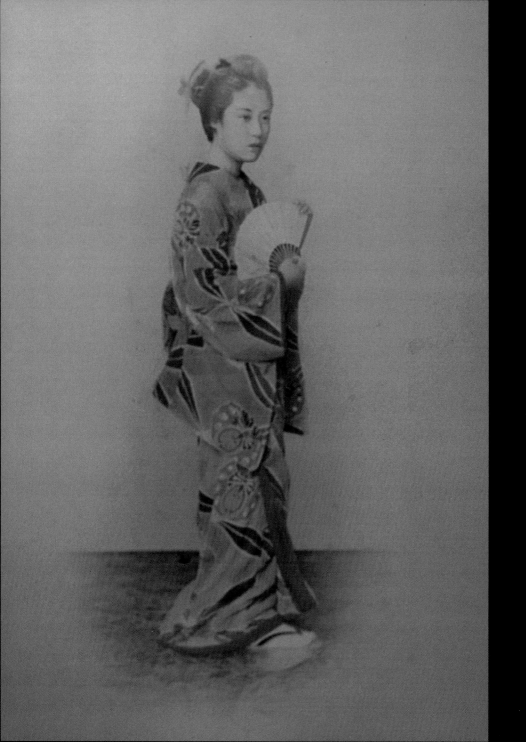

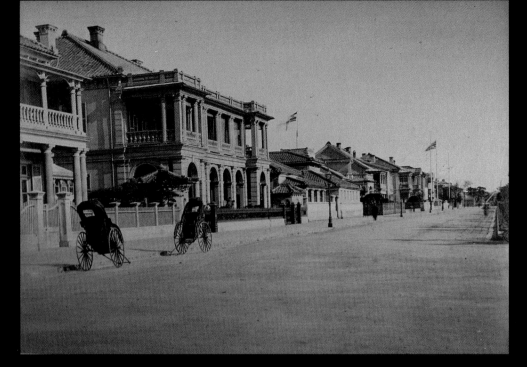

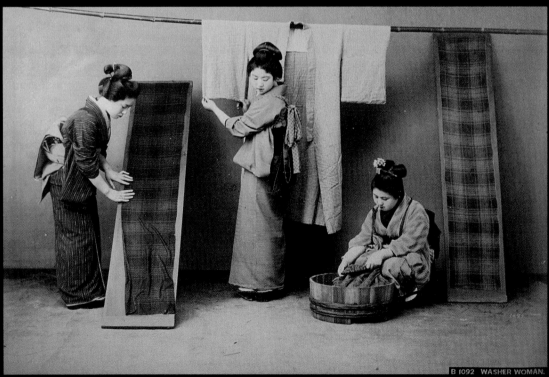

B 1092 WASHER WOMAN.

61. *(Above)* FARSARI. **The Bund, Kobe, 1890s.***
62. *(Below)* FARSARI. **Washerwomen, 1880s.***

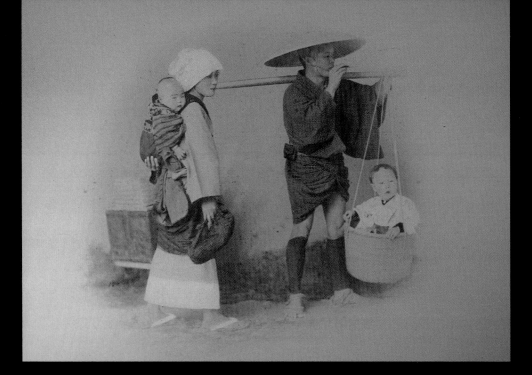

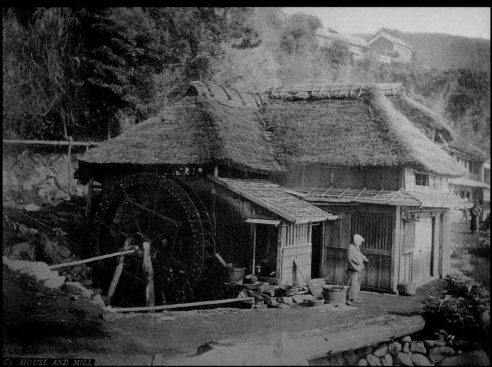

63. *(Above)* FARSARI. Traveling family, c.1890.
64. *(Below)* FARSARI. Country scene, c.1890.*

65. *(Above)* UENO. Main gate of the Suwa shrine, Nagasaki, 1870s.
66. *(Below)* UENO. Nagasaki river scene, c.1870.

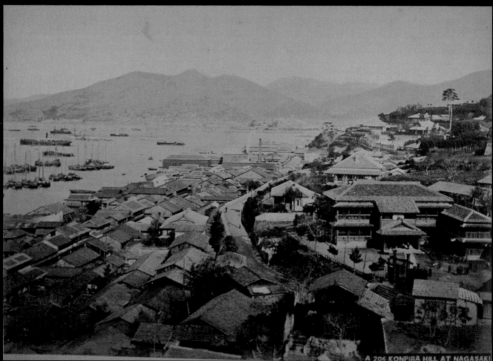

A 206 KONPIRA HILL AT NAGASAKI

67. *(Above)* UENO. Nagasaki, c.1880.*
68. *(Below)* UENO. Konpira Hill, Nagasaki, 1880s.

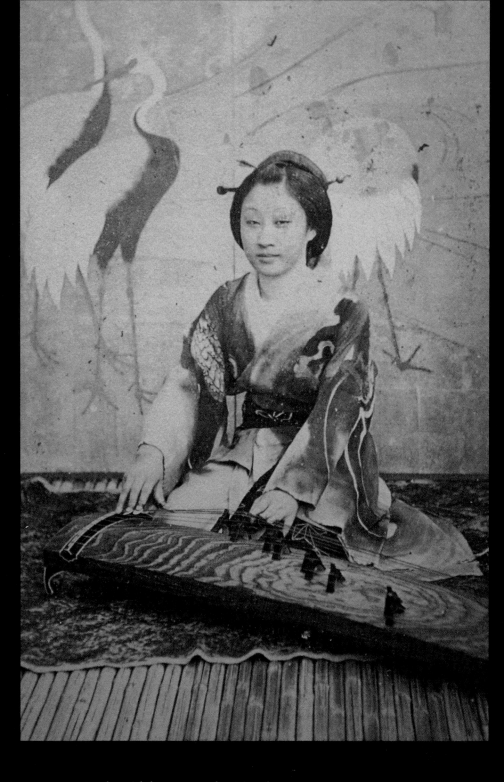

69. SHIMOOKA. Geisha with koto, carte-de-visite photograph, c.1870.

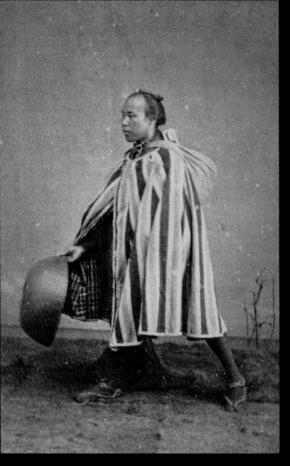

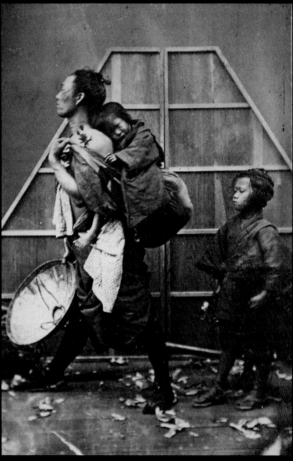

70. *(Above)* SHIMOOKA. Man in traveling clothes, carte-de-visite photograph, c.1870.
71. *(Below)* SHIMOOKA. Poor traveler and his children, carte-de-visite photograph, c.1870.

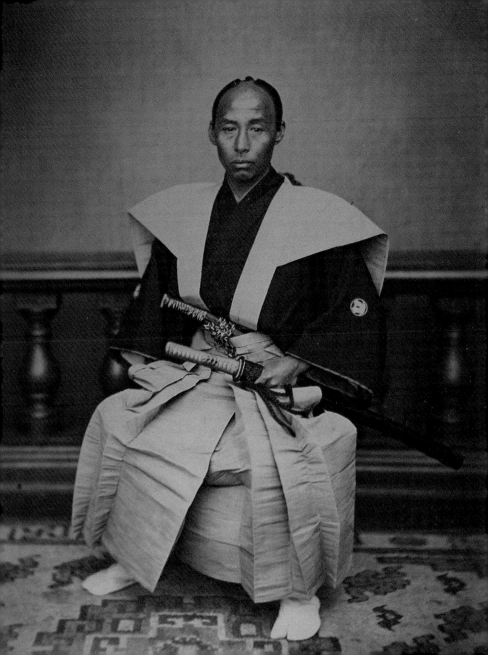

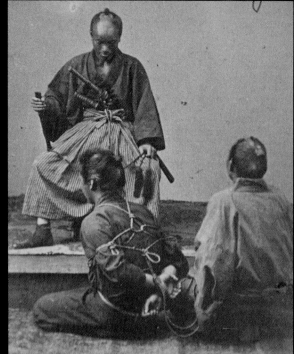

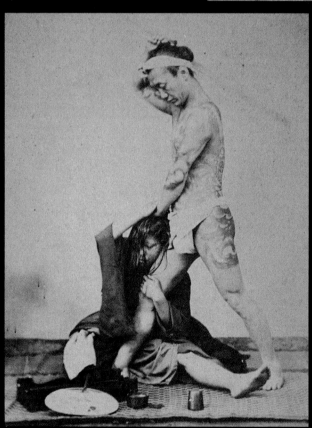

73. *(Above)* SHIMOOKA. Bound criminal before official, carte-de-visite photograph, c.1870.
74. *(Below)* SHIMOOKA. Tattooed man and victim, carte-de-visite photograph, c.1870.*

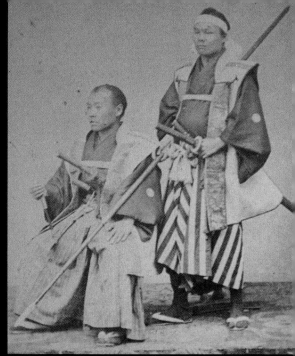

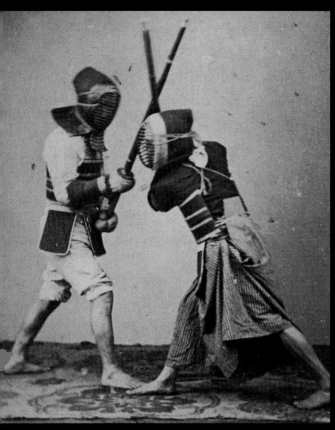

5. *(Above)* SHIMOOKA. Two samurai, carte-de-visite photograph, c.1870.
6. *(Below)* SHIMOOKA. Kendo match, carte-de-visite photograph, c.1870.

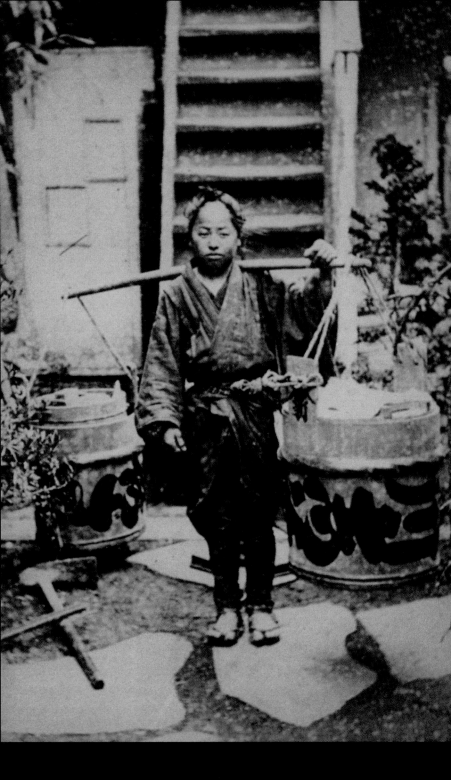

77. SHIMOOKA. Street peddler, carte-de-visite photograph, c.1870.

78. *(Above)* SHIMOOKA. Group with bonsai tree, carte-de-visite photograph, c.1870.
79. *(Below)* SHIMOOKA. Women with child and drum, carte-de-visite photograph, c.1870.

KAWA SAKI DAISHI

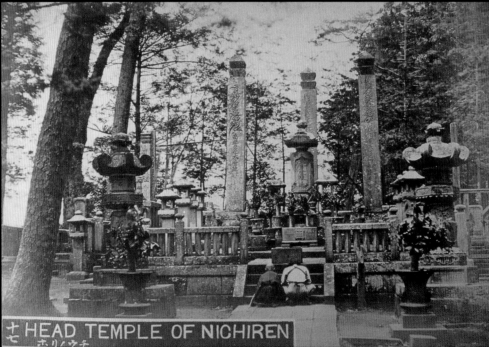

HEAD TEMPLE OF NICHIREN

80. *(Above)* SHIMOOKA. Kawasaki Daishi, c.1874.
81. *(Below)* SHIMOOKA. The Muonji temple, c.1874.*

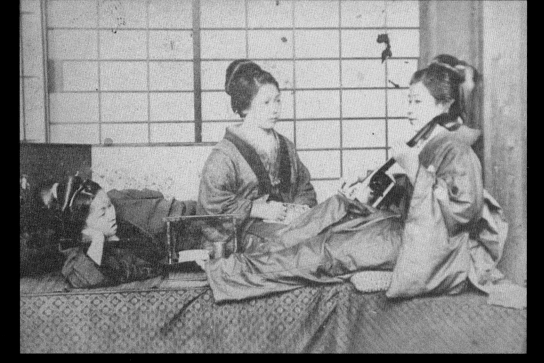

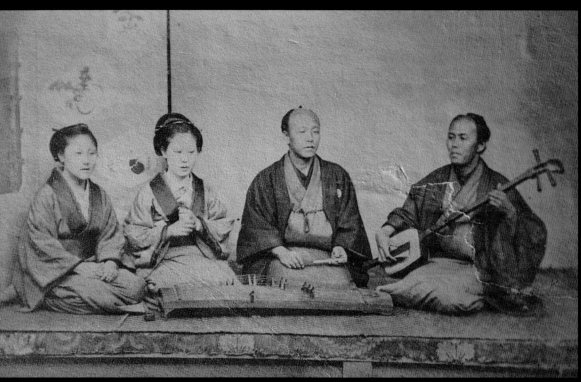

82. *(Above)* SHIMOOKA. Teahouse girls, carte-de-visite photograph, c.1870.*
83. *(Below)* SHIMOOKA. Musicians, carte-de-visite photograph, c.1870.

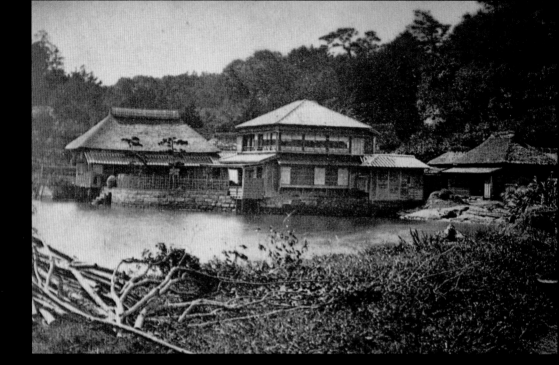

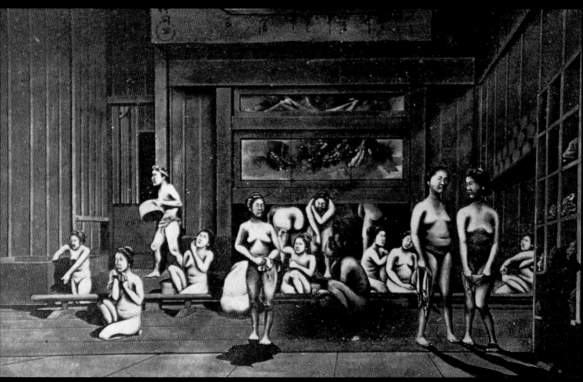

84. *(Above)* SHIMOOKA. Houses by river, carte-de-visite photograph, c.1870.
85. *(Below)* SHIMOOKA. Bathhouse, carte-de-visite photograph of an illustration, c.1870.*

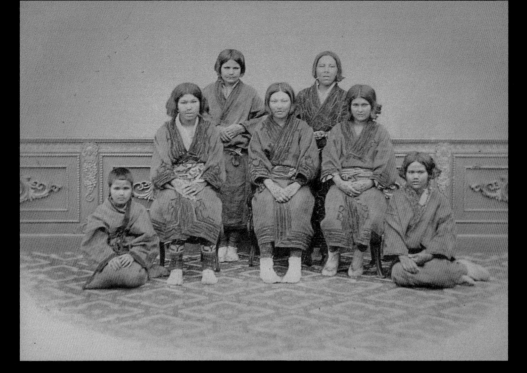

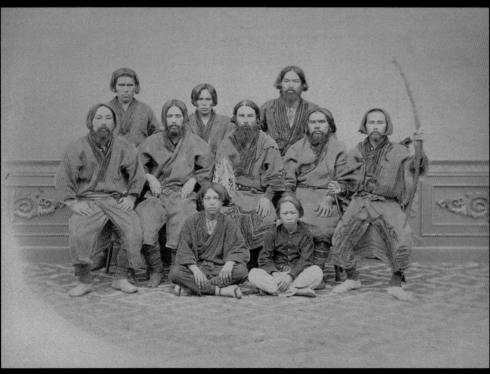

86. *(Above)* UCHIDA. Group of Ainu women, 1870s.
87. *(Below)* UCHIDA. Group of Ainu men, 1870s.*

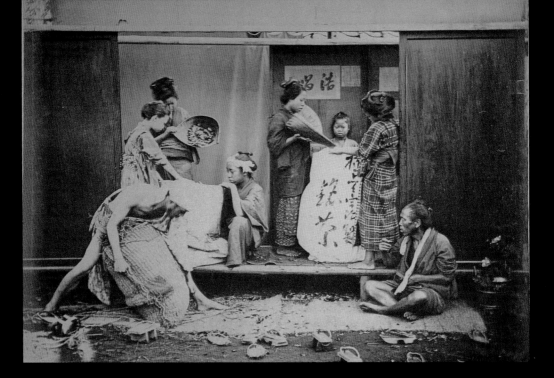

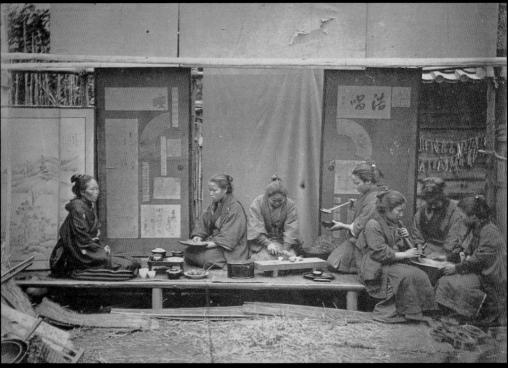

88. *(Above)* SUZUKI. Packing tea for export, 1870s.*
89. *(Below)* SUZUKI. Eating rice, 1870s.*

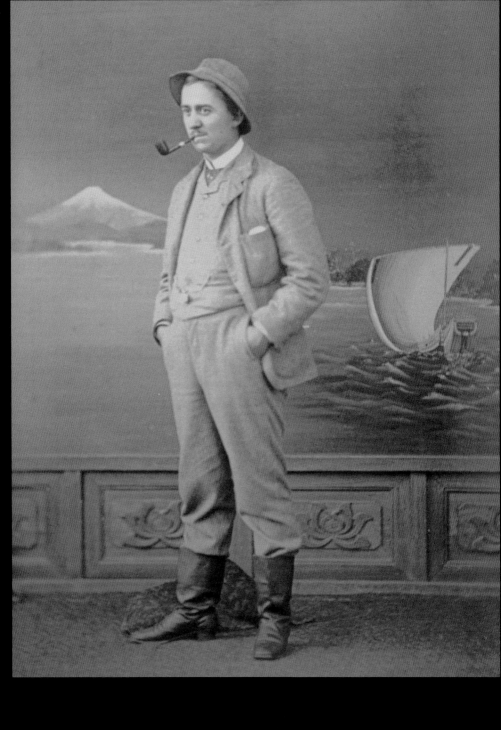

90. SUZUKI. Unidentified Westerner, cabinet card, c.1880.*

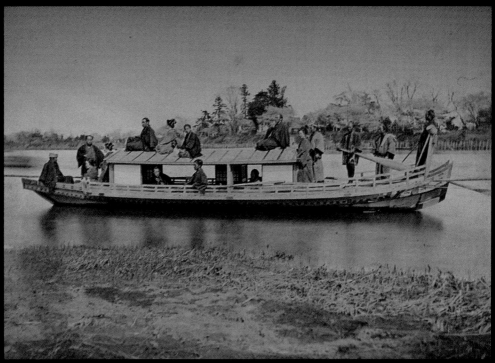

91. *(Above)* USUI. Ueno Park, c.1880.*
92. *(Below)* USUI. Pleasure boat on the Sumida River, Tokyo, c.1880.

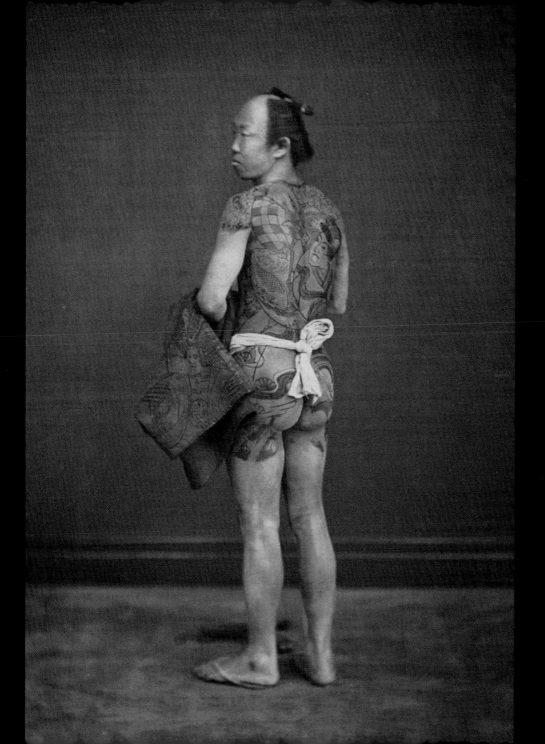

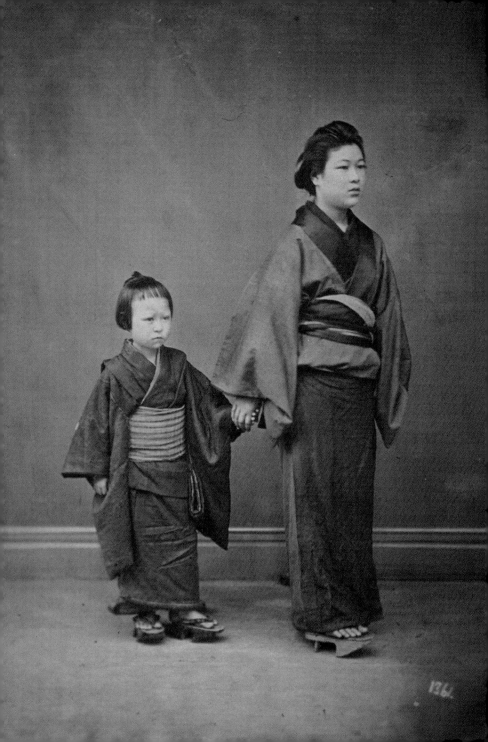

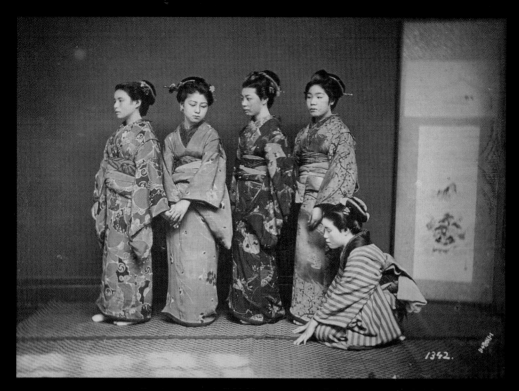

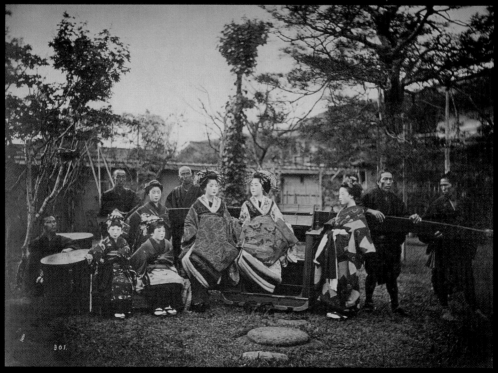

95. *(Above)* USUI. Geisha, c.1880.
96. *(Below)* USUI. *Oiran*, or high-class courtesans, and attendants, c.1880.*

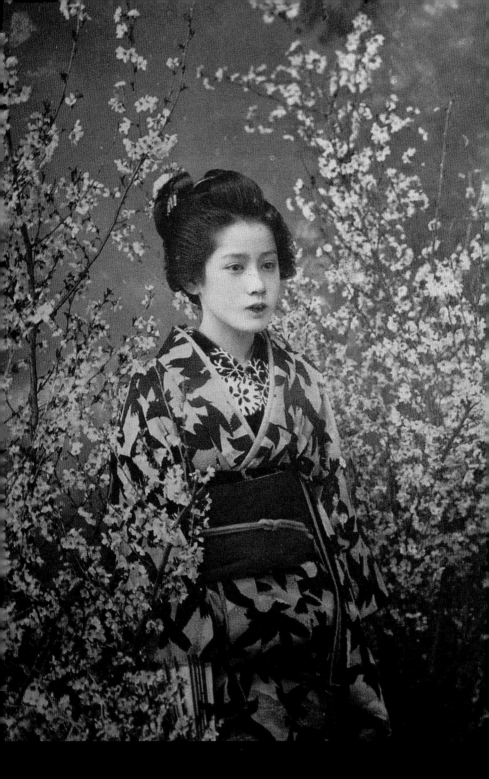

7. OGAWA. **Japanese beauty with cherry blossoms, c.1890.**⁎

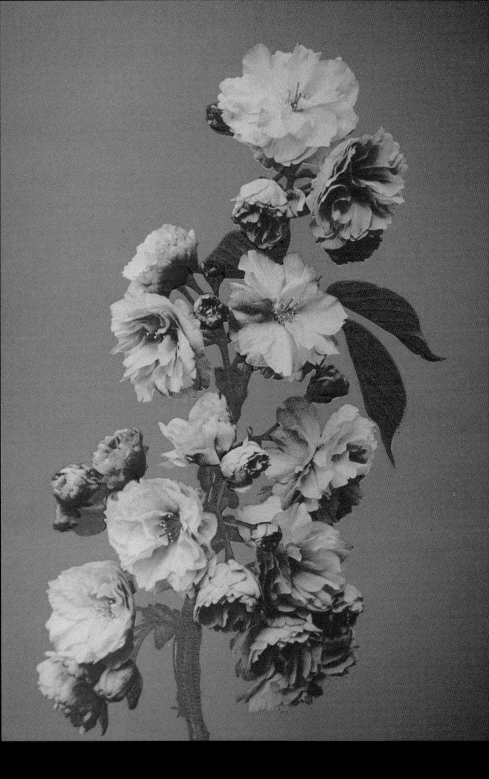

98. OGAWA. Japanese flower study, 1890s.*

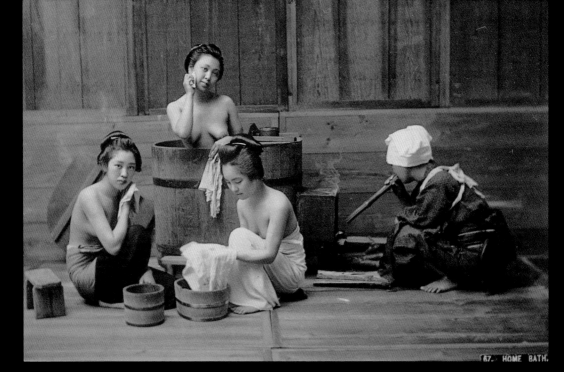

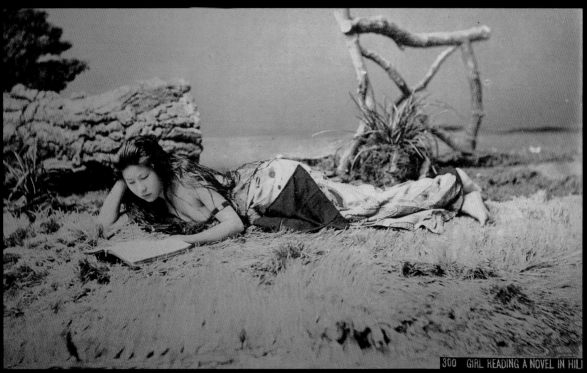

99. *(Above)* KUSAKABE. **Home bathing, 1890s.***
100. *(Below)* KUSAKABE. **Girl reading a novel, c.1890.**

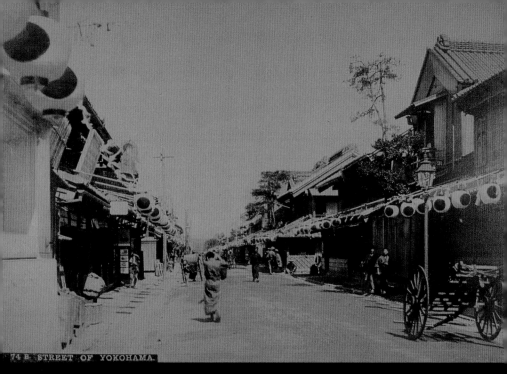

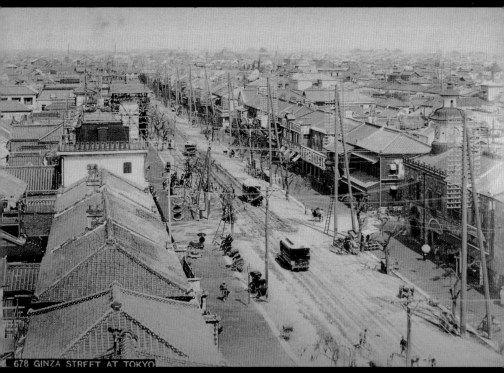

01. *(Above)* TAMAMURA. Yokohama street, 1890s.
02. *(Below)* TAMAMURA. Ginza Street in Tokyo, 1890s.*

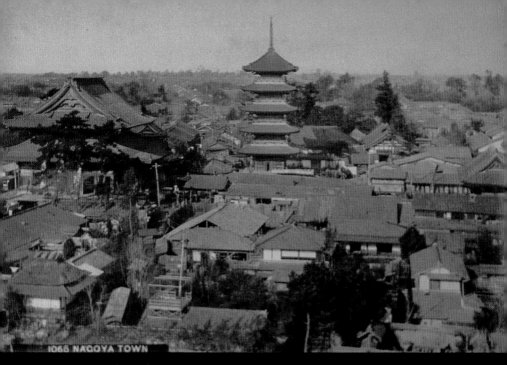

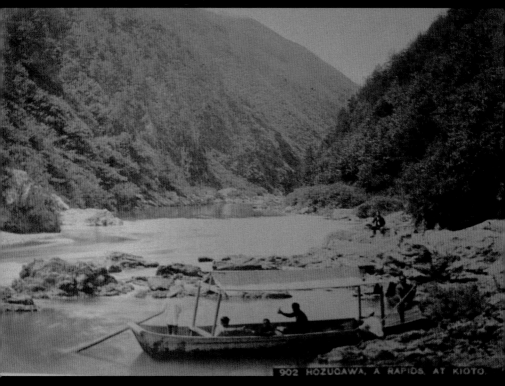

103. *(Above)* TAMAMURA. Nagoya, c.1890.
104. *(Below)* TAMAMURA. Hozugawa Rapids, Kyoto, c.1890.

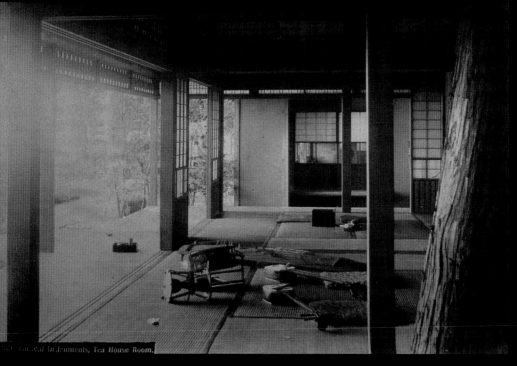

Tu..eai In.truments, Tea House Room.

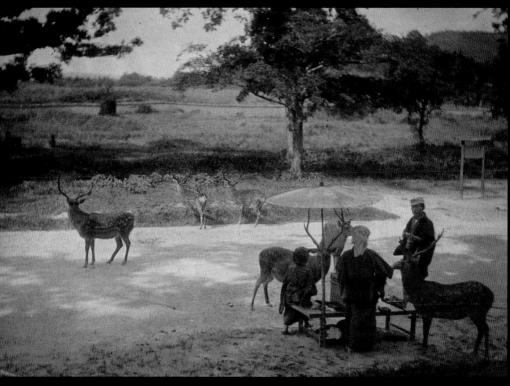

105. (*Above*) ISAWA. Musical instruments, teahouse room, 1890s.*
106. (*Below*) Photographer of the Shin-E-Do studio. Deer at Nara Park, c.1890.

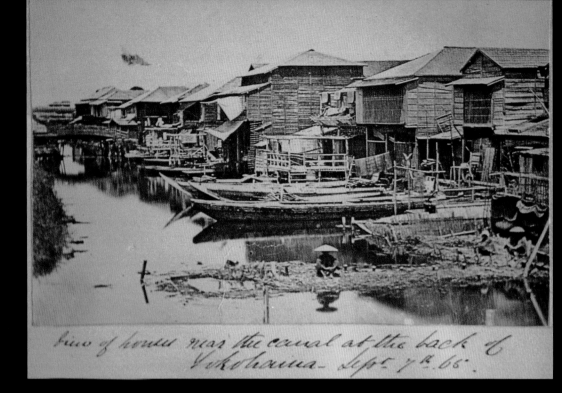

View of houses near the canal at the back of Yokohama. Sept 7th 65.

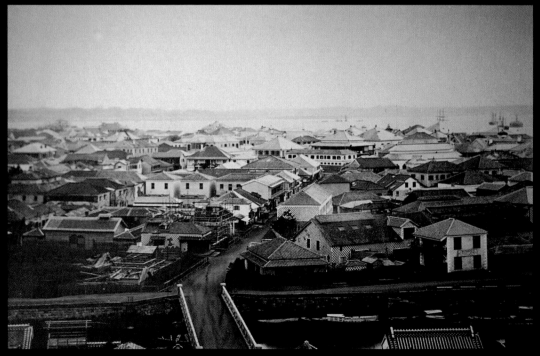

107. *(Above)* BEATO. "Native town," Yokohama, 1865.*
108. *(Below)* Unknown photographer. Yokohama, 1860s.

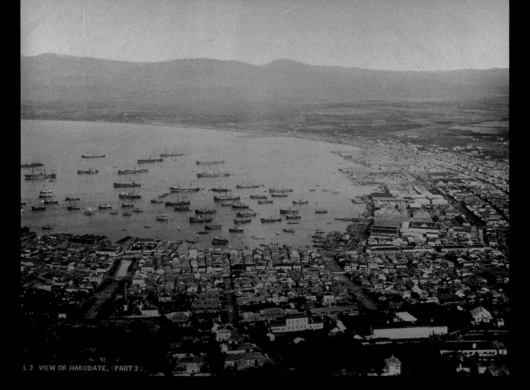

L 2 VIEW OF HAKODATE, (PART 2)

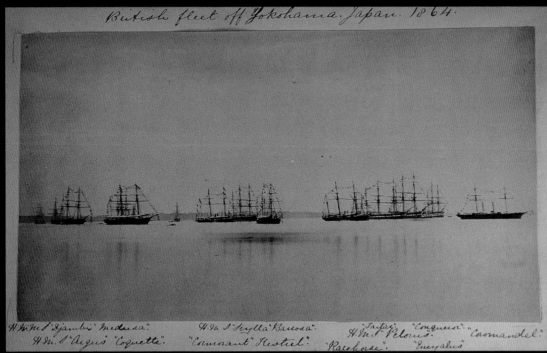

British fleet off Yokohama. Japan. 1864.

H.M.S.'Djambi' 'Medusa'. H.M.S.'Scylla' 'Barosa'. 'Tartar' 'Conqueror'.
 H.M.S.'Argus' 'Coquette'. 'Cormorant' 'Kestrel'. H.M.S.'Pelorus'. 'Coromandel'.
 'Racehorse'. 'Euryalus'.

109. *(Above)* Unknown photographer. Hakodate, 1880s.*
110. *(Below)* Unknown photographer. British fleet off Yokohama, 1864.*

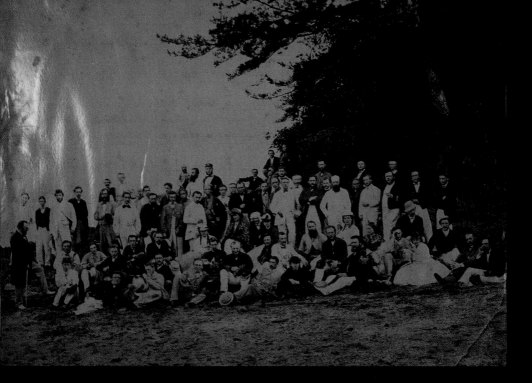

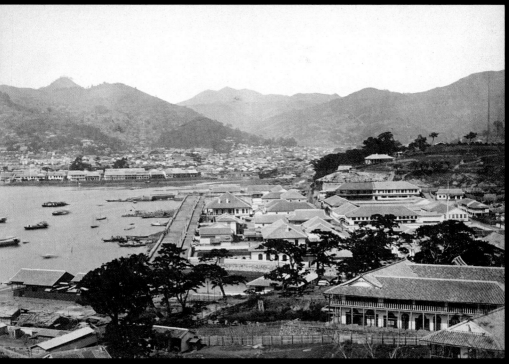

111. *(Above)* BEATO. Picnic party on Rat Island, 1865.*
112. *(Below)* BEATO. Nagasaki, with Deshima in the background, 1860s.*

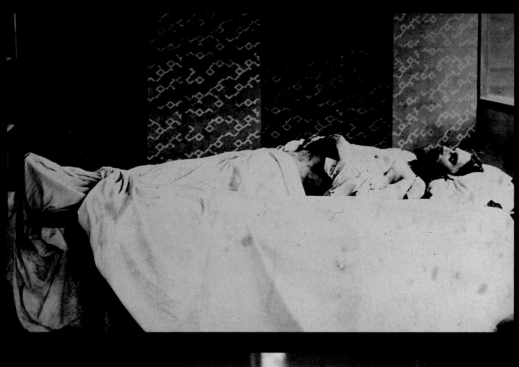

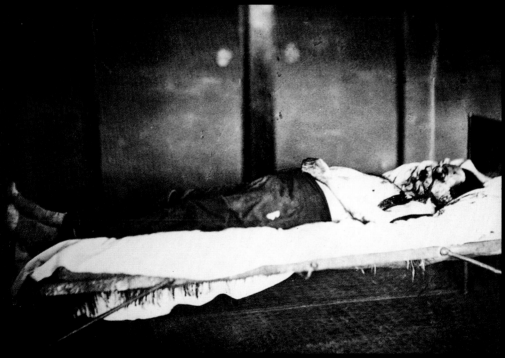

113. *(Above)* Unknown photographer. Body of Charles Richardson, 1862.*
114. *(Below)* Unknown photographer. Body of Lieutenant Camus, 1863.*

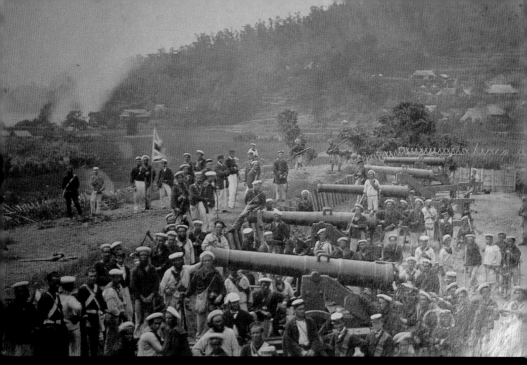

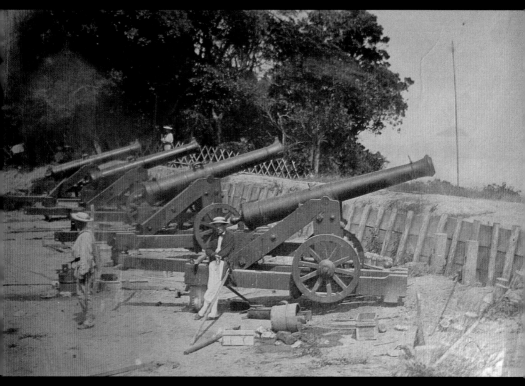

115. *(Above)* BEATO. Capture of the Choshu battery at Shimonoseki, 1864.*
116. *(Below)* BEATO. Guns captured by the French at Shimonoseki, 1864.

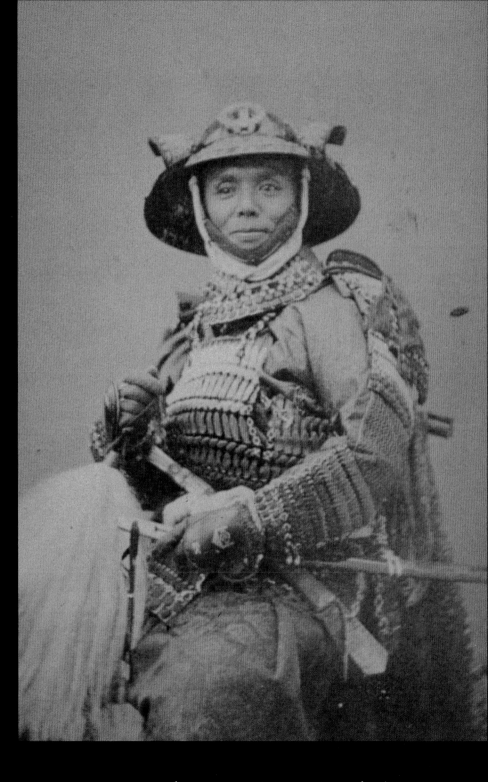

117. GASPARD FÉLIX TOURNACHON (known as NADAR). Kawazu Izu-no-kami, 1864.*

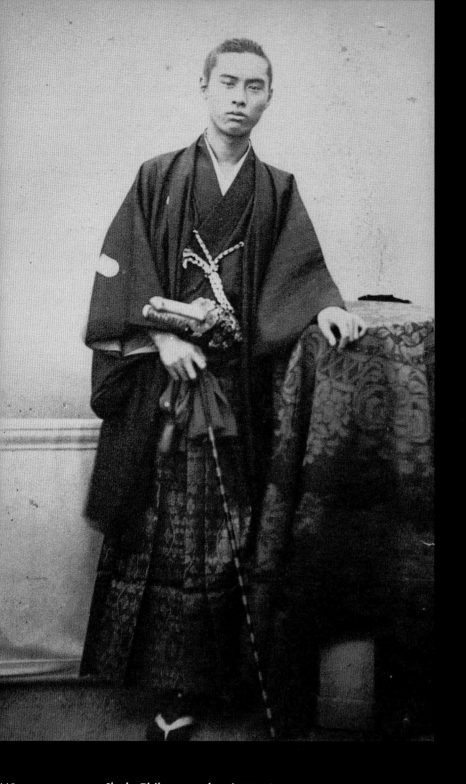

118. ANTONIO BEATO. Ikeda Chikugo-no-kami, 1864.*

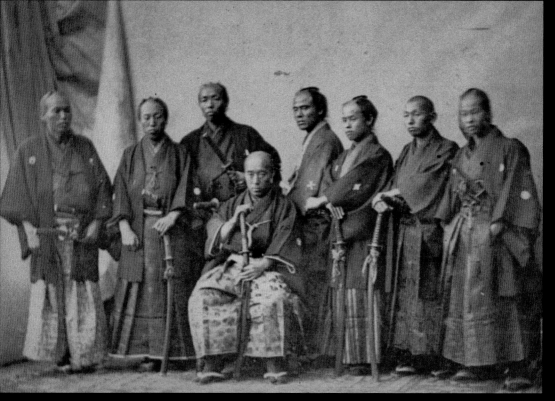

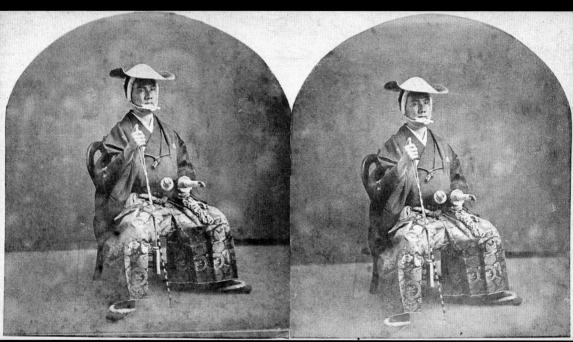

119. *(Above)* GASPARD FÉLIX TOURNACHON (known as NADAR). Shogunal mission in Paris, 1862.*
120. *(Below)* Unknown photographer. Member of the shogunal mission to the U.S., 1860.

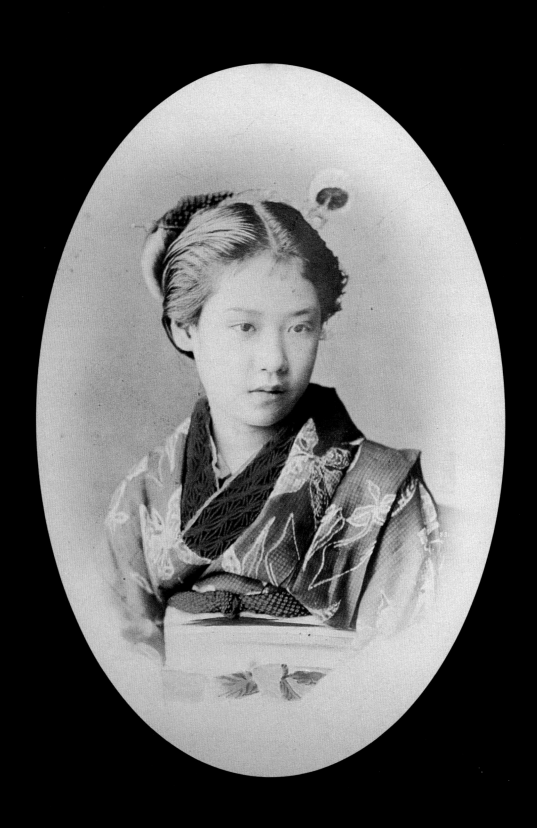

121. Unknown photographer. Officer's daughter, 1880s.*

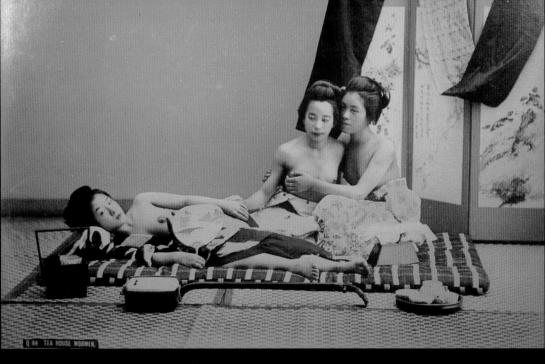

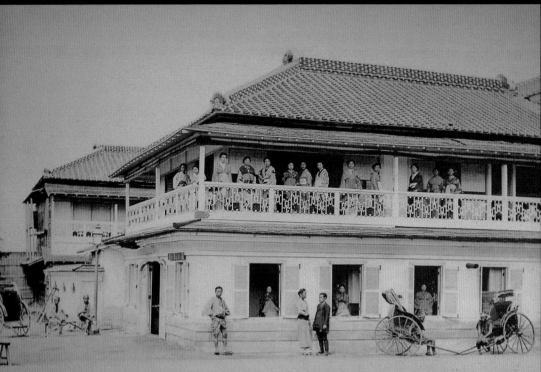

122. *(Above)* Unknown photographer. Teahouse women, c.1890.*
123. *(Below)* BEATO. Women of the Yoshiwara, 1860s.*

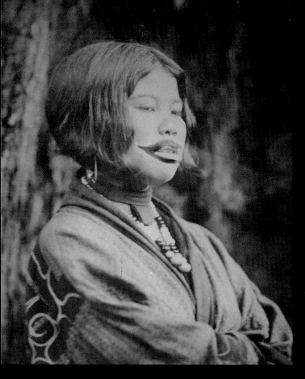

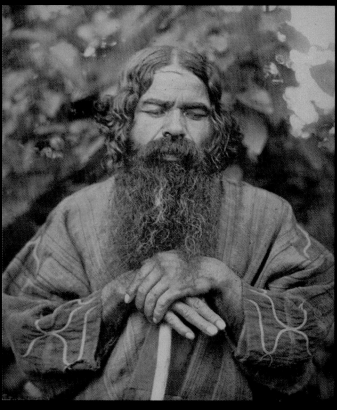

124. *(Above)* Unknown photographer. Ainu woman, c.1890.*
125. *(Below)* Unknown photographer. Ainu man, c.1890.*

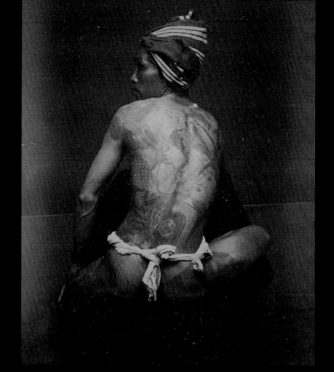

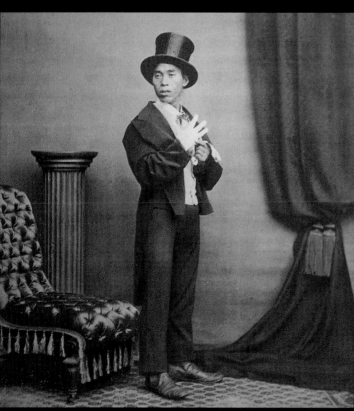

126. *(Above)* Unknown photographer. *Bettō*, or groom, tattooed, 1880s.*
127. *(Below)* STILLFRIED. Japanese in Western clothes, 1870s.*

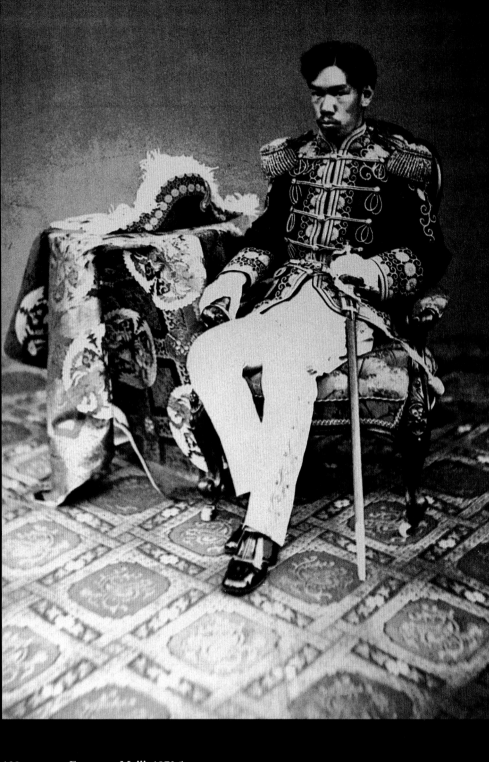

128. UCHIDA. Emperor Meiji, 1873.*

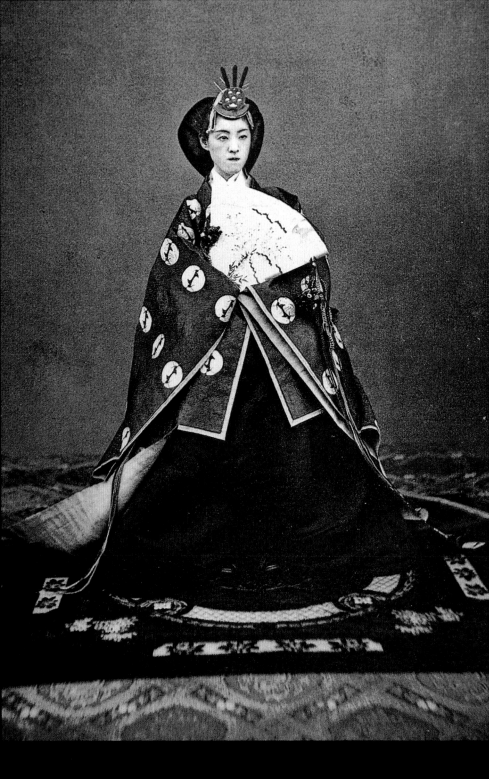

129. UCHIDA. Empress Meiji, 1872.*

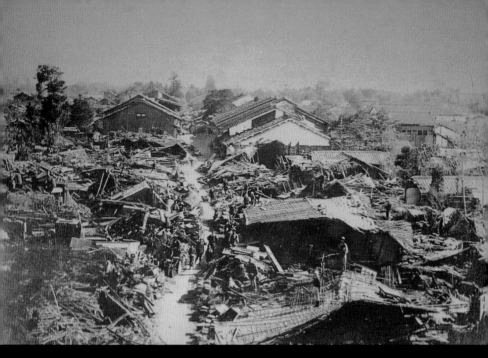

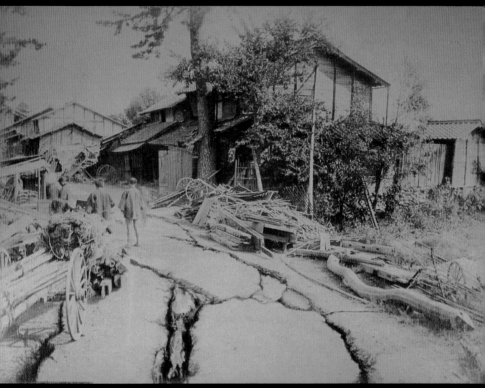

30. *(Above)* Unknown photographer. Kitagatamachi after the Gifu earthquake, 1891.
31. *(Below)* Unknown photographer. Wakanoori village after the Gifu earthquake, 1891.

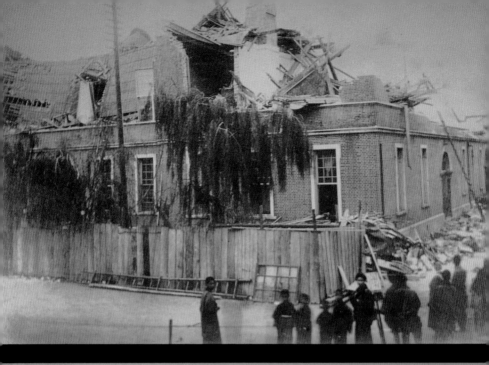

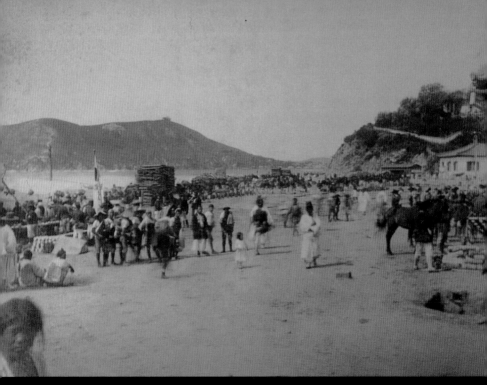

32. *(Above)* Unknown photographer. Nagoya post office after the Gifu earthquake, 1891.
33. *(Below)* J. A. VAUGHAN. Japanese troops landing at Chemulpo, Korea, 1894.*

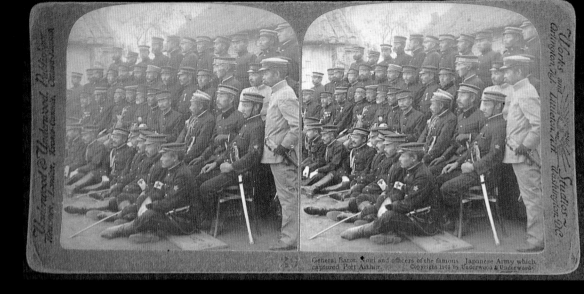

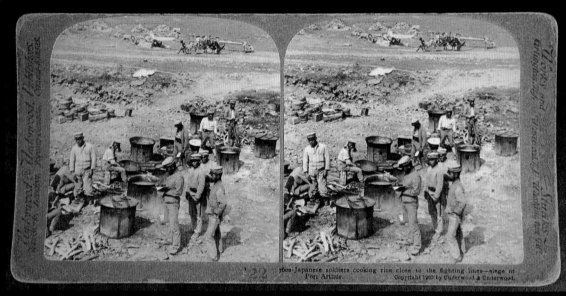

134. *(Above)* Unknown photographer. General Baron Nogi and officers, stereograph, 1905.*
135. *(Below)* Unknown photographer. Japanese soldiers cooking rice, stereograph, 1905.*

Notes on Selected Images

2. *(p. 6)* Typical lacquered album, late 1890s. Usually containing fifty original, handcolored photographs, such albums were produced very much with the tourist market in mind.

3. *(p. 12)* SHIMOOKA. Edo Castle, c.1874. Until the Meiji Restoration, Edo Castle was the headquarters of the shogunate. After the transfer of the emperor's residence from Kyoto to Tokyo in 1869, the area enclosed by the inner defenses of the castle became the Imperial Palace.

4–6. *(p. 14)* CALDESI AND COMPANY. Members of the first shogunal mission to Europe in London, 1862. A shogunal mission to Europe in 1862 under Takenouchi Yasunori, governor of Shimotsuke (present-day Tochigi Prefecture), attempted unsuccessfully to negotiate postponement of the opening of Japanese ports until 1868. Of particular interest here is the portrait on the lower left of Kawasaki Tomin, medical officer to the mission and an early student of photography. Several recently discovered portraits of samurai of the Saga clan have been ascribed to him.

7. *(p. 14, lower right)* GASPARD FÉLIX TOURNACHON (known as NADAR). Ikeda Chikugo-no-kami, 1864. In 1863 Ikeda Nagaoki, governor of Chikugo Province (now the southern part of Fukuoka Prefecture), was appointed head of a mission that was given the impossible task of securing French agreement to the closure of Yokohama to foreign trade. The negotiations went badly for Ikeda, and on the mission's return to Japan, he and his assistant, Kawazu Sukekuni, were dismissed and placed under house arrest. Although pardoned in 1867, Ikeda chose to spend the rest of his life in self-imposed seclusion. After his death, among his personal effects was found one of Nadar's portraits with a poem on the reverse lamenting his fate.

8. *(p. 27)* USUI. Shoemaker, c.1880. The man made or repaired *geta,* wooden shoes that are still worn outdoors today.

9. *(p. 28)* BEATO. Street vendor, 1860s. The man sold *amazake,* a sweet drink made from fermented rice.

10. *(p. 30)* Unknown photographer. Shimooka Renjo in later life, c.1900s. The elderly Shimooka is dressed almost like a Buddhist pilgrim. In his right hand he carries the lotus-wood staff from which he took his name. Renjo is written with the Chinese characters for lotus and stick.

13. *(p. 65, above)* ELIPHALET BROWN, JR. Japanese woman, lithograph, 1856. This lithograph was copied from one of the daguerreotypes taken by Brown in 1854 and published in the official report of Perry's mission, *Narrative of the Expedition of an American Squadron to the China Seas and Japan . . .* The original daguerreotype, along with several hundred others taken by Brown, was supposedly lost in a fire at the printing plant in Philadelphia.

14. *(p. 65, below)* ICHIKI SHIRO. Shimazu Nariakira, daguerreotype, 1857. This daguerreotype,

discovered in 1975 in the Shimazu family archives in Kagoshima, is the oldest surviving portrait taken by a Japanese. Shimazu family records note that on September 17, 1857, during fine weather, three plates were taken of Lord Shimazu (1809–58).

15. (*p. 66, above*) BEATO. Island of Deshima, 1865. Deshima was an artificial island completed in Nagasaki Bay in 1636 to house foreign traders in one location. A few years later, all foreigners, except the Dutch and Chinese, were expelled from Japan. In 1641 the Dutch were ordered to reside in Deshima, where they remained until Japan began to open again to foreigners after the Kanagawa Treaty was signed with the United States in 1854. Deshima is said to owe its distinctive shape to the whim of the shogun, who, when asked what shape the island should take, spread out his fan in reply. Researchers at Nagasaki University claim that the handwritten inscription on the photo is Beato's.

16. (*p. 66, below*) Unknown photographer. Dutch officials at Deshima, c.1862–63. This exceptionally rare photograph shows the interior of the Dutch settlement. With its lavish quarters for Japanese officials and Dutch merchants, games rooms (which featured a billiard table), and two large warehouses, Deshima was an expensive foothold for the Dutch government to maintain. By the nineteenth century, trade with Japan did not provide enough profits to support the maintenance of Deshima, and the settlement was retained purely for political reasons.

17–22. (*p. 67–68*) These six stereographs first appeared in T. C. Westfield's *The Japanese: Their Manners and Customs* in 1860–61.

20. (*p. 68, above*) Unknown photographer. Port of Kanagawa, stereograph, 1860–61. From Westfield's *The Japanese: Their Manners and Customs*. This is the earliest known photo of Kanagawa.

21. (*p. 68, center*) Unknown photographer. American legation in Edo, stereograph, 1860–61. From Westfield's *The Japanese: Their Manners and Customs*. Erroneously identified as the Emperor's temple, this structure is actually Zenpukuji, which temporarily housed the American legation in Edo. Unlike his European colleagues, the United States envoy expressed faith in assurances by the shogunate that the foreign representatives and their legations would be safe from attack, and in this photograph no defensive arrangements are apparent. Following the assassination in January 1861 of the legation secretary, however, sentry boxes were built along the approach to the temple.

23–24. (*p. 69–70*) These two carte-de-visite photographs are attributed to Parker because they employ the same studio carpet and backdrop as those of image 25 (Worswick collection).

25. (*p. 70, right*) PARKER. Woman with umbrella, carte-de-visite photograph, 1863–68. The photographer's studio imprint on the reverse of this carte-de-visite portrait makes this the only photograph known to the author that can be attributed with certainty to Charles Parker. This image comes from the Worswick collection, which is probably the best collection of photographs from the *bakumatsu,* or last days of the Tokugawa shogunate.

26–28. (*p. 71*) These three stereographs taken by Burger in 1869 are from the Rob Oechsle colletion.

29–32. (*p. 72–73*) These four photographs originally appeared in the *Far East* during the 1870s.

31. (*p. 73, above*) Unknown photographer. Itinerant Japanese cobblers, 1870s. From the *Far East*. Traditional footwear, made mainly of straw and easy to repair or replace, was worn by most Japanese until the end of the nineteenth century. Here one cobbler, apparently unaccustomed to Western-style footwear, stares in bafflement at a leather shoe that was probably provided by the photographer.

33. (*p. 74, above*) BEATO. Namamugi, on the Tokaido, 1860s. The Tokaido, literally the eastern sea

road, was the main highway connecting Edo and the imperial capital at Kyoto. Processions of daimyo regularly passed up and down the Tokaido on their way to and from the Tokugawa court. In 1862 Namamugi, a village on the Tokaido between Kanagawa and Kawasaki, was the site of an unfortunate encounter between the entourage of the imperial envoy and a party of British sightseers, which resulted in the murder of one of the latter, Charles Richardson, and precipitated the so-called Anglo-Satsuma War.

34. *(p. 74, below)* BEATO. The prince of Satsuma and his principal officers, c.1866. Shown is Shimazu Tadayoshi, nephew of Nariakira, whose portrait appears on page 65. This image may also include Saigo Takamori, who died at the head of the Satsuma Rebellion in 1877 and remains one of the heroes of the Meiji era. Saigo is thought to have disliked all things Western, including photography, and no photographic likeness of him is known for certain to exist.

35. *(p. 75)* BEATO. Warrior in armor, 1860s. Dressed in full armor virtually unchanged since the beginning of the Edo period, this samurai commander strikingly exemplifies the old warrior caste that was to disappear as Japan's armed forces were reorganized along Western lines.

36. *(p. 76)* BEATO. *Bettō,* or groom, tattooed, 1860s. By the end of the Edo period, tattooing had reached a level of artistic sophistication unknown in the West. The practice was popular among those whose trades required them to display their bodies, in particular porters, palanquin bearers, and grooms, and among groups with a strong sense of identity, such as firemen and gangsters. Attempts by the Meiji government to ban tattooing as a sign of "backwardness" proved unsuccessful, not least in the face of Western admiration. Sporting traditional topknots, these grooms display their tattoos for posterity.

39. *(p. 78)* BEATO. Girl playing the samisen, 1860s. This carefully posed portrait features, besides the samisen, a teapot, hibachi, and umbrella, props that appear in other Beato studio photos.

40. *(p. 79, above)* BEATO. Lord Shimazu's quarters, Edo, 1860s. Obliged to attend the shogun's court at regular intervals, the Satsuma daimyo maintained a clan residence in Edo. The original structure was burned down in 1861 by Satsuma retainers to provide their lord with a pretext for absenting himself from Edo. In an attempt to secure his return, the shogunate subsidized its reconstruction, but in 1868 the residence was destroyed again, this time for good, by supporters of the shogun. The site on which the structure stood is not far from the present-day Shinagawa Station.

41. *(p. 79, below)* BEATO. Lord Arima's quarters, Edo, 1860s. In addition to providing the shogunate with hostages in Edo, the alternate-attendance system was intended to encourage daimyo to divert their funds into the maintenance of quarters in the capital. Clan prestige often assisted in the shogunate's plan, as lords vied with one another in building the most imposing residence in the city. Shown here, near present-day Shiba Park, are two such estates. Partly visible on the left is the residence of the Arima family, daimyo of Kurume, and on the right that of the Kuroda family, lords of the neighboring Akizuki domain.

44. *(p. 82, above)* BEATO. Bridge at Iiyama, 1860s. Iiyama, a village near Atsugi in present-day Kanagawa Prefecture, and the surrounding countryside were famous for the cultivation of mulberry trees for sericulture.

45. *(p. 82, below)* BEATO. Samurai of the Satsuma clan, 1860s. This carefully posed photograph neatly shows the transition from traditional military dress to Western-style uniforms that occurred among samurai. The topknot and the distinctive two swords worn at the waist, however, remain.

46. *(p. 83, above)* BEATO. The Wakamiya shrine, Kamakura, 1860s. As in Beato's view of the *daibutsu,* or large Buddha, at Kamakura, this image pictures a small group of foreigners on the left that may include both the photographer himself and the artist Charles Wirgman.

47. (*p. 83, below*) BEATO. The *daibutsu,* or large Buddha, Kamakura, 1860s. Constructed in the middle of the thirteenth century, this 11.4-meter (37.4-foot) bronze statue of the Buddha Amida at the Kotokuin temple remains the most outstanding feature of the city of Kamakura. The two foreigners seated in front of the *daibutsu* might be Beato on the left and his friend Charles Wirgman, the English artist, on the right. The author once saw an inscription on an image that read B and W.

48. (*p. 84*) BEATO. Firemen, 1860s. Fulfilling an essential function in the fire-prone cities of Edo-period Japan, firemen enjoyed a correspondingly high status among townsfolk, which was reflected, among other things, in distinctive uniforms such as these.

50. (*p. 85, below*) BEATO. Nagasaki, c.1867–68. This scene shows the Nakashima River running through Nagasaki.

52. (*p. 86, below*) STILLFRIED. Reclining nude, 1870s. IN 1887 a Tokyo newspaper reported with indignation that a certain foreign photographer in Yokohama was offering large sums of money to local women to let him photograph "their uncovered bodies" and was sending his handiwork abroad. Similar activities by Stillfried over a decade earlier seem to have gone unnoticed, a reflection perhaps of how Victorian attitudes toward nudity had not yet gained ground in Japan.

53. (*p. 87*) STILLFRIED. Woman dressing, 1870s. The effusive, handwritten caption, "The fairest sight in Japan are Japan's fair daughters," was added by the original owner of this nude study.

54. (*p. 88*) STILLFRIED. Two women embracing, c.1880. The affected eroticism of this study doubtless appealed to the foreign buyer.

55. (*p. 89*) STILLFRIED?/KUSAKABE? Girl in heavy storm, c.1880. The photo is an extremely impressive studio composition. Wires were inserted into the clothing to simulate the effect of wind, while scratches made on the negative gave the effect of rain. The image is usually attributed to Stillfried, but the setting looks suspiciously like that seen in many Kusakabe studio prints.

56. (*p. 90, above*) FARSARI. Tsurugaoka Hachiman Shrine, c.1890. Dedicated to the Shinto diety who protects warriors and maintains the well-being of the community, Tsurugaoka Hachiman Shrine was established in Kamakura in 1180.

57. (*p. 90, below*) FARSARI. Sacred bridge at Nikko, c.1890. The *shinkyō,* or sacred bridge, was originally crossed by visitors to the Toshogu shrine in Nikko. Although the bridge is now used only for certain festivals, it remains one of Nikko's most popular tourist attractions.

59. (*p. 91, below*) FARSARI. Enoshima, c.1890. The island of Enoshima, in Sagami Bay near Kamakura, is dedicated to the Buddhist goddess Benten, who, according to a local legend, made the island rise from the sea in the sixth century.

61. (*p. 93, above*) FARSARI. The Bund, Kobe, 1890s. With the British and German consulates visible in the background, the Westernization of the city is very much apparent. Only the presence of rickshaws serves as a reminder that the photograph was taken in Japan.

62. (*p. 93, below*) FARSARI. Washerwomen, 1880s. The image is a carefully posed studio composition showing maids drying kimono material.

64. (*p. 94, below*) FARSARI. Country scene, c. 1890. During the Tokugawa period (1603–1868) waterwheels such as this were widely used in the production of textiles, flour, and oil.

67. (*p. 96, above*) UENO. Nagasaki, c.1880. This photograph forms part of a four-section panorama of Nagasaki. Such scenes of the city often appear in Kusakabe Kimbei's albums, with the captions and numbers altered. The author believes that rather than going to the trouble of creating his own portfolio of Nagasaki scenes, Kusakabe came to an arrangement with Ueno by which he was permitted to use some of the latter's views.

72. (*p. 99*) UENO. Samurai, c.1870. The contemporary handwritten inscription on the mount of this photograph identifies the sitter as one "Kharadaki Itchi" (Harada Kiichi?).

74. (*p. 100, below*) SHIMOOKA. Tattooed man and victim, carte-de-visite photograph, c.1870. This curiously posed photo shows a tattooed man apparently on the point of striking a woman.

81. (*p. 104, below*) SHIMOOKA. The Muonji temple, c.1874. Large-format prints such as this and the two following Shimooka studies are even rarer than his carte-de-visite photographs. Apart from the examples shown here, the author knows of only four other Shimooka images in this format, and those are in private Japanese collections. Shimooka's distinctive captioning style is clearly visible in these images. Nichiren is the name of the thirteenth-century monk who established the sect of Buddhism that bears his name.

82. (*p. 105, above*) SHIMOOKA. Teahouse girls, carte-de-visite photograph, c.1870. The girl on the right is playing the samisen, a three-stringed, lutelike instrument originally associated with the pleasure quarters and urban entertainment districts of the Edo period.

85. (*p. 106, below*) SHIMOOKA. Bathhouse, carte-de-visite photograph of an illustration, c.1870. Mixed public bathing was one of the first targets of the Meiji government's policy to introduce Western standards of decency into Japanese daily life, and from as early as 1869 the sexes were to be kept separate. However, the appearance in this group of a lone male figure, standing on the left with a basin, suggests that the regulations were either ignored or not too strictly enforced. The artist was probably Shimooka himself.

87. (*p. 107, below*) UCHIDA. Group of Ainu men, 1870s. Note the distinctive wainscoting and carpet seen in Uchida's studio works.

88. (*p. 108, above*) SUZUKI. Packing tea for export, 1870s. The photo is from the "*shajō* series."

89. (*p. 108, below*) SUZUKI. Eating rice, 1870s. Photohistorians had been puzzled by the identity of the photographer who took a series of photographs featuring the distinctive veranda-like set, or *shajō*, shown here. Recent research by the author has resulted in a definite attribution to Suzuki.

90. (*p. 109*) SUZUKI. Unidentified Westerner, cabinet card, c.1880. The importance of this photograph, which bears the imprint of Suzuki's studio on the reverse, is that it clearly shows a background screen and wainscoting that appear in some of Suzuki's other photos. These props are of great help in identifying other examples of the photographer's work.

91. (*p. 110, above*) USUI. Ueno Park, c.1880. Originally a desolate wooded area in the north of Tokyo, Ueno was made into a Western-style public park in 1873 on the advice of a Dutch medical adviser to the Meiji government. This beautiful photograph seems almost like an impressionistic painting.

96. (*p. 113, below*) USUI. *Oiran*, or high-class courtesans, and attendants, c.1880. *Oiran* constituted the highest rank of courtesans in the hierarchy of the Yoshiwara pleasure quarters. Unlike their lower-ranking sisters, *oiran* were not usually put on display behind the lattice screens of their brothels, and some even enjoyed a degree of choice in their clients. These *oiran* are accompanied by four female attendants, whose apprenticeship as servants began from about the age of seven.

97. (*p. 114*) OGAWA. Japanese beauty with cherry blossoms, c.1890. The photo is a beautiful example of handcoloring. The artist has even succeeded in toning down the red pigment, which in photographs and prints of the Meiji era invariably took on a particularly garish hue.

98. (*p. 115*) OGAWA. Japanese flower study, 1890s. The print clearly demonstrates the extent to which Ogawa perfected the color collotype process. This image appeared in Francis Brinkley's *Japan: Described and Illustrated by the Japanese*.

99. *(p. 116)* KUSAKABE. Home bathing, 1890s. The addition of a servant pretending to blow the flames beneath the bath adds an air of authenticity to this charming studio group.

102. *(p. 117, below)* TAMAMURA. Ginza Street in Tokyo, 1890s. Known as Bricktown after the Western-style buildings that were constructed following the great fire of 1872, Ginza was a showcase for the "new" Tokyo. Horse-drawn trams can be seen going down to Shimbashi Station.

105. *(p. 119, above)* ISAWA. Musical instruments, teahouse room, 1890s. This rare example of Isawa's work shows how the photographer was able to use a simple setting with ordinary objects such as these musical instruments to create a surprisingly evocative atmosphere.

107. *(p. 120, above)* BEATO. "Native town," Yokohama, 1865. The image, which shows the original Japanese settlement in Yokohama, is one of the few surviving photographs taken of the city before the great fire of 1866.

109. *(p. 121, above)* Unknown photographer. Hakodate, 1880s. The port of Hakodate, located in southern Hokkaido, was opened to foreign trade in 1859 but did not prove as successful as the treaty ports of Yokohama and Kobe, which were opened the same year. During the Meiji Restoration, Hakodate was the last stronghold of the shogun's supporters and capitulated to the imperial army only after a six-month siege.

110. *(p. 121, below)* Unknown photographer. British fleet off Yokohama, 1864. The vessels shown represent most of the British fleet in the Far East, the majority of which participated in the bombardment of Kagoshima and the multinational expedition to Shimonoseki. Third from the right is the flagship HMS *Euryalus,* to which Beato was attached during the operations at Shimonoseki.

111. *(p. 122, above)* BEATO. Picnic party on Rat Island, 1865. The photo shows Nagasaki's foreign residents celebrating Queen Victoria's birthday on May 24, 1865. Visible in the front row, cradling his rifle, is Thomas Blake Glover. This famous Scottish merchant, active in Nagasaki from 1859, was a major supplier of Western armaments to the Satsuma and Choshu clans before the Meiji Restoration. He also assisted several young samurai from these domains in evading the shogun's ban on foreign travel and pursuing their studies in England. Glover later served as an advisor to the Meiji government.

112. *(p. 122, below)* BEATO. Nagasaki, with Deshima in the background, 1860s. This image is sometimes wrongly attributed to Ueno Hikoma.

113. *(p. 123, above)* Unknown photographer. Body of Charles Richardson, 1862. On September 14, 1862, a party of four English sightseers was attacked by Satsuma retainers after apparently failing to make way for their lord's procession. Richardson was killed immediately, and two of his companions were seriously injured. When help arrived from Yokohama, Richardson's body was found covered with sword cuts, "any one of which was sufficient to cause death." E. M. Satow, in *A Diplomat in Japan,* notes that after Richardson's murder European residents "came to regard any two-sworded Japanese as a likely assassin and if they passed one in the street thanked God as soon as they had passed him and found themselves in safety."

114. *(p. 123, below)* Unknown photographer. Body of Lieutenant J. J. H. Camus, 1863. Riding through the outskirts of Yokohama on October 14, 1863, Lieutenant J. J. H. Camus, an officer attached to the French legation, was pulled from his horse and hacked to pieces by a group of antiforeign extremists. According to E. M. Satow in *A Diplomat in Japan,* "His right arm was found at a little distance from his body, still clutching the bridle of his pony. There was a cut down one side of the face, one through the nose, a third across the chin, the right jugular vein was severed by a slash in the throat, and the vertebral column was

completely divided. The left arm was hanging on by a piece of skin and the left side laid open to the heart. All the wounds were perfectly clean, thus showing what a terrible weapon the Japanese *katana* was in the hands of a skillful swordsman." Camus's murderers were never caught, and foreign residents in Japan, still unnerved by Richardson's murder the year before, took to traveling either armed or in groups.

115. *(p. 124, above)* BEATO. Capture of the Choshu battery at Shimonoseki, 1864. Officers and men of HMS *Euryalus* and Royal Marines pose for the camera after occupying one of the Choshu batteries during the international punitive expedition to Shimonoseki in September 1864.

117. *(p. 125)* GASPARD FÉLIX TOURNACHON (known as NADAR). Kawazu Izu-no-kami, 1864. Famed for his portrait photographs of contemporary literati, the flamboyant French photographer Nadar had taken a series of portraits of the members of the Japanese mission sent to France in 1862. The visit of Ikeda Nagaoki and his entourage to Paris in 1864 provided Nadar with an opportunity to expand his portfolio of Japanese subjects. Shown here in full samurai armor is the assistant head of the Ikeda mission, Kawazu Sukekuni, *kami*, or governor, of Izu Province (now the eastern half of Shizuoka Prefecture).

118. *(p. 126)* ANTONIO BEATO. Ikeda Chikugo-no-kami, 1864. In 1863 Ikeda Nagaoki, governor of Chikugo Province (now the southern part of Fukuoka Prefecture), was appointed head of a mission that was given the impossible task of securing French agreement to the closure of Yokohama to foreign trade. En route to France the Ikeda mission visited Egypt, where members were photographed by Felice Beato's brother, Antonio, in Cairo.

119. *(p. 127, above)* GASPARD FÉLIX TOURNACHON (known as NADAR). Shogunal mission in Paris, 1862. Part of the mission that accompanied Takenouchi Yasunori, governor of Shimotsuke (present-day Tochigi Prefecture), on his mission to Europe in 1862. Seated is Shibata Sadataro, head of the mission staff.

121. *(p. 128)* Unknown photographer. Officer's daughter, 1880s. Variously attributed to Stillfried, Farsari, and Kusakabe, this charming portrait enjoyed great popularity during the last two decades of the nineteenth century, appearing not only in tourist albums but even in travel guides to Japan. Clearly this image corresponded with Western notions of Japanese feminine beauty. However, the author once saw an inscription that read "Eurasian Beauty."

122. *(p. 129, above)* Unknown photographer. Teahouse women, c.1890. In the same manner as hostess bars today, teahouses traditionally employed girls to entice customers inside and keep them amused. Usually the girls provided only conversation and banter but, as this unusually erotic photograph suggests, other services were sometimes available.

123. *(p. 129, below)* BEATO. Women of the Yoshiwara, 1860s. Formally licensed pleasure quarters had existed in the Yoshiwara district since the early Edo period and continued to operate until their abolition in 1957 under the Prostitution Prevention Law. At this Yoshiwara brothel in the 1860s, women are displayed in the windows at ground level, while those with time to spare gaze at the photographer from the upstairs balcony. Outside, rickshaw drivers patiently await their fares.

124. *(p. 130, above)* Unknown photographer. Ainu woman, c.1890. The custom of tattooing around the mouth was distinctive to women of the Ainu and signified that a girl had reached marriageable age. However, as a result of intermarriage between Ainu and Japanese settlers in Hokkaido, this practice fell into decline.

125. *(p. 130, below)* Unknown photographer. Ainu man, c.1890. The Ainu people are the indigenous inhabitants of Japan's northernmost island, Hokkaido. Long regarded as aliens by the Japanese, the Ainu retained their unique lifestyle until the Meiji era, when the administration and economic development of their homeland were taken over by the Japanese government.

For more venturesome foreign tourists in late nineteenth-century Japan, an encounter with the "hairy Ainu" was an essential part of a trip to Hokkaido.

126. *(p. 131, above)* Unknown photographer. *Betto,* or groom, tattooed, 1880s. Although Japanese tattooing was much admired by Western visitors and especially by photographers, approval was by no means universal. In 1880 the admission of a similarly adorned Japanese male to illustrate a lecture given before the Asiatic Society of Japan was opposed by members who moved that "the specimen should be relegated to the exterior of the premises, where if anyone who desired might examine him critically."

127. *(p. 131, below)* STILLFRIED. Japanese in Western clothes, 1870s. At first sight this portrait seems to show the adoption of Western-style clothes in Japan. On closer inspection, however, the outsize clothes and shoes appear to be castoffs lent for the occasion by the photographer.

128. *(p. 132)* UCHIDA. Emperor Meiji, 1873. Taken when the sitter was only twenty, this image represents the first true likeness of a member of the imperial family. For the first time the emperor's subjects could see the face of their ruler, and the significance of this image was appreciated afterward by the government, which attempted to ban all printing and circulation of the photograph and replace it with a lithograph. The emperor was not to be photographed again until 1889.

129. *(p. 133)* UCHIDA. Empress Meiji, 1872. In 1869 eighteen-year-old Ichijo Haruko married Emperor Meiji, her junior by two years. As empress, she presided over a gradual improvement in the position of women in Japan. Unlike her husband (shown opposite), the empress here wears traditional Japanese court costume. Although the marriage was happy, it produced no children, and the emperor fathered an heir by another woman.

133. *(p. 135, below)* J. A. VAUGHAN. Japanese troops landing at Chemulpo, Korea, 1894. Early in 1894 a domestic rebellion in Korea led to Chinese intervention in support of the ruling Yi dynasty. Determined to dispute Korea's status as a tributary of the Chinese empire, the Japanese government followed suit by dispatching troops to Chemulpo, present-day Inchon, in June 1894. The landing shown here was the prelude to a full-scale war between Japan and China that began on August 1, 1894. Vaughan was a correspondent for the *Illustrated London News,* which reproduced this photo as an engraving.

134. *(p. 136, above)* Unknown photographer. General Baron Nogi and officers, stereograph, 1905. From the Underwood and Underwood series *The Russo-Japanese War.* Nogi Maresuke, with his distinctive white beard, photographed with the staff of the Third Army. As commander of the besieging army at Port Arthur, Nogi relentlessly pursued an offensive strategy that resulted in the loss of almost sixty thousand men before the fortress fell. On the death of Emperor Meiji in 1912, Nogi took his own life, an act that was venerated as a symbol of loyalty.

135. *(p. 136, below)* Unknown photographer. Japanese soldiers cooking rice, stereograph, 1905. From the Underwood and Underwood series *The Russo-Japanese War.* One of the most bitterly fought actions of the war was the siege of Port Arthur, where, in an eerie foretaste of the trench warfare of the First World War, a Russian garrison held out for almost eleven months against desperate attacks by the Japanese.

Appendix
1
Early Japanese Photographs

Following is a list of representative early images and the photographers who likely took them. Each photo is identified by a number and title. Some numbers on images included letters, e.g., A102; here these appear with the number shown first, i.e., 102 A. Some, though not all, original spelling mistakes in titles have been corrected. (Some early photographers deliberately misspelled words!) At first I had wanted to depict the title as it was originally rendered, but upside-down and back-to-front lettering proved too troublesome to include. Also, note that some early photos are identified with titles that can vary slightly with the actual image. Photographers often modified or completely changed titles and, to a lesser extent, numbers. Finally, I admit to a certain inconsistency in rendering of titles that I cannot adjust because some photographs are no longer in my possession.

Brackets around a title mean that the title did not appear on the image but is one I have written. An ellipsis marks a title that has been shortened for this list only. A question mark after a photographer's name indicates that the attribution is likely but not verified.

The following initials represent the names of early photographers whose work is included in the appendix:

F Farsari	*OK* Ogawa Kazumasa	*Shin* Shin-E-Do
I Izawa	*OS* Ogawa Sashichi	*Su* Suzuki
Ka Kashima	*R* Ryo-Un-Do	*T* Tamamura
K Kusakabe	*S* Stillfried	*Ue* Ueno
Na Nakajima	*Sh* Shimooka	*U* Usui

NO.	TITLE	PHOTOGRAPHER	NO.	TITLE	PHOTOGRAPHER
1	Imaichi Nikko Road	*Ka?/OK?*	2 N	The Garden of Sweat Flag in Horikiri at Tokyo	*F*
1	Railway Iron Bridge at Nagara	*K*			
2	Red Lacquered Bridge, Nikko	*U*	3	[Portrait of Smiling Woman with Ring on Marriage Finger]	*T*
2	Sacred Bridge Nikko	*OK*			
2	Telegraph and Post Office at Nagoya	*K*	3	Spinning Thread Company at Atsuta near Nagoya	*K*
2	Workmen's Holiday	*K*	4	The Bridge at Biwajima, Nagoya	*K*
2 M	Restaurant, Kyoto	*F*	4 D	Fuji from Kashiwabara	*Shin*

NO.	TITLE	PHOTOGRAPHER	NO.	TITLE	PHOTOGRAPHER
4 J	Nikko Moddo Fall *K*		16	American Hatoba *R*	
5	Dancing Party *K*		16	Wind Costume *K*	
5 A	The Sacred and Temporary Bridges *K*		16 O	Geisha Girls *F*	
5 B	Ikao *K*		17	Gate of Chionin Temple, Kioto *F*	
5 B	Oriental Hotel Kobe *Shin*		17	Head Temple of Nichiren *Sh*	
5 F	Pine Tree Kinkakuji, Kyoto *K*		17	Nikko Temple *OS*	
5 I	The Sacred Bridge *K*		17 P	Singing Girls *F*	
5 O	Tonosawa *T*		18	Nikko *U*	
6 X	Yokohama Park *F*		18 G	Ojigoku *K*	
7	Jinrikshaw *K*		18 J	Yumoto, Nikko *K*	
7	The Castle *Sh*		19	Japanese Funeral *K*	
7 A	Nunobiki Water Falls at Kobe *F*		19 L	Daibutsu *K*	
8	[Four Young Women Sitting on Veranda] *T*		20	Funeral Service . . . *K*	
8	Kago, the Traveling Chair *K*		20	Revolving Lantern . . . *OS*	
8 G	Road to Tonosawa *T*		20 F	Rokakudo Temple *K*	
8 X	Yokohama Park *F*		20 O	[Three Young Women with Heads Together] *F*	
9	Temple Front Nikko *OS*		20 U	Singing Girls *F*	
9 B	Castle Rocks Mioji *K*		21	Graveyard *K*	
9 C	Fuji from Joshiwara *K*		21	Revolving Lantern . . . *OS*	
9 L	Ise, Mioto—Seki *K*		21 A	Transplanting Rice *Shin*	
10	Girls at Home *K*		21 E	Asamayama *K*	
10	Pagoda Nikko *OS*		22	Girls Dancing *K*	
10	View from Fudzimidai Hakone Fudzimi *Sh?*		22	Korean Bell . . . *OS*	
10 B	Asakusa Park at Tokyo *T*		22	[Waterfall, Nikko] *Sh*	
10 G	Shirabe Cascade Dogashima *K*		22 A	Lantern *K*	
10 O	Hakone *T*		22 G	Fujiyama *K*	
11	Bank at Nagara *K*		23	Exterior of the Nikko Temple *U*	
11	Front Gate Nikko *OS*		23	Playing Samisen . . . *K*	
11	Playing Samisen . . . *K*		23	Town Hachiiski Nicco *Sh?*	
11	[Three Young Women Standing, Holding Hands] *T*		23 A	Yomeimon (Front) *K*	
11 A	The Sanbutsudo, Kyoto *K*		23 C	Cutting Rice *K*	
11 H	Shampooing *K*		24	Grounds at Wakamori . . . *K*	
12	Front Gate Nikko *OS*		24	[Old Man Wearing Large Hat] *T*	
12 L	Nagoya Castle *K*		24	Tea House Girls *K*	
13	Crushed by Earthquake *K*		24 H	View of Moji *F*	
13	Girl in Winter Costume *K*		25	Eating Rice *K*	
13	Stable Nikko *OS*		26	Afternoon Lunch *K*	
13	[Two Men Top Knotted, Sitting, Eating] *T*		26	Fujiyama from a Swamp Fuji *Sh?*	
			26	Tea Drinking *K*	
13 A	Ikuta Temple at Kobe *F*		26	Yomeimon Great Gate . . . *OS*	
13 A	The Pagoda, Iyeyasu *K*		26 C	The Snowing *F*	
14	Buddhist Priests *K*		26 U	[Girl Facing Left with Umbrella and Baby on Back] *F*	
14	Houses in Gifuken Broken by Earthquake *K*		26 X	Bentendori, Yokohama *F*	
15	Houses at Gifuken (Earthquake) *K*		27	[Beggar Standing, Smoking] *T*	
			27	Yomeimon . . . *OS*	
			28	Girls Playing Samisen *K*	
			28 C	Young Nurse *K*	

NO.	TITLE	PHOTOGRAPHER	NO.	TITLE	PHOTOGRAPHER
28 E	Wada *K*		45	[Porcelain Shop] *T*	
29	Peasant *R*		45 X	Canal Yokohama *F*	
30	Bronze Portal . . . *OS*		46	The Acqueduct *Sh*	
30 A	Nanko Temple at Kobe *F*		46 L	Mukojima . . . *F*	
30 Y	Tea House of Oswa Park *F*		47	View from Iwafuchidaito *Sh?*	
31	Fujiyama from Ohashi Tokaido *Sh?*		47	Yenoshima *Sh?*	
31	Nikko Toshogu . . . *K*		47 E	The Kisogawa *K*	
31	Washing at Home *K*		48	Stone Basin . . . *OS*	
31 A	Daibutsu at Kobe *F*		48 P	Dancing Party *F*	
31 A	Ishidan . . . *K*		49	Great Gate Iyemitsu . . . *OS*	
31 P	Singing Girls *F*		49	Kogo . . . *K*	
32	Belfry at Nikko *F*		49 G	Bund Nagasaki *Ue*	
32 M	Shimokamo, Kioto *F*		50	Plain of Arima *T*	
32 V	Kyobashi Tokyo *F*		50	Sewing . . . *K*	
33	Wooden Image . . . *K*		50	View from Old Pine Tree in Ooyu-wamura to Fudzisaw *Sh?*	
34	Jinrikshaw *K*				
34	Kawasaki Daishi *Sh*		50 E	Venomura *K*	
34	[Masseur] *T*		51	Eating *K*	
34 B	Idol Image . . . *K*		51	Okaromon . . . *Su*	
35 B	Idol Image . . . *K*		51	Urami Waterfall near Nikko *U*	
36	Chiuzenji *U*		51	West Castle *Sh?*	
36	[Four Men Standing on One Leg] *T*		52	Kokamon . . . *Su*	
36 Q	Miyako Dance *F*		52	Waterfall Shirait Onotaki in Kamii-demura, Suruga *Sh?*	
37	Dainichido at Nikko *F*				
37	Dancing *K*		52	Yeno . . . *Sh?*	
38	[Two Women Playing Go] *T*		52 E	Tsumago *K*	
38 D	The Carp *Ue*		52 G	Bund Nagasaki *F*	
38 X	4th July Yokohama . . . *F*		52 P	Singing Girls *F*	
39	Carrying Children *K*		52 S	Dancing Party *F*	
39	Shiba at Tokyo *F*		53	Bridge Fudzibashi, on River Fudzikawa *Sh?*	
39 P	Singing Girls *F*				
40	Bronze Gate and Tomb Iyeyasu Nikko *OK*		53 A	Maple Garden . . . *T*	
			53 C	Japanese Shoe Shop *Shin*	
40	Bronze Tomb . . . *OS*		54	Inside Iyemitsu Temple Nikko *OK?/OS?*	
40	[Flower Salesman with Pruners] *T*				
40 C	Rain Coats *Shin*		54	Shinto Priests . . . *K*	
41	Futahara . . . *OS*		54 B	Lotus Flowers at Kamakura *T*	
41	Shinkoji Hiogo *R*		55	Inside Iyemitsu . . . *OS*	
41	Wrestlers *K*		55	[Two Men Pulling Two Women in Kago] *T*	
41 C	Japanese Lantern Makers *K*				
42	Coolies Wayside . . . *K*		55 H	Kintaibashi *F*	
42 F	Rapids near Kyoto *K*		55 P	Singing Girls *F*	
43	Pounding Rice *K*		55 V	Singing Girls *F*	
43	Tenshi Dai *Sh*		56	Foregate of Church Honmondzi Ikeeamimura *Sh?*	
44	[Two Women Carrying Babies] *T*				
44 F	One Hundred Steps at Yokokama *F*		56	Silk Store *K*	
44 G	Takaboko . . . *F*		56 P	Geisha Girl *F*	
44 L	Mukojima, Tokio *F*		57	Yurami Nikko *Su*	
45	Blind Shampooer *K*		57 G	Oura, Nagasaki *F*	

NO.	TITLE	PHOTOGRAPHER	NO.	TITLE	PHOTOGRAPHER
58	Bronze Tomb . . . *Su*		74	Nitenmon . . . *Su*	
58	Kirifuri Nikko *Su*		74 B	Street of Yokohama *T*	
58	The Castle *Sh*		75	Bridge Kintaiko at Yuwakum Suwoo *Sh?*	
58 P	Singing Girls *F*				
59	[Country Men and Women Eating and Singing] *Sh?*		75	Ueno Palace *Sh?*	
			75 X	Asakusa Park *F*	
59	Daija River Nikko . . . *OS*		76	Ushi Gomi *Sh*	
59	Plum Garden Belonged to Mr Yamamoto . . . *Sh?*		76	[Woman with Doll on Back] *T*	
			76 A	Lake from Motohakone *F*	
59 F	On the Grand Canal, Osaka *K*		76 A	[Three Girls in Three Jinrikishas] *T*	
60	Yirami Nikko *Su*		76 B	Osaka Street *T*	
60 B	Yokohama *F*		77	Dancing *K*	
60 I	Nikko Sandaiko . . . *K*		77	Seido Chinese Colece *Sh*	
61	Dainichido Nikko *Su*		77 B	Osaka Street *T*	
61	[Two Girls Kneeling on Cushions] *T*		77 X	Shinbashi Tokyo *K*	
61 A	[Man with Basket and Brush-laden Cart] *T*		78	Miyanoshita *U*	
			78 B	Sanjiu *T*	
61 G	Oura Nagasaki *F*		78 D	Asakusa . . . *F*	
61 Q	Saruhashi, Koshu *F*		79	Hanzo Gate *Sh*	
62	Church Shozio Kodzi Fudzisawa *Sh?*		79 B	Sanjiu . . . *T*	
			80	Visiting Ceremonials *K*	
62	Japanese Junk *K*		80 L	Loom *K*	
62 L	Iseyama *F*		81	[Houses next to River] *Su*	
63	Dainichido Nikko *Su*		81	Shohe Bridge *Sh*	
63	Shoe Repairer *K*		81 G	Shinto-Temple at Nagasaki *F*	
64	[Two Men Carrying Woman in Kago] *T*		82	Tonosawa One of Places of Hot Springs Hakone *Sh?*	
64	Weaving Silk *K*		82	Yoshiwara Girls *K*	
64 I	Sandaiko . . . *K*		82 B	Inland Sea *T*	
65	Dainichido *Su*		82 S	Yomeimon *K*	
65	Jinrikisha *K*		83	Ichinotaki Waterfall Nikko *OK*	
65	Sokokura *U*		84	Freight Cart *K*	
65 L	Singer Playing *F*		85	Miyanoshita *Sh?*	
66	Wedding Ceremony *K*		85 F	A Farmer's Abode *T*	
66 J	Richer's Palace *Shin*		86	Snow Costume *K*	
67	Ganman . . . *OS*		86	[Woman Looking in Mirror, Kneeling] *Sh?*	
68	Distant View from Baniogawa . . . *Sh?*		86 A	Lotus Pond at Kamakura *F*	
68	Sokokura *U*		86 F	Rice Planting *T*	
68 A	New Road Kiga Hakone *F*		87	Fujiyama *Su*	
69	Packhorse *K*		87	[Three Fishermen Examining Fish] *Sh?*	
70	Sawyers *K*				
72 A	Rain Coats *K*		87 A	[Picnic by Lake] *T*	
72 G	Inasa, Nagasaki *F*		88	Post Runner *K*	
72 H	Nunobiki Fall . . . *K*		88 A	[Girl Kneeling, Playing Samisen] *T*	
73	Konkonchiki-Girls *K*		88 D	Kameido, Tokyo (Wisteria Flower) *F*	
73	Ueno Palace *Sh*				
73 K	[Two Women] *F*		88 R	Awaiishima . . . *K*	
74	Girls Dancing *K*		89 W	Japanese Lady *F*	

NO.	TITLE	PHOTOGRAPHER	NO.	TITLE	PHOTOGRAPHER
90	Fujiyama, Yoshida *U*		107 A	Mississipy Bay Yokohama *F*	
90	Hakone *U*		108	Gilt Door . . . *OS*	
90	View of Miyanoshita, Hot Spring *Sh?*		109	Samurai in Armor *K*	
91	Hakone *U*		111	Karamon . . . *OS*	
92	[Three Women Having Tea] *T*		112	[Woman with Child on Back] *Sh?*	
93	Enoshima *S*		112	Yomeimon Gate . . . *OS*	
93	Girl *K*		114	Girl Looking at Two Mirrors *K*	
93	The Tomb-Stones of Revenge *Sh?*		115	Norimono *K*	
93	Tonosawa *U*		115 A	[Musicians] *T*	
93	[Woman with Umbrella] *T*		118 B	Futawarasan Temple . . . *T*	
94	New Years Greeting *K*		119	Daibutsu *U*	
94 B	Wisteria . . . *T*		119	Putting on Dress *K*	
95	Daibutsu . . . *Su*		120	Reading Letter *K*	
95	Sort of Sacred Pillars . . . *Sh?*		120	Voluntary Harikiri *F*	
95 B	Wisteria . . . *T*		121	[Carpenter] *Sh?*	
95 P	Fuji from Omiya (Tokaido) *F*		121	[Kendo] *T*	
96	Kozodawara *Sh?/Su?*		121	Playing with Music *K*	
96 A	Post Office Yokohama *F*		122	View from Waterfall Yumotaki, to Atsukawa . . . *Sh?*	
97	[Woman Kneeling, with Pile of Firewood on Back] *Sh?*		123	[Plant Seller] *T*	
97 C	Pilgrims *K*		123 A	Enoshima Island *T*	
98	Fishing *K*		124	Sweeping *K*	
98	Koshiu *U*		125	Jinrikisha *K*	
98 Q	Jinrikisha (Carriage) *F*		125 A	Suwa Temple Gate at Nagasaki *Ue*	
99	[Carpenters] *T*		126	Uyeno Public Garden Tokio *U*	
99	Yumagayashi . . . *Su*		127	[Plant Seller] *T*	
99 B	Girls Playing in Garden *F*		127	Tea Drinking *K*	
99 D	Dancing Party *F*		127	[View of Boiling Spring] *U*	
99 J	[Young Woman Laughing, Umbrella in Left Hand] *F*		127 A	Suwa Temple Gate at Nagasaki *Ue*	
100 B	Nagoya Castle *T*		128	Ancient Noble's Style *K*	
100 D	Japanese Lantern Maker *K*		128	Shinto Priest *F*	
101	Kanagawa *U*		128 B	Water Fall . . . *T*	
101	Tea Drinking *K*		129	Buddhist Priests *F*	
101 A	Entrance to Kasuga . . . *T*		129	[Holes, Possibly Hot Springs, with Huts in Background] *Sh?*	
102	Shiba *Sh?*		129	[Japanese Lady] *T*	
102 A	Arashiyama . . . *T*		129 B	Chiuzenji Lake *T*	
103	Flower Seller *K*		130	Jinriksha *F*	
103	Karamon Gate . . . *OS*		131	View from Bridge Yanagibashi to Station *Sh?*	
103	Picking Tea Leaves *K*		132	Inside of a Theatre *K*	
103 A	Kiyomizu Pagoda . . . *T*		132	Servant Girl *F*	
104	Iyeysu Temple . . . *OS*		132	[Woman with Umbrella] *T*	
104	[Man Resting on Cross Stick Supporting Vegetables] *Sh?*		133 B	Kegon Waterfall . . . *T*	
104 H	Upper Fall . . . *K*		134	Harakiri *K*	
105	Carving in Door Nikko *OS*		134 A	Nagoya Castle *T*	
105 B	Rokkakudo Temple . . . *T*		135 A	View of Nakajima Nagasaki *Ue*	
106	Carving in Door Nikko *OS*		136	[Two Girls Kneeling] *T*	
			137	Japanese Junks *K*	

NO.	TITLE	PHOTOGRAPHER	NO.	TITLE	PHOTOGRAPHER
138	Playing Goban *F*		177	[Woman with Umbrella] *T*	
138 B	Moat at Tokyo *T*		178	[Three Men and Oxen] *T*	
139	Fencing *F*		180	Spinning Cotton *F*	
139	[Two Buddhists] *T*		181	Shuttlecock *F*	
139 B	Musume Summer Costume *K*		182	Dancing Girls *K*	
140	Preparing Rice Ground *K*		185	[Woman in Rickshaw] *T*	
141	Planting Rice *K*		185 A	Inasa at Nagasaki *Ue*	
143	Basket Seller *K*		189	Stone Basin . . . *OS*	
143	Island Noshima Kanazawa *Sh?*		189 B	Miyajima . . . *T*	
143 A	Takaboko Nagasaki *Ue*		190 A	Mogi Road at Nagasaki *Ue*	
144	[Woman by Street Lamp with Child] *T*		192 A	View of Nagasaki *Ue*	
			193 A	Unzen Ojigoku at Nagasaki *Ue*	
144 B	Stone Lanterns . . . *T*		198	Double Temple . . . *OS*	
145	[Dressing] *T*		199	Hakone *U*	
145	Takindo Nikko *Ue*		199	[Six Buddhist Priests] *Sh?*	
145 A	Oura at Nagasaki *Ue*		199	View of Night, Omori in Tokio *Ka?/OK?*	
147	Doctor *K*				
147	View from Iwafuchidai to Fudzisan *Sh?*		199	[Woman Sleeping] *T*	
			204	Dancing *K*	
148	[Girls Sleeping] *T*		206 A	Konpira Hill at Nagasaki *Ue*	
148	Takino Road Nikko *OS*		208	Katase Temple, near Yenoshima *Sh?*	
149	Place for Shipbuilding Yoko-suka *Sh?*		208	Oram and Aiol Waterfall Nikko *Ka?/OK?*	
150	[Man by Well and Thatched Roof] *Sh?*				
			210	Eating Soba *F*	
150	Miyanoshita Road *T*		214	Cherry Blossoms . . . *T*	
151	Takashima-cho *S*		216	Bund of Settlede Kobe *F*	
151	Tea House Garden *K*		217	Group of Children *K*	
152	Girls' New Year Games *K*		218 B	[Two Girls, One Smoking Pipe] *T*	
153	Interior of Nikko Temple *Ka?/OK?*		219	Wrestling *F*	
155	[Girl] *T*		221	Ikuta Kobe *T*	
155	Preparing Dinner *K*		222	Selling Flowers *K*	
160	[Two Children, One Carrying Baby] *T*		223	Kamakula *T*	
			223 A	Daibutsu Kiogo *K*	
161	Asakusa, Tokio *U*		224	Jinriki *F*	
162	Uyeno Tokio *U*		225	Bronze Idol . . . *T*	
162 A	Love Letter *F*		227	Girl *K*	
164	Adorning the Face . . . *K*		227	Kamakura *T*	
164 A	Boys Festival Yokohama *T*		227	Reading in Bed *K*	
165	[Three Men in Boat] *T*		228	Nishi Otani . . . *T*	
167	Inuwaka, Choshii *Na*		228	Snow (Winter) *F*	
167	Strolling Musicians *K*		228 A	Mukojima at Tokio *F*	
167	[Woman in Jinrikisha] *T*		229	Iris Blossoms . . . *T*	
167 B	Hakodate *K*		229	Yacht *F*	
169	Carving in Door . . . *OS*		233	Nunobiki . . . *T*	
174	[Three Women] *T*		237 A	Temple of Yanaka Tokio *F*	
174	Wisteria . . . *K*		238	Bamboo Grove *K*	
175	[Two Women] *T*		239	Marugame . . . *T*	
176	Dinner *F*		239	Ozashiki . . . *K*	
			240	Japanese Old Man *K*	

NO.	TITLE	PHOTOGRAPHER	NO.	TITLE	PHOTOGRAPHER
241	Chrysanthemum *K*		294	Hakodadi *S*	
241	Dogashima *T*		295	Sacred Bridge . . . *T*	
241	Wara *Sh?*		295 B	Osaka-Hotel, Osaka *F*	
241 A	Tea House Mukojima Tokio *F*		297	[Barefoot Young Woman with Fan with Foot on Knee] *S*	
241 B	Dogashima *T*				
242	Chrysanthemum *K*		298	Girls Showing Obi *K*	
242	Hakone . . . *T*		300	Girl Reading a Novel in Hill *K*	
243	Inland Sea *T*		302	Atago Hill Tokio *Ka?/OK?*	
244	Chrysanthemum *K*		302	Imaichi Road . . . *T*	
248	[Man on Bridge Wearing Straw Hat] *T*		303	[Two Men on Village Street] *T*	
			312	Imaichi at Nikko *T*	
251	Arima . . . *T*		313	Wrestlers *K*	
253	[River, Snow] *Sh?*		314	Dainichido Gardens . . . *T*	
253 B	Harbour Kobe (Part 3) *F*		314	Great Gate Shiba Tokio *Ka?/OK?*	
254 A	Public Garden Yokohama *F*		327	[Vegetable Vendor] *S*	
256	Bluff Gardens Yokohama *T*		333	Enoshima Island *T*	
256	[Bridge] *Sh?*		334	[Half-nude Woman Looking at Mirror] *S*	
257	Daiyagawa . . . *T*				
259	Benten Dori, Yokohama *T*		334	Nara *U*	
259	Girls at Home *K*		335	Nara *U*	
261	Coolie *K*		337	Nara *U*	
262	Tea House . . . *T*		338	Gate of Enoshima *T*	
263	Tea House . . . *T*		338	Hopscotch *K*	
264	Wisteria . . . *T*		338	Kasuga, Nara *U*	
265 B	Bund at Kobe *F*		340 A	Maruyama, Kioto *F*	
266	Tomioka *T*		342 B	Kiga *T*	
269	Maiko *T*		344 A	Tonosawa *T*	
270	Nakajima . . . *T*		346	Tonomine *U*	
270 A	Garden of Hotsuta in Tokyo *F*		346	Yomeimon . . . *T*	
271	Stone Idol . . . *T*		347	Tomb . . . *T*	
272	[Two Men on Bridge] *Sh?*		347	Tonomine *U*	
273	Garden at Manganji . . . *T*		348	Tonomine *U*	
274	Enoshima *T*		348	Urami Falls *T*	
276	Daibutsu Tokyo *T*		349	Nikko *T*	
276	[Kobe Waterfront] *Sh?*		351 A	Large Bridge Sanjo at Kioto *F*	
276	[Open Space, Trees] *Sh?*		353	Dainichido . . . *T*	
278	Pagoda . . . *T*		354	Gate of Eaimitsu . . . *T*	
278	[Stream, House, Temple] *Sh?*		355	Kamakura *Sh?*	
279	Yomemon Gate . . . *T*		356	Biwa Lake *U*	
281	[Bell and Two Men] *U*		358	Karasaki *U*	
281	[Cherry Blossoms and Two Men, One Sitting] *Sh?*		359	Nikko *T*	
			360	Temple Fugisawa *Su*	
281	Kanyeiji . . . *T*		363	Karamon . . . *T*	
285	Scenery of Uyeno . . . *T*		364	Yomemon . . . *T*	
286 A	View of Enoshima *F*		365	Karamon . . . *T*	
289	Time Bills . . . *T*		365	Ooji, Tokio *U*	
291	Temple of Yokohama *T*		366	Yenosima *Su*	
292	Kashiwabara *T*		367	Yomeimon . . . *T*	
293	[Temple] *Sh?*		368	Uyeno Park . . . *OS*	

NO.	TITLE	PHOTOGRAPHER	NO.	TITLE	PHOTOGRAPHER
369 A	Miyanoshita	*T*	441	Gardens at Kyoto	*T*
369 B	Miyanoshita	*T*	441	[Japanese Ships]	*OK?*
374	[Three Women Dancing]	*T*	444	[Bridge over Stream and Rickshaw]	*OK?*
375	Lotus Pond . . .	*OS*			
381	[Bridge]	*T*	445	Tokyo	*T*
382	Ichinotaki . . .	*T*	446	Cherry Avenue . . .	*OS*
385	[Hotel]	*S*	449	[House, Rickshaw with Ladies Pulled by Men (old number 17 deleted)]	*OK?*
385	Miyanoshita	*T*			
386 A	Yumoto	*T*			
388	[Wooden Bridge]	*T*	450	Garden, near Tokyo	*T*
389	Ojigoku . . .	*K*	450	[Two Priests Looking at Temple (old number 320 deleted)]	*OK?*
389	Ojigoku Hot Spring	*T*			
394 A	Ikuta Temple, Kobe	*K*	454	Oyeno Tokyo	*T*
395	Tokaido Bridge	*T*	454 A	Red Lacquer . . .	*K*
397	Yebiya . . .	*OS*	456	Takaboko	*T*
397 B	Miyanoshita	*T*	457	[Two Girls, One Resting on Elbow, the Other Kneeling]	*S*
398	Shiba, Tokio	*U*			
399	Autumn View of Maples Oji Tokio	*Ka?/OK?*	458 A	Nagasaki	*T*
			460	Takaboku . . .	*T*
400	Shiba, Tokio	*U*	462 B	Nagasaki Harbour	*T*
401	[Barge on River with Thirteen Japanese]	*Ka?/OK?*	463	Fujiyama . . .	*T*
			463	Palace Garden Tokio	*Ka?/OK?*
402	Kashiwabara . . .	*T*	465	Main Street Nagasaki	*T*
402	[Tree over River]	*OK?*	465	Suspension Bridge Koshiu	*U*
403	Tango . . .	*T*	470	Tonoki, Koshiu	*U*
408	[Mount Fuji in Distance]	*T*	471	Kobe	*T*
411	Uyeno Tea House	*T*	481	Tamagawa	*T*
412 A	Sarusawa Lake at Nara	*F*	484	Daibutsu . . .	*T*
413	[Trees, Houses, and Overhanging Branches]	*OK?*	484	Minobu Koshiu	*U*
			486	Ikegami	*T*
418	Yokohama, Main Street	*S*	486	Minobu Koshiu	*U*
419	[Country Scene, Flowers by Roadside, Rickshaws]	*OK*	488	Shiba . . .	*T*
			490	Minobu Koshiu	*U*
419	Yokohama, Water Street	*S*	494	Shiba . . .	*T*
420	Preparing Dinner	*U*	495	Ueyno . . .	*T*
420	Stone Steps . . .	*T*	499	Wisteria . . .	*T*
422	Honmoku	*T*	500	Wisteria	*T*
424	Niwomon . . .	*T*	501	Wharf Yokohama	*K*
425	[Temple]	*T*	501 A	Carvings on the Yashamon, Nikko	*F*
425	Wisteria . . .	*OS*	502	Kiyomizu . . .	*T*
427	Gate of Eamitsu . . .	*T*	503	View of Bund	*K*
427	Ogiya	*OS*	504	Wharf Yokohama	*K*
428	Cherry Blossoms . . .	*T*	505	Grand Hotel . . .	*K*
429	Sacred Bridge . . .	*T*	506	Grand Hotel . . .	*K*
436	Pagoda at Tokyo	*T*	506	Katsuragawa	*T*
437	Gongen Road	*K*	507	Yatobashi . . .	*K*
439	The 101 Stone Steps . . .	*T*	510	View of Yokohama	*K*
439 A	Ishiyamadera Temple Omi	*F*	511	Daibutsu, Kamakura	*Ka?/OK?*
441	Fujikawa	*U*	511	Honmura Street . . .	*K*

NO.	TITLE	PHOTOGRAPHER	NO.	TITLE	PHOTOGRAPHER
513	German Club . . . *K*		550	Amma *T*	
514	Kasuga Nara *T*		550	Honmoku *K*	
514	Post Office *K*		550	Kasatori—Toge, Shinano *U*	
515	Noga Hill . . . *K*		553	Grand Hotel . . . *K*	
515 A	Chuzenji . . . *K*		554	Benten Dori . . . *K*	
516	Custom House . . . *K*		554	Miyajima *T*	
516	Ginkakuji . . . *T*		555	Custom House . . . *K*	
516	Miogi, Joshu *U*		555	[River, Mountains, Boats] *OK?*	
517	Town Koncho-Dori . . . *K*		555 B	Nagoya Castle *T*	
519	Honmura . . . *K*		556 B	Nara *T*	
520	Benten Dori . . . *K*		559	Cherry at Bluff . . . *K*	
521	Festival Lanterns . . . *K*		560	Sailing Ship *T*	
521	Suzuki Hotel, Nikko *U*		561	Cherry Blossoms . . . *K*	
523	Yakushi Temple . . . *K*		563	From the Bluff . . . *K*	
524	Cherry Blossoms . . . *T*		566	Theatre Street . . . *K*	
524	Entrance to Temple . . . *K*		567	Nagasaki Harbour *T*	
525	Sengen *K*		568	Oura at Nagasaki *T*	
525	Shiba . . . *T*		568	Snow Scene Bluff . . . *K*	
525	[Swimming in Sea] *OK?*		569	Bluff Garden . . . *K*	
526	One Hundred Steps . . . *K*		570	Bluff Garden . . . *T*	
526	Shiba at Tokyo *T*		570	Nagasaki *T*	
527	Shiba at Tokyo *T*		571	Mukojima *T*	
527	Tonosawa *Ka?/OK?*		572	Cherry Blossoms . . . *T*	
528	Yokohama *K*		573	Mukojima . . . *T*	
529	Camp Hill *K*		574	Daibutsu . . . *T*	
530	Shiba . . . *T*		579	No 9 at Kanagawa *K*	
531	Hachiman . . . *T*		583	Kiyomizu Temple . . . *T*	
531	Nectarine *K*		584	Chionin Temple . . . *T*	
532	Bluff Yokohama *K*		586	Lake, Hakone *Ka?/OK?*	
532	Kamakura *T*		589	Tochinoki *U*	
533 D	Inside of Iyemitsu . . . *T*		591	Inland Sea *T*	
534	[Carved Gate] *T*		600	Chionin Gate . . . *T*	
535	Daibutsu . . . *T*		601	Tonosawa *T*	
536	Daibutsu . . . *T*		602	Hamagoten . . . *K*	
536	Interior of Honmura . . . *K*		603	Lacquered Tomb *K*	
537	Shiba *T*		603	[Pilgrim with Stick inside Temple Gardens] *OK?*	
538	View of Yokohama Harbour *K*				
539	Club Hotel . . . *K*		604	Great Gate . . . *K*	
539	Miyanoshita Road *Ka?/OK?*		605	500 Stone Lanterns . . . *K*	
540	Cherry Blossoms *K*		606	Hakone Lake *T*	
541	Miogi Mt. Joshu *U*		606	Nachi Kishu *U*	
542	Garden at Nikko *U*		606	Stone Basins . . . *K*	
542	Mississippi Bay . . . *K*		607	Children Playing on Park Yokohama *F*	
543	Shiba . . . *T*				
545	Yokohama *K*		607	Shiba Tokyo *K*	
546	View from Camp Hill . . . *K*		608	Ise *U*	
547	View of Fishing . . . *K*		608	Temple Gate . . . *K*	
548	Tea House . . . *K*		609	Temple at Shiba . . . *K*	
549	View of Honmoku *K*		610	Hakone *T*	

NO.	TITLE	PHOTOGRAPHER	NO.	TITLE	PHOTOGRAPHER
610	Temple at Shiba . . . *K*		654	View of Atago . . . *K*	
611	Temple at Shiba . . . *K*		655	Atagoyama . . . *K*	
612	Temple at Shiba . . . *K*		657	[Portrait of Old Man Sitting, Holding Fan] *S*	
613	Bronze Gate and Tomb of Iyeyasu . . . *K*		657	Tomb of 47 Ronin *K*	
613	Hakone Lake *T*		661	Daibutsu . . . *T*	
615	Temple Shiba . . . *K*		662	Sumicho Yoshiwara *K*	
616	Festival Car at Kioto *Ka?/OK?*		663	[Woman with Samisen] *S*	
616	Road at Miyanoshita *T*		665	Uyeno . . . *K*	
616	Temple Shiba . . . *K*		666	[Woman in Informal Costume] *S*	
617	Road at Miyanoshita *T*		667	Uyeno Park . . . *K*	
618	Bronze Lanterns . . . *K*		668	Seiyoken Hotel . . . *K*	
618	Kurohozon Temple . . . *K*		671	[Japanese Lady] *S*	
619	Kanabutsu . . . *K*		672	Uyeno Stone Lantern . . . *K*	
619	Road at Kiga *T*		673	Horiuji Temple and Pagoda, Tatsuta *Ka?/OK?*	
620	Benten Garden . . . *K*		674	Cherry Park . . . *K*	
620	Kiga *T*		675	[Man Wearing Court Costume] *S*	
621	Tokyo Castle . . . *K*		675	Uyeno Park Tokyo *K*	
622	Garden Street . . . *K*		678	Ginza Street . . . *T*	
623	Garden Street *K*		679	Playing Deers Kasuga Avenue at Nara *Ka?/OK?*	
624	The Mikado's Garden . . . *K*		679	View of Hakone Lake *K*	
625	Bronze Bell . . . *T*		680	Mikado Palace Bridge . . . *K*	
626	Hakone *T*		680	Playing Deers Kasuga Avenue at Nara *Ka?/OK?*	
626	Main Street Tokyo *K*		681	Jizo Hakone *T*	
627	Main Street Tokyo *K*		681	Tokyo City *K*	
627	Marquis Satake's Garden Tokyo *K*		682	Kasuga Temple Avenue at Nara *Ka?/OK?*	
629	Cherry Bank at Koganei *K*		684	Uyeno Tokyo *K*	
630	Gojiosaka Otani, Kioto *Ka?/OK?*		686	[Portrait of Old Woman] *S*	
631	Asakusa Temple . . . *K*		687	Cherry Avenue . . . *K*	
631	Miyagino . . . *T*		689	Enoshima *T*	
632	Inside Asakusa Temple . . . *K*		689	Ushigafuchi Tokyo *K*	
632	[O-kin-san, Owner of Yokohama Refreshment House] *S*		691	Shokonsha . . . *K*	
634	Miyanoshita from Dogashima *T*		694	Uyeno Tokyo *K*	
635	Asakusa Pagoda *K*		699	Uyeno Park Tokyo *K*	
636	House Boat . . . *K*		702	Hakone *Su*	
637	Autumn View . . . *K*		704	Islet Shodenshima in Yenoshima Kamakura *Sh?*	
638	Asakusa Temple . . . *K*		705	Wisteria *K*	
638	Minoo near Osaka *U*		706	[Canal] *OK?*	
639	Sumida River . . . *K*		706	Uyeno Tea House . . . *K*	
640	Daibutsu Nara *U*		708	Castle of Osaka *Ka?/OK?*	
640	Wisteria . . . *K*		709	Hakone *Su*	
641	Asakusa Temple . . . *T*		709	Shogun Temple . . . *K*	
641	[Barge on Rapids] *OK?*		709	[Temple in Nikko] *U*	
641	Wisteria . . . *K*		709	Torii at Nikko *T*	
642	Dogashima *T*				
646	Pagoda at Horinji . . . *T*				
648	Uyeno Park . . . *K*				
649	Horikiri Iris . . . *K*				

NO.	TITLE	PHOTOGRAPHER	NO.	TITLE	PHOTOGRAPHER
710	Shogun Temple . . . *K*		774	Kudan-Zaka, Tokyo *R*	
711	Stone Steps . . . *T*		775	Ishidan, Nikko *K*	
713	Mizuya . . . *T*		775	View of Stone Steps . . . *K*	
713	[Photograph Painter] *S*		776	Bronze Gate . . . *K*	
714	[Actor Performing Noh] *S*		777	Bronze Tomb . . . *K*	
714	Tomb Iyaysu . . . *K*		777	Imaichi Road . . . *T*	
715	[Back View of Tattooed Man] *S*		777	Kintai Bridge, Iwakuni *I*	
715	Yomeimon Gate . . . *T*		780	Tagonow Rabashi *Su*	
717	Interior Ikegami . . . *K*		781	Niomon Nikko *K*	
721	Cherry Blossoms, Koganei, Tokyo *R*		781	Sandai Shogun . . . *K*	
721	Horikiri Iris . . . *K*		783	Yashiamon Nikko *K*	
723	Autumn View . . . *K*		785	[Buddhist in Front of Tomb] *K*	
724	Iris Garden . . . *K*		785	Ikao *T*	
726	Iris Garden at . . . *K*		786	Iyemitsu Tomb . . . *K*	
727	Yomeimon Gate . . . *T*		788	Takino-O Nikko *K*	
728	[Families Bathing and Swimming in Stream] *OK?*		789	Ganman Nikko *K*	
728	Kiga Hakone *Su*		790	Danchido . . . *K*	
728	[Two Samurai] *S*		792	Kirifuri Cascade . . . *K*	
729	Ashinoyu Hakone *Su*		793	Urami Cascade . . . *K*	
729	Yomeimon Gate *T*		796	Nikko Road *K*	
731	Ginza Street, Tokyo *R*		797	View on the Road to Chiusenji *K*	
740	Niomim Gate . . . *T*		798	Hodo Cascade . . . *K*	
743	Imaichi Road . . . *T*		799	Kegon Waterfall . . . *K*	
746	View of Miyajima *Ka?/OK?*		800	Chiusenji Lake . . . *K*	
747	[Curio Shop] *T*		801	Chiusenji Lake . . . *K*	
748	Sacred Bridge . . . *T*		802	Chiusenji Lake . . . *K*	
750	Sacred Bridge . . . *T*		802	[Man with Court Costume and Fan] *S*	
751	Grove of Criptom . . . *K*		803	Yumoto Nikko *K*	
751	View of Imaichi . . . *K*		805	Sorinto . . . *K*	
752	Kachi-Ishi . . . *K*		806	Chiusenji Lake . . . *K*	
753	View of Sacred Bridge . . . *K*		807	One Hundred Stone Images *K*	
755	View of Sacred Bridge . . . *K*		807	Stone Idols . . . *T*	
756	Sanbutsudo . . . *K*		808	Riudzu Cascade . . . *K*	
757	Front Gate Nikko *K*		809	Haruna *T*	
758	Front Portal Nikko *K*		809	View of Chiusenji Road *K*	
759	Pagoda at Nikko *K*		810	Yomeimon (Great Gate) *K*	
760	Storehouse . . . *K*		813	Road at Hakone *T*	
761	Horimono . . . *T*		814	Hakone *T*	
763	Bronze Portal . . . *K*		816	[Portrait of Man] *S*	
764	Revolving Lantern *K*		818	Garden at Tokyo *T*	
765	Bell Nikko *K*		821	View of Matsushima *Ka?/OK?*	
765	[Norimono] *S*		826	View of Matsushima *Ka?/OK?*	
766	View of Nagasaki *Ka?/OK?*		832	Nakajima Stone Lantern Nagasaki *Ka?/OK?*	
766	Wall Carving . . . *K*		851	Kitanono Tenzin *Su*	
767	Great Gate . . . *K*		851	View of Ikao *K*	
769	Great Gate . . . *K*		852	Kyoto Palace *Su*	
771	Karamon . . . *K*		852	View of Ika Street *K*	

NO.	TITLE	NO.	TITLE
853	Ikao *K*	915	Gojio at Kyoto *T*
854	Hakone Lake *K*	917	Kinkakuji Garden *T*
856	Haruna Road . . . *K*	918	Chioin at Kyoto *T*
856	Lake of Kinkakuzi *Su*	920 C	Kinkakuji Garden . . . *T*
859	East Mountain of Onsen . . . *Su*	922	Sanjiyo . . . *T*
859	Funiu Waterfall . . . *K*	923	Honganji Gate . . . *T*
860	Gion Temple Gate Kioto *Ka?/OK?*	928	Kiyomizu at Kyoto *T*
861	Fuji from Hakone Lake *T*	930 A	Kyoto Town . . . *T*
863	Haruna Fuji and Lake *K*	930 B	Kyoto Town . . . *T*
864	Kiyomidzu Temple, Kioto *Ka?/ OK?*	933	Town of Osaka *T*
		938	Harbour of Kobe *T*
866	Nozoki Iwa . . . *K*	942	Nagoya Castle *T*
869	View of Haruna *K*	942	Nijiubashi Bridge . . . *T*
870	Handa River Maibashi *K*	943	Inari Fushimi *T*
871	Wadarase . . . *K*	944	Fushimi *T*
872	View Kiribara Bridge . . . *K*	944	Sakura . . . *K*
881	Ajikawa, Osaka Large Junk *Ka?/ OK?*	946	Nigetsudo . . . *T*
		947	Bronze Bell . . . *T*
883	Shiraito Waterfall . . . *K*	950	Sarusawa at Nara *T*
884	Fujiyama from Tokaido . . . *K*	953	Hakone Road *K*
886	Fujiyama from Tagonoura . . . *K*	954	Shiba at Tokyo *T*
888	Fujiyama from Fujikawa . . . *K*	954	View of Miyanoshita Road *K*
889	Fishes with Cormorants at Nagara River, Gifu *Ka?/OK?*	955	Sanmai Bashi Tea House *K*
		956	Kasuga at Nara *T*
889	Fujiyama from Iwabuchi . . . *K*	956	Yumoto *K*
893	Fujiyama from Mishiku . . . *K*	957	Tamadare Waterfall *K*
894	Fujiyama from Iwabuchi . . . *K*	957	View of Tonosawa *K*
895	Fujiyama *K*	958	Tamadare . . . *K*
896	Fujiyama from Gotenba *K*	959	Kasuga at Nara *T*
897	Fujiyama from Yoshida *K*	959	Tonosawa *K*
897	[Japanese Curio Shop] *S*	960	Miyanoshita Road . . . *K*
899	View of Rapids at Kyoto *K*	962	View of Miyanoshita *K*
900	Fujiyama from Omiya . . . *K*	964	Miyanoshita Fujiya Hotel *K*
900	Hozugawa . . . *T*	965	Miyanoshita Fujiya Hotel *K*
901	Fujiyama from Maeda . . . *K*	967	Miyanoshita Fujiya Hotel *K*
901	Hozugawa . . . *T*	968	View of Miyanoshita *K*
902	Fujiyama from Omiya . . . *K*	969	Fujiya Hotel at Miyanoshita *K*
903	Hozugawa . . . *T*	969	View of Dogashima *K*
904	Fujiyama from Numagawa . . . *K*	970	Fujiya Hotel . . . *K*
904	Hozugawa . . . *T*	973	Miyanoshita . . . *K*
905 A	Country Bridge . . . *K*	976	Redidents of Cave . . . *K*
905 B	Arashi Yama . . . *T*	977	Kameya Garden . . . *K*
906	Fujiyama from Odaki . . . *K*	978	Miyanoshita . . . *K*
908	Castle at Kyoto *T*	979	Horiuji . . . *T*
908	Fujiyama from Kawaibashi *K*	979	Ojigoku . . . *K*
911	Fujiyama from Gotenba *K*	980	Ashinoyu Hot Spring . . . *K*
912	Fujiyama from Gotenba *K*	980	Miyanoshita . . . *K*
912	Manuyama at Kyoto *T*	981	Stone Image . . . *K*
914	Garden at Kyoto *T*	982	Futagoyama . . . *K*

NO.	TITLE	PHOTOGRAPHER	NO.	TITLE	PHOTOGRAPHER
983	View of Kiga *K*		1020 B	Jinrikisha *F*	
984	Kiga *K*		1021	Daibutsu Bronze . . . *K*	
984	Mississippi Bay . . . *T*		1025	Shinobadzu Pond Uyeno *Ka?/OK?*	
987	Dry Goods Store *R*		1031	Lotus Pond . . . *K*	
987	Honmoku *T*		1033	Flower Show *T*	
987	Rapids at Kiga *K*		1034	Peonies . . . *T*	
988	Gongen Road Hakone *K*		1037	Shinto Temple . . . *K*	
988	Takinogawa . . . *T*		1038	Kamakura *K*	
989	Hakone Lake *K*		1038	[Weaving] *Su*	
990	Hakone Lake *K*		1039	Nojima . . . *K*	
991	Fujiyama from Hakone Lake *K*		1040	Lotus Blossom . . . *T*	
991	Ojigoku . . . *K*		1042	Musicians *U*	
992	Hakone Village *K*		1043	Gardens at Tokyo *T*	
993	Fujiyama . . . *K*		1045	Arsenax Grounds Yokosuka *K*	
993	Ojigoku . . . *K*		1045	Street at Atami *K*	
994	Hafuya Hotel . . . *K*		1053	[Family Meal] *Su*	
994	Yokohama Bluff *T*		1053	Tea House "Ebisuya" Eno-shima *Ka?/OK?*	
995	Hafuya Hotel . . . *K*		1054	[Young Lady] *U*	
996	Stone Image . . . *K*		1055	Takinogawa . . . *T*	
996	View of Hakone Lake *K*		1056	Stone Gate . . . *K*	
997	Ancestral Worship *K*		1057	Bird's-eye View Tokyo *T*	
997	Futagoyama . . . *K*		1059	[Planting Rice Seedlings] *Su*	
998	Fujiyama from Otometoge *K*		1061	Shichiriwahama near Enoshima *Ka?/OK?*	
998	Hakone Lake *K*		1062	Mitake Koshiw *K*	
1000	Fuji from Otome-Toge *Ka*		1064	Fujiyama . . . *T*	
1000	Hakone Lake *K*		1064 B	Girl, Raining *K*	
1000	Lespedeza . . . *OS*		1065	[Harvesting] *Su*	
1001	Tomioka *K*		1065	Nagoya Town *T*	
1003	Tomioka *K*		1066	Hachiman Temple Kamakura *Ka?/OK?*	
1004	Sakaigi . . . *K*		1067	[Peeling the Grain] *Su*	
1004 B	Afternoon Lunch *K*		1078	Kinkakuji Garden . . . *T*	
1005	Totsuka Tokaido *K*		1081	[Men's Hairdresser] *U*	
1006	Main St. of Yokohama *T*		1081	Nunobiki . . . *T*	
1007 B	Girl Playing . . . *K*		1081	[Washing Rice] *Su*	
1007 B	Girl Playing on Gekin *F*		1082	Fuji from Kawai-Bashi *Ka?/OK?*	
1010	Street in Yenoshima *K*		1083	Midera at Otsu *T*	
1011	Mr S Kajima's Country Seat at Mukojima *Ka?/OK?*		1087	[At a Festival] *Su*	
1012	View of Yenoshima *K*		1087	Lake of Biwa *T*	
1014	Cave of Yenoshima *K*		1089	Fuji and Kurasawa *Ka?/OK?*	
1014	[Hand-grinding] *Su*		1090	[Celebrating Girls Festival] *Su*	
1015	Cave of Yenoshima *K*		1091	[Celebrating a Buddhist Festival] *Su*	
1016	Enoshima *K*		1091	Hozugawa Rapids Kyoto *T*	
1016	Rice Planting *T*		1092 B	Washer Woman *F*	
1016	[Spinning Thread] *Su*		1094	Ishiyamadera . . . *T*	
1018	Daibutsu . . . *K*		1098 B	Home Bathing *K*	
1020	Musical Instruments, Tea House Room *I*		1104 A	Ferry Boat *T*	
1020	Veno Park . . . *T*				

NO.	TITLE	PHOTOGRAPHER	NO.	TITLE	PHOTOGRAPHER
1106 B	Girl a Water from Well *F*		1207	Nunobiki . . . *K*	
1107	Enoshima *T*		1208	Metaki . . . *K*	
1107	Miogizan . . . *K*		1208	[Waterfall] *T*	
1113	Usuitoge . . . *K*		1210	Temple . . . *K*	
1114	Fuji from Sattatoge *Ka*		1211	Bronze Image . . . *K*	
1116	Asamayama . . . *K*		1212	Nanko Temple . . . *K*	
1123	Wada Village . . . *K*		1213	Mayasan . . . *K*	
1124	Fuji and Kashiwabara Lake *Ka*		1214	Mayasan . . . *K*	
1124	Wanda Pass . . . *K*		1218	Awaji-Shima . . . *K*	
1125	Fuji and Hinonkishinden *Ka*		1219	View of Awaji-Shima . . . *K*	
1125	Wada Pass . . . *K*		1220	View of Arima *K*	
1126	Shimono . . . *K*		1221	View of Arima *K*	
1127	Shimono . . . *K*		1222	View of Arima *K*	
1128	Large Tree . . . *K*		1223	View of Arima *K*	
1129	Source of Tenrin . . . *K*		1224	View of Arima *K*	
1133	Dainichido . . . *T*		1225	Tennoji Temple Osaka *K*	
1135	Kegon Falls . . . *T*		1226	Maikonohama *Ka?/OK?*	
1135	[Making Paper] *Su*		1226	Osaka Castle *K*	
1135	Sakurasawa . . . *K*		1227	Osaka Castle *K*	
1136 B	Coolie . . . *K*		1230	Naniwa Bridge Osaka *K*	
1137	Kisogawa . . . *K*		1232	Yebisu Bashi Osaka *K*	
1138	Pine Tree at Kinkakuji, Saikio *Ka?/ OK?*		1233	View of Sumiyoshi Bridge . . . *K*	
			1235	Eshiyama . . . *K*	
1142	Pleasure Boat on Hotsugawa, Ara- shiyama *Ka?/OK?*		1236	Biwa Lake . . . *K*	
			1237	(Karasaki Pine Tree) . . . *K*	
1142	Torii . . . *K*		1238	Ishyama-Tera . . . *K*	
1142	Torii Pass . . . *K*		1239	Biwa Lake . . . *K*	
1143	Kisogawa River . . . *K*		1240	Daibutsu Temple . . . *K*	
1147	Komagatate . . . *K*		1241	Daibutsu Temple . . . *K*	
1149	Fukushima . . . *K*		1243	Daibutsu or Bronze . . . *K*	
1151	Kakemashi . . . *K*		1246	Nigetsudo Nara *K*	
1154	Kisogawa . . . *K*		1247	Lake Sarusawa Nara *K*	
1155	Maruyama, Saikio *Ka?/OK?*		1248	Kasuga Nara *K*	
1159	Interior of "Mankayen" (Tea House) Saikio *Ka?/OK?*		1249	View of Nara *K*	
			1250	Kasuga Temple Nara *K*	
1159	Namegawa . . . *K*		1251	Tonomine Yamato *K*	
1164	Nagoya Castle *K*		1252	Bentendori Yokohama *T*	
1165	Sixteen Images Chion-in Temple, Saikio *Ka?/OK?*		1255	Nara *K*	
			1257	Kasuga Nara *K*	
1166	Nagoya Castle *K*		1262	Suwayama . . . *K*	
1167	Nagoya Castle *K*		1265	Minatogawa, Kobe *K*	
1168	Great Gate . . . *K*		1272	Kikuya Tea House, Uji *K*	
1168	Komagatake . . . *T*		1279	Miko at Nara *K*	
1182	[Girl Holding Colored Ball] *K*		1304	Niew of Kyoto *K*	
1194	Miidera, Otsu *Ka?/OK?*		1307	Buddhist Images . . . *K*	
1196	Large Pine Tree at Karasaki, Lake Biwa *Ka?/OK?*		1309	Entrance Gate . . . *K*	
			1310	Yaami Hotel Kyoto *K*	
1202	Kobe *K*		1312	Kiyomizu . . . *K*	
1203	View of Kobe *K*		1313	[Kendo] *U*	

NO.	TITLE	PHOTOGRAPHER	NO.	TITLE	PHOTOGRAPHER
1314	Kiyomidzu . . . *K*		1568	Bronze Portal . . . *K*	
1316	Japanese Graves . . . *K*		1570	Canonical . . . *K*	
1317	Graves Kurodani . . . *K*		1573	Carved Temple Wall . . . *K*	
1318	Gojio-Saka . . . *K*		1575	Great Gate Nikko *K*	
1320	Otani Kyoto *K*		1576	Two Images in . . . *K*	
1326	Gion Street Kyoto *K*		1579	Great Gate *K*	
1331	Ginkakuji . . . *K*		1580	Top Image . . . *K*	
1333	Shimo Kamo . . . *K*		1582	[Temple Carving] *K*	
1334	Shimo Kamo . . . *K*		1594	Yomei . . . *K*	
1336	[Japanese Family] *U*		1595	China Wood . . . *K*	
1336	Kinkakuji Garden . . . *K*		1596	Pillar Door . . . *K*	
1337	Kinkakuji . . . *K*		1598	Gilded Door . . . *K*	
1339	Mikado's Garden Kyoto *K*		1599	Inside Iyeyasu . . . *K*	
1341	[Theatrical Players] *U*		1600	Carved Cat Nikko *K*	
1342	Arashiyama . . . *K*		1602	Iyeyasu's Tomb . . . *K*	
1345	Kyoto Rapids . . . *K*		1603	Pantomine . . . *K*	
1346	View of Rapids . . . *K*		1609	Iyemitsu's Stone . . . *K*	
1347	Kyoto Rapids *K*		1611	Jikokuten . . . *K*	
1348	Rapids at Kyoto *K*		1613	Wind Devil . . . *K*	
1351	Kyoto Rapids *K*		1614	Thunder Devil . . . *K*	
1353	Kyoto Rapids *K*		1615	Yashamon . . . *K*	
1354	Kyoto Rapids *K*		1619	Gokuzaka . . . *K*	
1362	Sanjiu Sangendo . . . *K*		1624	View on the Road . . . *K*	
1363	Sanjiu Sangendo . . . *K*		1626	Large Stone . . . *K*	
1365	View of Rapid *K*		1628	Ichinotaki . . . *K*	
1366	Byodin Temple . . . *K*		1630	Hannia . . . *K*	
1367	Person Who Fishes . . . *K*		1632	Kegon Waterfall . . . *K*	
1368	Person Who Fishes . . . *K*		1634	Chiusenji Lake . . . *K*	
1369	Yaami Hotel . . . *K*		1635	Chiusenji Lake . . . *K*	
1384	[Japanese Shoemaker] *U*		1639	Copper Mining . . . *K*	
1386	View of Matsushima *K*		1661	View Ojigoku . . . *K*	
1395	[Cloth Merchant] *U*		1662	Ojigoku . . . *K*	
1405	[Yokohama Pier] *Ka?/OK?*		1663	Hakone Lake *K*	
1436	Onomichi Inland Sea *K*		1664	Fujiyama . . . *K*	
1437	Onomichi Bingo . . . *K*		1664	Miyanoshita . . . *K*	
1439	Tomotsu . . . *K*		1665	Hakone Village *K*	
1521	Girls for Cooling . . . *OS*		1668	Hafuya Hotel . . . *K*	
1549	Playing at Musical Instruments *Ka?/ OK?*		1669	Hakone Village . . . *K*	
1551	Imaichi . . . *K*		1670	Hakone Lake *K*	
1553	Nikko Hotel *K*		1671	Otometoge . . . *K*	
1554	Sacred Bridge . . . *K*		1675	Kanogawa River . . . *K*	
1558	Nikko Garden *K*		1678	Shuzenji Hot Spring *K*	
1560	Sambutsodo . . . *K*		1679	View of Hakone Lake *K*	
1563	Bell Nikko *K*		1680	View of Hakone Lake *K*	
1564	Interior . . . *K*		1683	Great Hot Boiling Springs . . . *K*	
1565	Front View . . . *K*		1684	Yokoiso at Atami *K*	
1566	Monkey Carved . . . *K*		1985	[Lady Playaing Koto] *S*	
			1987	[Portrait of a Girl] *S*	

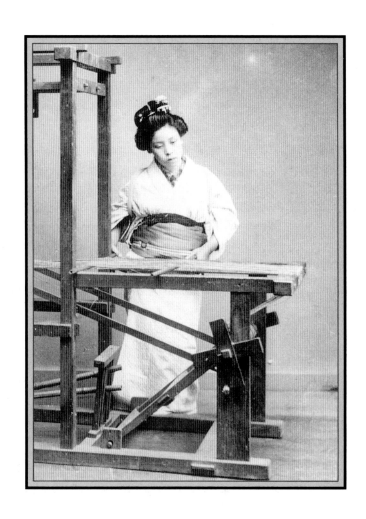

Appendix
2
Photographic Terms

albumen paper a light-sensitive paper prepared with a coating of egg white and a salt (e.g., ammonium chloride) and sensitized by being treated with a solution of silver nitrate. This very popular form of photographic printing paper, introduced in 1850, was used for the vast majority of nineteenth-century Japanese photographs.

cabinet card a photograph somewhat larger than a portrait photo (usually $5^1/_4$ x 4 in) that was placed on a mount that measured $6^1/_2$ x $4^1/_4$ inches. The cabinet card came into use in the late 1860s and early 1870s when the demand for carte-de-visite photographs waned.

carte de visite a close-trimmed photograph ($2^1/_4$ x $3^3/_4$ in) mounted on a slightly larger card that served as a popular form of visiting card in the 1860s. Cartes de visite depicted views, portraits, and other subjects.

collotype process a high-quality, fine-grain printing process whereby gelatine is applied to a glass plate that is allowed to dry and then exposed to a photographic image. The process was invented by Alphonse Poitevin in 1855 and was popularized in Japan in the 1890s by Ogawa Kazumasa, who produced many beautiful collotype works.

daguerreotype the first successful commercial photographic process, invented by Louis J. M. Daguerre in 1839 and used by Eliphalet Brown, Jr., for the first known photographs of Japan in 1853. A daguerreotype is a direct positive that results from a sensitized copper plate exposed for approximately fifteen minutes. The daguerreotype is a unique photograph since no negative is used.

dry-plate process a process that uses a photographic plate coated with a sensitized emulsion and dried before exposure. This revolutionary process, introduced in 1873, made the transport and storage of prepared glass plates easier.

handcoloring the coloring with watercolors of photographs by artists. The process, introduced in Europe but never popular there, became an art form in Japan from the 1860s. Beato may have been the first to employ handcoloring consistently in Japan. It is my opinion that handcoloring is a very underappreciated art form.

lantern slide a slide on which a photographic positive is printed on clear glass and the

image projected onto a screen. Many Japanese lantern slides were attractively handcolored.

stereograph a print consisting of two images of the same object taken from slightly different angles. The two images are mounted side by side on a stiff card and viewed through a stereoscope to produce a three-dimensional image. The stereoscopic process was invented by Sir Charles Wheatstone in 1838.

wet-collodion (wet-plate) process a process invented by Frederick Scott Archer in 1851 in which a glass plate was coated with a special chemical mixture and exposed while still wet. Exposure would take just a few seconds but the operation was messy and cumbersome.

Bibliography

Alcock, Sir Rutherford. *The Capital of the Tycoon: A Narrative of a Three Years' Residence in Japan.* London: Longman Green, 1863.

Angus, D. C. [pseud.]. *Japan: The Eastern Wonderland.* London: Cassell and Company, Limited, 1904.

Banta, Melissa, and Susan Taylor, ed. *A Timely Encounter: Nineteenth Century Photographs of Japan.* Cambridge, Massachusetts: Peabody Museum Press, 1988.

Barr, Pat. *The Coming of the Barbarians: A Story of Western Settlement in Japan, 1853–1870.* London: Macmillan, 1967.

Barr, Pat. *The Deer Cry Pavilion: A Story of Westerners in Japan, 1868–1905.* London: Macmillan, 1968.

Bennett, Terry. "The Early Photographers, Photographing Japan 1860's–1890's." *Japan Digest,* January, April, July, October 1991.

Brinkley, Francis, ed. *Japan: Described and Illustrated by the Japanese.* Boston: J. B. Millett Co., 1897.

Burton, W. K. "A Japanese Photographer." *Anthony's Photographic Bulletin,* vol. xxi, 1890.

Burton, W. K. "Kajima Seibei." *The Practical Photographer,* August 1, 1894.

Burton, W. K. "K. Ogawa." *The Practical Photographer,* June 1, 1894.

Chamberlain, Basil Hall. *Japanese Things.* Tokyo: Charles E. Tuttle Company, 1971.

Chamberlain, Basil Hall, and W. B. Mason. *A Handbook for Travellers in Japan.* 4th ed., London: J. Murray, 1894.

Clark, John, John Fraser, and Colin Osman. "A Chronology of Felix (Felice) Beato." *Japanese-British Exchanges in Art 1850s–1930s.* Privately printed by the authors, 1989.

Cortazzi, Hugh, and Terry Bennett. *Japan: Caught in Time.* London: Garnet Publishing, 1995.

Dai-ichi Art Center, ed. *Nihon Shashin Zenshu 1 Shashin no Makuake.* Tokyo: Shogakkan, 1985.

Edel, Chantal, tr. *Once Upon a Time: Visions of Old Japan from the Photos of Beato and Stillfried and the Words of Pierre Loti.* New York: Friendly Press Inc., 1986.

Farsari, Adolfo. *Keeling's Guide to Japan.* 4th ed., Yokohama: Kelly and Walsh, 1890.

Fox, Grace. *Britain and Japan, 1858–1883.* Oxford: Oxford University Press, 1969.

Hawks, Francis L. *Narrative of the Expedition of an American Squadron to the China Seas and Japan. Performed in the Years 1852, 1853, and 1854. Published by Order of the Congress of the United States.* Washington, D.C.: A.O.P. Nicholson, 1856.

Himeno, Jun'ichi. "The Japanese Modernization and International Informativeness Viewed from Old Photographs—the Nagasaki Photo-history." *Old Photography Study No. 1,* April 1994.

Humbert, A. *Japan and the Japanese Illustrated.* London: Richard Bentley and Son, 1874.

Jocelyn, the Honorable William Nassau. Private journal, 1858–1859. Manuscript in the possession of the Yokohama Archives of History.

Kanagawa Shinbunsha. *Meiji no Yokohama Tokyo Nokosareteita Garasu Kanban Kara.* Yokohama: Kanagawa Shinbunsha, 1989.

Loti, Pierre. *Madame Chrysantheme.* Tokyo: Charles E. Tuttle Company, 1973.

Negretti, P. A. "Henry Negretti—Gentleman and Photographic Pioneer." *The Photographic Collector,* vol. 5, no. 1, 1984.

Nihon Shashinka Kyokai, ed. *Nihon Shashin Shi 1840–1945.* Tokyo: Heibonsha, 1971.

Notehelfer, F. G., ed. *Japan Through American Eyes—The Journal of Francis Hall, Kanagawa and Yokohama 1859–1866.* Princeton, New Jersey: Princeton University Press, 1992.

Ogawa Dosokai, ed. *Sogyo Kinen Sanju Nenshi.* Tokyo: Ogawa Shashin Seibansho, 1913.

Osman, Colin. "New Light on the Beato Brothers." *British Journal of Photography,* October 16, 1987.

Osman, Colin. "The Later Years of Felice Beato." *Royal Photographic Society Journal,* November 1988.

Ozawa, Takesi. *Bakumatsu Shashin no Jidai.* Tokyo: Chikuma Shobo, 1994.

Ozawa, Takesi. *Shashin de Miru Bakumatsu Meiji.* Tokyo: Sekai Bunkasha, 1990.

Ozawa, Takesi. "The History of Early Photography in Japan." *History of Photography,* October 1981.

Pantzer, Peter. "An Austrian Nobleman Rocked the Cradle of the Photographic Great Power Japan." *Austria Today,* vol. 4, 1989.

Paske-Smith, M. *Western Barbarians in Japan and Formosa in Tokugawa Days 1603–1868.* New York: Paragon Book Reprint Corporation, 1968.

Pedlar, Neil. "Appendix II: Freemasons of Yokohama 1866–1896." *An Indexed List of British Marriages Solemnized during Extraterritoriality 1860–1899 in Japan.* Newquay: Four Turnings Publication, 1993.

Philipp, Claudia Gabriele, Dietmar Siegert, and Rainer Wick, ed. *Felice Beato in Japan. Photographien zum Ende der Feudalzeit, 1863–1873.* Heidelberg: Edition Braus, 1991.

Rea, Mary Alice. Private journal, 1881. Manuscript in the possession of the Yokohama Archives of History.

Rogers, G. W. "Early Recollections of Yokohama 1859–1864." *The Japan Weekly Mail,* December 5, 1903.

Rosenberg, Gert. *Wilhelm Burger. Ein Welt- und Forschungsreisender mit der Kamera. 1844–1920.* Wien and Munchen: Christian Brandstatter, 1984.

Rosin, Henry. "Études sur les débuts de la photographie japonaise au 19e siècle." *Bulletin de l'Association franco-japonaise,* no. 16, April 1987.

Saitoh, Takio. *F. Beato Bakumatsu Nihon Shashinshu.* Yokohama: Yokohama Archives of History, 1987.

Saitoh, Takio. "Photography in Yokohama and W. Saunders," *The PhotoHistorian,* no. 86, Autumn 1989.

Saitoh, Takio. "Shashinshi no Genryu o Tazunete." *Yokohama Kaiko Shiryokan Kanpo News,* no. 30, May 3, 1990.

Satow, Sir Ernest. *A Diplomat in Japan.* Tokyo: Charles E. Tuttle Company, 1983.

Satow, Sir Ernest, and A. G. S. Hawes. *A Handbook for Travellers in Central and Northern Japan.* Yokohama: Kelly and Co., 1881.

Ueno, Ichiro, et al. *Shashin no Kaiso: Ueno Hikoma. Shashin ni Miru Bakumatsu Meiji.* Tokyo: Sangyo Noritsu Tanki Daigaku Shuppanbu, 1975.

Van Zandt, Howard F. *Pioneer American Merchants in Japan.* Tokyo: Lotus Press, 1980.

Wenckstern, Friedrich von. *A Bibliography of the Japanese Empire: Being a Classified List of the Literature in European Languages Relating to Dai Nihon (Great Japan) Published in Europe, America and in the Far East.* Vol. I, Leiden: E. J. Brill, 1895, vol. II, Tokyo: Maruzen, 1907.

Westfield, T. C. *The Japanese: Their Manners and Customs*. London: Photographic News Office, 1862.

White, Stephen. "Felix Beato and the First Korean War, 1871." *The Photographic Collector*, vol. 3, no. 1, Spring 1983.

White, Stephen. "The Far East." *Image*, vol. 34, nos. 1–2, 1991.

Winkel, Margarita. *Souvenirs from Japan*. London: Bamboo Publishing, Ltd., 1991.

Woods, Sir Henry F. *Spunyarn: Strands from a Sailor's Life*. London: Hutchinson and Company, 1924.

Worswick, Clark. *Japan Photographs: 1854–1905*. New York: Penwick Publishing, Inc., 1979.

Worswick, Clark. *Notes on Japanese Collections of Photographs*. Tokyo: Pacific Press Service, 1988.

Worswick, Clark. "The Disappearance of Uchida Kyuichi [*sic*] and the Discovery of Nineteenth Century Asian Photography." *Image*, vol. 36, nos. 1–2, Spring/Summer 1993.

Yokohama Kaiko Shiryokan, ed. *Saishoku Arubamu. Meiji no Nihon—Yokohama Shashin no Sekai*. Yokohama: Yurindo, 1990.

Zannier, Italo. *The Beato Brothers*. Venezia: Ikona Photo Gallery, 1983.

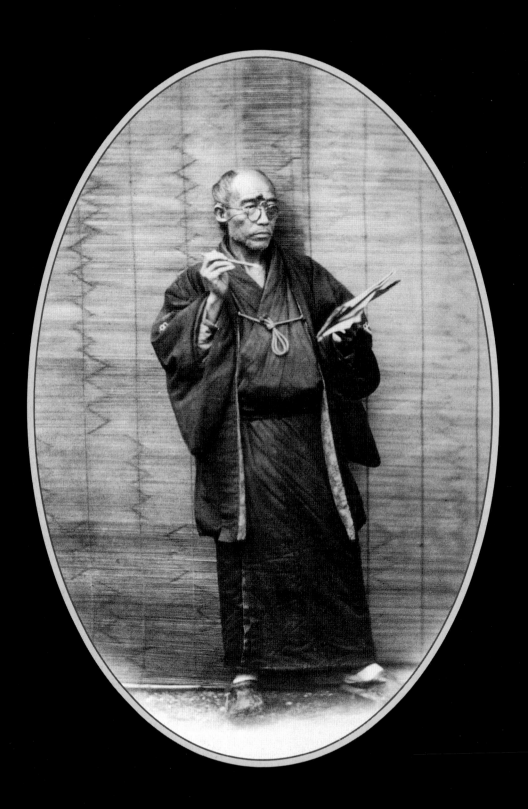

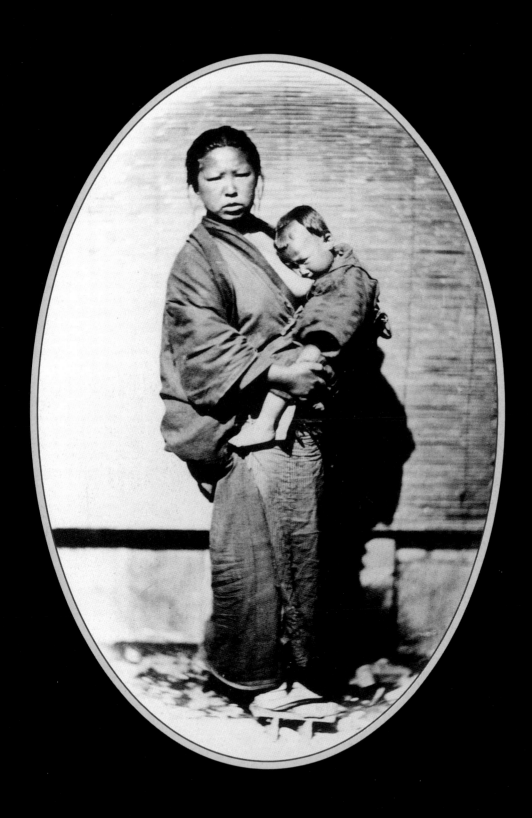

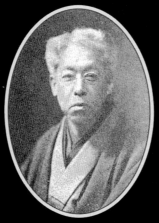

TAMAMURA KOZABURO

OGAWA KAZUMASA

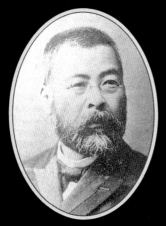

SUZUKI SHIN'ICHI

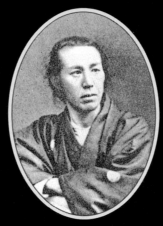

YOKOYAMA MATSUSABURO

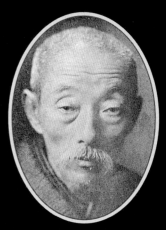

ESAKI REIJI

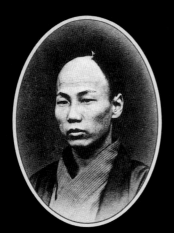

UENO HIKOMA

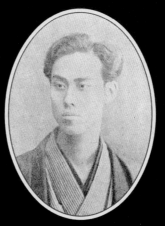

KASHIMA SEIBEI

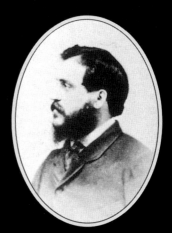

FELICE BEATO